theresa kim

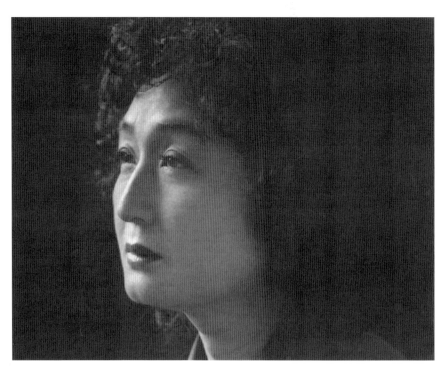

김테레사. 1982. 주명덕 사진.
Theresa Kim. 1982. Photo by Joo Myung-Duck.

theresa kim

김테레사 작품집 1978-2010

열화당
youlhwadang publishers

차례 Contents

김테레사의 예술세계, '자유와 열정의 파드되'

손수호孫守鎬 문화저널리스트

선의 율동, 면의 역동

김테레사는 열정과 몰입의 작가다. 1979년 뉴욕 프랫 인스티튜트Pratt Institute 대학원 졸업 이후 쉼 없이 달려온 여정은 시종일관 활기찬 에너지로 가득하다. 늘 모자를 쓰듯, 늘 붓을 잡고 아름다움의 근원을 찾는 미美의 순례자였다. 삶이 다이내믹하듯, 그림도 늘 움직이는 대상을 좇았다. 피에로에서 투우鬪牛, 말馬, 무희舞姬로 이어지는 율동에서 무대 위의 거대한 아우라를 본다.

김테레사는 또한 자유로운 영혼의 소유자다. 화단정치에서 멀리 떨어져 독자적인 화풍을 구사했다. 누구의 눈치도 보지 않은 채, 스스로 작업자이자 감독관의 역할을 감당했다. 개념미술이나 설치미술이 성행할 때도, 좋은 그림보다 재미있는 그림이 판을 칠 때에도 곁눈질하지 않았다. 순수미술의 힘을 신뢰했기에 가능했다.

김테레사의 작품은 선과 면의 하모니로 요약할 수 있다. 선의 율동이 거침없이 뻗어 나간다면, 면의 역동은 생생히 살아 숨쉰다. 직관으로 흐름을 포착하고, 짜임새있게 공간을 꾸린다. 두 요소는 서로 호응하고 화답하면서 김

Theresa Kim's Art World: A Pas de Deux of Freedom and Passion

Shon Suho Cultural Journalist

Rhythm of lines, dynamic of surfaces

Theresa Kim is an artist of passion and absorption. Since completing a graduate degree from New York's Pratt Institute in 1979, she has tirelessly pursued an itinerary packed with unflagging energy. Kim has been an aesthetic pilgrim, always seeking the roots of beauty in her painting as she does in the hats she wears. Just as her life has been dynamic, her paintings have always followed moving subjects. With a rhythm that flows from pierrots to bullfights, horses, and dancers, they evoke the great aura of the stage.

Kim is also the possessor of a free spirit. Keeping well away from the politics of the art world, she has pursued her own individual style. Without worrying what anyone else may think, she has taken the roles of both supervisor and worker herself. Even when conceptual art and installation art were running wild, or when good pictures seemed to be less in demand than interesting pictures, she didn't turn her eyes in that direction. This was possible because she believed in the power of pure art.

Theresa Kim's works can be summed up as the harmony of line and surface. The rhythm of lines flows out without hindrance, while the dynamic of surfaces lives and breathes with vital energy. Kim grasps the flow

테레사 예술의 굳건한 성城을 이룬다.

순수미술의 정점에 오르기까지 비장의 무기로 활용된 것은 춤과 사진이다. 김테레사는 붓으로 춤을 추었고, 캔버스를 안무했다. 안무는 카메라 작업과 연결되면서 평생 이어지는 공간경영의 견고한 프레임이 된다.

"그림은 안무다"

그의 자유분방한 예술은 어떻게 형성됐을까. 그 비밀의 처소에 닿기 위해서는 가족사의 한 자락을 들춰 볼 필요가 있다. '테레사'는 '김인숙金仁淑'이 세 살 때 받은 세례명이다. 이름에는 가족사가 녹아 있고, 가족의 사연은 현대사와 동심원을 이룬다. 테레사는 동심원을 비추는 빛과 그림자의 합성어인 셈이다.

1943년 서울에서 태어난 김테레사는 아버지를 따라 세 살 때 강원도 철원으로 옮겨 어린 시절을 보냈다. 당시 철원은 삼팔선 이북 땅이었다. 그의 말에는 지금도 북녘 사투리가 가끔 나온다. 예를 들면 '어떤'을 '어떠런'으로 발음하는 식이다.

건축가였던 아버지는 사진과 그림, 음악을 즐긴 인텔리였다. 딸에게 일찌감치 예술적 세례를 퍼부은 것은 건축가가 예술에 느끼는 친연성 때문이었을 것이다. 고사리 같은 손에 붓을 쥐어 줬고, 일곱 살 때 야외출사野外出寫에 데

by intuition, and constructs well-proportioned spaces. As the two elements combine and respond to each other, she builds a strong fortress of art.

The secret weapons that Kim has used to reach the pinnacle of pure art are dance and photography. Kim has danced with the brush and choreographed the canvas. Choreography connected with the camera to form a strong frame for the management of space throughout Kim's life.

"Painting is choreography"

How did Kim's free-spirited art take shape? To find where that secret lies, we must look into a part of her family history. Born In sook Kim, she was given the Christian name Theresa at the age of three. That name is infused with her family history, and her family's story revolves around the modern history of Korea. The name Theresa thus becomes a compound word combining the light that illuminates those concentric circles with dark shadows.

Born in Seoul in 1943, at the age of three Theresa Kim went with her father to Cheolwon, Gangwon Province, and there she spent her childhood. Cheolwon lay north of the 38th Parallel, and Kim's speech still bears traces of North Korean dialect.

Her father, an architect, was an intellectual who enjoyed photography, painting, and music. So her early

리고 갔다. 시각예술에 대한 원초적 본능을 일깨운 시기였다.

아버지는 드물게 발레를 익히는 기회를 만들어 주기도 했다. 테레사는 서양춤을 익히면서 내면에서 솟아나는 율동의 즐거움을 알게 됐다. 유성기에서 음악이 흘러 나오면 자연스럽게 몸을 움직였고, 더러 독창적인 동작을 만들어내기도 했다.

이런 어린 테레사의 무대감각은 당대의 춤꾼 최승희崔承喜 눈에 띄어 집중적인 교육을 받았다. 최승희는 춤에 재능이 있는 어린 싹을 발굴하기 위해 전국을 돌던 참이었다. 사회주의 체제의 예술교육은 엄격했다. 발레리나를 주인공으로 한 영화를 보면서 예술영웅을 꿈꿨고, 노동자 위문공연을 하면서 직접 무대를 밟기도 했다. 최승희의 순회지도를 받으면서 보낸 철원 생활 이 년은 삶을 지배하는 값진 경험이었다.

그러나 다복했던 어린 시절은 육이오 전쟁으로 종말을 고한다. 아버지는 납북됐고, 모녀는 미군의 도움으로 피란길에 나섰다. 천신만고 끝에 닿은 곳이 호남 땅 전주였고, 거기서 고단한 삶의 짐을 부리게 된다. 어머니는 아버지와 달리 예술을 멀리하도록 했다. 전쟁이 없었으면 제이의 최승희를 꿈꿀 만큼 춤에 재능을 보였는데도 어머니는 한사코 반대했다. 품에 안고 잠들던 분홍빛 토 슈즈마저 감춰 버렸다.

테레사는 그림에서도 특출난 재능을 발휘했다. 화구畵具가 없어 굴러다니는 골판지에 그린 그림을 전주여고 미술

artistic initiation was due to the affinity that an architect felt for art. He put a brush into her tiny hand, and when she was seven took her on outdoor photography excursions. This was the time when her basic instinct for visual art was awakened.

Kim's father also gave her a rare opportunity to learn ballet. In learning Western dance, she came to know the joy of rhythmic movement that poured out from within. As the music streamed out of the gramophone, she moved her body naturally and sometimes made original movements.

The young Theresa's feeling for the stage caught the eye of the famous dancer Choe Seunghui (1911-1967), and she began to receive systematic training. Choe had been roaming the whole country in search of young people with a gift for dance. Under the socialist system, artistic education was strict. When she saw a movie about a ballerina, Kim dreamed of becoming an artistic heroine, and even went on stage giving performances to encourage the workers. These childhood years in Cheolwon, receiving peripatetic instruction from Choe Seunghui, provided a precious experience that guided her through life.

But Kim's happy childhood was ended by the Korean War. Her father was abducted to the North, while mother and daughter fled with the aid of the American military. After great trouble and hardship they arrived in Jeonju, Jeolla Province, where they eked out a hard existence. Unlike her father, Kim's mother steered her away from art. Kim had shown such talent for dance that if there had been no war she might have

교사는 높게 평가했다. 학교에서는 당연히 미대 진학을 권유했으나, 테레사는 어머니의 뜻을 받들어 숙명여대 교육학과를 선택하게 된다.

이렇듯 테레사의 성장기를 지배한 것은 춤과 그림이다. 특히 어린 시절에 접한 춤의 경영, 즉 안무choreography가 회화감각과 만나 평생의 예술적 자양분이 된다. 무대공간을 연출하듯, 화폭도 안무의 연장으로 인식하는 것이다. 기실 춤이라는 장르에서 창작자는 무용수가 아니라 안무가다. 안무는 춤을 구성하고, 무용수는 무보舞譜에 따라 춤을 실연한다. 테레사는 안무와 실연을 익히면서 무용적 감수성을 터득했다. 그림에 안무적 요소가 반영됐으니, 동세動勢가 그토록 힘있고 물 흐르듯 자연스럽다.

카메라, 운명의 힘

대학에서 테레사를 유혹한 것은 춤도 붓도 아닌 카메라였다. '숙미회淑美會'라는 사진 동아리에 들어간 그는 운명의 힘을 느끼듯 카메라의 매력에 빠져들었다. 이때 사진반을 지도하던 사람이 주명덕朱明德과 김승원金勝元이었다.(주명덕은 이후 한국의 사진계를 대표하는 작가로 성장했고, 김승원은 그의 배우자라는 신분과 함께 맨해튼의 유명한 외과의사가 됐다)

dreamed of becoming a second Choe Seunghui, but her mother resolutely opposed her dancing. She even hid the pink toe shoes that Theresa had held in her arms when she slept. But Theresa also showed an outstanding talent for painting. As she had no painting materials, she drew pictures on scraps of cardboard, and these were greatly admired by the art teacher at Jeonju Girls' High School. At school they naturally advised her to apply to art college, but Theresa followed her mother's wishes and chose the education department at Sookmyung Women's University.

Thus, what guided Kim as she grew up was dance and pictures. In particular, it was the encounter between the management of dance—choreography—and a feeling for painting, that provided the artistic nourishment for Kim's whole career. She came to think of the canvas as an extension of choreography, as if directing the space of the stage. In dance, the creator is not the dancer but the choreographer. The choreographer forms the dance, and the dancer performs it according to the dance score. Kim had acquired a feeling for dance by learning both choreography and performance. It is because her paintings reflect choreographic elements that they have such powerful kinetic force and look as natural as flowing water.

The camera, force of destiny

At university, what fascinated Theresa Kim was not dance or the paint brush, but the camera. Having joined

카메라의 메커니즘을 익히자마자 공모전에 출품했다. 권위있는 동아사진콘테스트에 1968년과 1969년 이태에 걸쳐 특선을 차지해 주변을 놀라게 했다. 기라성 같은 기성작가를 제치고 대학원생이 대상을 차지한 것이다. 첫해 수상작은 붓장수 노인을 찍은 〈허심虛心〉, 두번째는 〈대화對話〉라는 작품이다. 카메라 프레임은 그에게 무대처럼 친숙한 공간이었다. 더구나 둘 다 당시로는 보기 힘든 컬러 사진이었다. 한국 공모전 시장에 컬러 시대를 연 주인공이 김테레사였고, 동아일보가 이를 공증했다.

그의 사진을 유달리 좋아한 사람은 동아일보 회장 김상만金相万과 화가 남관南寬이었다. 김상만은 자주 가든파티를 열어 주며 앞날을 축복했고, 남관은 경복궁景福宮 향원정香遠亭을 찍은 그의 사진과 자신의 그림을 바꾸자고 제의할 정도였다. 테레사는 파리 유학에서 돌아와 화단에 새 바람을 일으키던 남관을 많이 따랐다. 그에게서 예술의 지향점과 시야를, 화가라는 직업의 가치와 윤리를 배웠다.

김테레사는 일찍 사진에 두각을 나타낸 데 대해 "어릴 때 아버지의 카메라 렌즈를 들여다본 것이 도움이 됐을 것"이라고 설명했지만, 나는 엄지의 지문이 없어질 정도로 카메라 레버를 당긴 몰입과 투신이 그를 '젊은 대가大家'로 만들었다고 본다.

the photography club Sukmihoe, she became entranced with the charms of the camera as if feeling the force of destiny. The teachers of the photography class at this time were Joo Myung Duck and Sung Won Kim. Joo later developed into one of the leading photographers in Korea, while Kim became a famous surgeon in Manhattan—and Theresa's husband.

Theresa had no sooner become accustomed to the camera's mechanism than she started entering competitions. To the amazement of all around her, she took Gold Prize in the prestigious Dong-A Photo Contest for two consecutive years, 1968 and 1969. A university senior had won the prize over the heads of established star photographers. The winning work in the first year was *The Old Brush Seller*, and in the second, *Conversation*. The camera frame was a space in which Kim was as much at home as she was on the stage. Moreover, both works were color photographs, a medium rare in Korea at the time. It was Theresa Kim who opened the color era in Korean photography contests, as witnessed by *The Donga-A Ilbo* newspaper.

Two people who particularly liked Kim's photographs were Kim Sangman, president of *The Dong-A Ilbo*, and the artist Nam Kwan (1911-1990) Kim Sangman (1910-1994) held garden parties to toast Theresa's future success, while Nam Kwan went so far as to offer to trade a painting of his own for Theresa's photograph of the Hyangwonjeong Pavilion at Gyeongbokgung Palace. Theresa was much influenced by Nam, who had brought a new current to the Korean art world on his return from studying in Paris. From him she learned

뉴욕에서 꽃핀 붓질

김승원과 결혼한 후 1972년에 미국으로 건너간 테레사는 사진의 영역을 계속 넓혀 나갔다. 카메라를 통해 인간을 관찰하는 것은 여전히 즐거운 일이었다. 1973년부터 뉴욕에 정착한 뒤 그리니치 빌리지Greenwich Village의 워싱턴 스퀘어Washington Square를 담았다. 광장을 찾는 다양한 사람들의 표정(뉴욕대생들의 싱그러운 웃음, 저글링하는 젊은이, 거리의 악사)은 오묘한 삶의 풍경화와 다름없었다. 도시의 표정은 그의 다큐멘터리 사진에 녹아들어 작품으로 승화했다. 이들 작품은 1975년 서울 미도파화랑에서 선보여 호평을 받았다.

그러나 뉴욕은 카메라 하나에 매달리게 할 만큼 단순한 도시가 아니었다. 끊임없이 창작 욕구를 자극하고 예술적 에너지에 휘둘리게 만든다. 그것이 뉴욕의 힘이자, 매력이다.

뉴욕대에서 영어공부를 시작한 한편으로, 커뮤니티 칼리지에 미술과목을 등록하면서 새로운 미래를 꿈꿨다. 예술을 향한 갈급증을 느끼던 참이었다. 어머니가 멀리 한국에 있었기에 가능한 시도였다. 출산을 한 몸이었기에 발레는 몰라도 그림은 가능할 것 같았다. 다행히 열정은 식지 않았고, 붓도 친숙하게 손에 들어왔다. 옛 전주여고 시절로 돌아간 느낌이었다.

커뮤니티 칼리지에서 그림 그리기에 자신감을 얻은 그는 내친 김에 뉴욕의 명문 프랫 인스티튜트 대학원에 도전키

the objective and viewpoint of art, and the value and ethics of the artistic profession.

Kim has explained her early success in photography by saying that she was helped by the things she had seen through her father's camera lens as a child, but in my view it was her own absorption and dedication, pressing the shutter until the lines wore off her fingertip, that made her a "young master."

Blossoming as a painter in New York

After marrying Sung Won Kim and moving to America in 1972, Theresa continued to expand the domain of her photography. She still enjoyed observing people with the camera. After settling in New York in 1973, she photographed Washington Square in Greenwich Village. The faces of the diverse people who came to the square (NYU students with their fresh smiles, young people juggling, street musicians) seemed like a profound landscape painting of life. In her documentary photographs, the face of the city is sublimated into a work of art. These works were shown at Seoul's Midopa Gallery in 1975, and well received.

But New York was not such a simple city that it could be captured by the camera alone. It continually stimulated the urge to create and stirred up artistic energy. That is New York's strength and fascination.

While starting to study English at NYU, Kim enrolled in an art course at a community college and began to dream of a new future. This was when she started to feel a thirst for art. It was possible because her mother

로 하고 포트폴리오와 스케치북을 내밀었다. 그를 면접한 보베Bové 교수가 눈을 크게 뜨며 말했다. "사진은 더 배울 것이 없다. 가르쳐도 좋을 실력이다. 한국인은 스킬이 강한 반면 창의력이 약한 게 흠인데, 테레사는 다르다." 그러면서 회화를 권유했다. 인생은 그렇게 전환점을 맞았다.

"드로잉을 낭비하지 마라"

누구나 그렇듯 테레사도 드로잉부터 시작했다. 프랫의 첫 학기 수업은 옷 벗은 남자가 방 한가운데 높은 곳에 서 있고, 학생들이 각자 드로잉하는 방식으로 이루어졌다. 문제는 속도였다. 모델은 삼십 초마다 자세를 바꾸었다. 학부에서 미술을 전공하지 않은 그는 스피드를 따라가지 못해 쩔쩔맸다.

경험의 부족을 메울 특별한 방도는 없었다. 도망갔다. 내리 한 달간 결석했다. 보베 교수가 찾아와 다시 시작하자고 했다. 모델 앞에서 눈을 감았다. 불현듯 카메라 앵글이 떠올랐다. 그렇다, 카메라 셔터를 누르듯 장면을 순간적으로 포착한 뒤 재구성하면 될 것을! 실제 그랬다. 그는 뷰파인더를 통해 모델을 힐끗 보고는 사진을 찍듯 속사 크로키를 했다. 마음이 편안해졌다. 모델의 어떤 동작도 잡아낼 수 있었다. 대상의 실루엣까지 보였다.

어느 날, 등 뒤에서 그의 드로잉을 보던 보베 교수가 신문용지로 된 드로잉 패드를 밀쳐내고 새 스케치북을 건네

was far away in Korea. Now that she was a mother herself, she might not be able to do ballet, but painting should be possible. Fortunately her passion had not cooled, and the brush came naturally to her hand. She felt as if she was returning to the old days at Jeonju Girls' High School.

Having gained confidence in painting at community college, now that she had started she thought she might as well try for admission to graduate school at New York's prestigious institution the Pratt Institute. When she submitted her portfolio and sketchbook, the professor who met her, Bové, opened his eyes wide in astonishment. "You have nothing more to learn about photography. You could teach it yourself. Most Koreans are strong in technique and weak in creativity, but you are different." Bové recommended her to study painting. It was a turning point in her life.

"Don't waste your drawings"

Like everyone else, Theresa began with drawing. In the first semester's class, a nude male model stood on a platform in the middle of the room while each student made a drawing. The problem was speed. The model changed his posture every thirty seconds. Not having majored in art at undergraduate level, Kim had a hard time keeping up.

There was no way to make up her lack of experience. She ran away. For one straight month she skipped

주었다. 그리고 조용히 말했다. "테레사, 이제 드로잉을 낭비하지 마라." 드로잉이 습작 아닌 작품으로 인정받는 순간이었다.

드로잉에서 정상의 감격을 맛본 테레사는 바로 수채화에 도전했다. 처음 잡아 본 워터컬러는 따뜻한 감성을 나타내기에 더없이 좋았다. 그렇게 수채화에 매진하던 중에 미술평론가 이경성李慶成 선생이 뉴욕을 찾았다. 해외에서 활동하는 한국인 화가들을 조사하던 중이었다. 그의 작품을 처음 본 선생은 놀라움을 금치 못했다. "데생력은 철사와 같은 강한 힘을 지니고 있고, 한국 사람이 빠지기 쉬운 중간색에서 과감히 탈출했다." 대담한 구도와 색채에서 화가의 자유롭고 순수한 영혼을 본 것이다. 1980년 이경성 선생의 주선으로 선화랑에서 귀국전을 마련했다. 신예 재미작가의 데뷔전은 떠들썩하게 치러졌다. 자태가 고운 여성작가, 대담무쌍한 화필, 이경성의 추천사…. 전시는 성공이었고, 홀연히 한 명의 스타 작가가 탄생했다.

김테레사는 "당시 신군부가 등장한 직후라 한국 사회가 전반적으로 가라앉아 있었다. 그 침울한 분위기에 젊은 작가가 밝고 화사한 색채를 들고 나오니 반응이 좋았던 것이다. 많은 사람이 내 그림의 평안한 이미지에 위로를 느꼈던 것 같다"고 추억했다.

이 년 후 선화랑에서 다시 열린 두번째 개인전에는 굵은 문자추상을 구사한 페인팅을 선보였는데, 이번에는 마더

class. Professor Bové came to see her and asked her to start again. Faced with the model, she closed her eyes. At once she thought of a camera angle. That was it: she must capture the scene in a moment, like pressing the shutter of a camera, then rearrange it. And so she did. After glancing at the model through her viewfinder, Kim was able to complete a croquis sketch just like taking a snapshot. Her heart became easy. She could capture any movement the model could make. She could even show the subject's silhouette.

One day, after looking at her drawings over her shoulder, Professor Bové pushed away her newsprint drawing pad and gave her a new sketchbook. Softly, he said, "Theresa, don't waste your drawings now." That was the moment when her drawings were recognized, not as practice, but as art works.

Having tasted how it felt at the top through drawing, Kim next turned to watercolors. She found that watercolor was an ideal medium for conveying a warm feeling. While she was working on watercolor painting, the art critic Lee Kyung Sung came to New York. Lee was making a survey of Korean artists working overseas. When he first saw Kim's works, he could hardly contain his amazement. "The drawing has a force as strong as wire, and she has boldly escaped from the neutral tints that Koreans so often indulge in." In Kim's bold compositions and colors, he saw the pure and free spirit of the artist. In 1980, Lee arranged a homecoming exhibition for Kim at the Sun Gallery in Seoul. As the debut show of a new artist living in America, the event made a big splash. A beautiful woman artist, using bold and vigorous brush strokes, recommended

테레사가 '도움'을 주었다. 1981년 5월, '시대의 성녀'로 추앙받던 테레사 수녀가 한국을 찾았고, 비슷한 시기에 같은 이름을 가진 화가가 미술전람회를 열고 있었으니 후광효과가 따랐다. 김테레사는 이제 혜성같이 나타난 신예가 아니라, 한국 화단에 독자적인 화풍을 선보이는 작가로 서게 됐다.

첫 전시 이후 꿈 같은 세월이 흘렀다. 국립현대미술관의 해외작가전에 참여하고, 중앙일보가 뉴욕에서 초대전을 열어 주기도 했다. 1984년 공창화랑에서의 전시는 문정현 신부와 전주 금암성당 건립을 위한 자선전의 성격이었다. 그는 이 성당에 모성의 슬픔으로 예수의 최후를 재구성한 십자가의 길Station of the Cross 십사처十四處를 제작해 바쳤다.(이 그림은 나중에 분가한 평화동 성당으로 이전되었다)

살아 움직이는 것의 아름다움

서울에서의 인기는 그를 잠시 안락의자에 앉아 있게 했다. 머물면 죽는 것이 예술이다. 그는 뉴욕에 돌아와 다시 벌판에 섰다. 나태해진 스스로에게 채찍질하며 새로운 길을 찾기 위해 광야에서 별을 보고 걸었다.

이때 섬광처럼 눈에 들어온 것이 피에로였다. 뉴욕 메디슨 스퀘어의 링링브라더스Ringling Brothers and Barnum & Bailey 서커스단에서 어릿광대 역할을 하는 피에로의 모습은 그에게 강렬한 표현충동을 느끼게 했다. 지금껏 삼대

by Lee Kyung Sung.... The exhibition was a success, and overnight a star artist was born. Kim recalls, "As this was right after the new military regime took power, the general mood of Korean society was subdued. In that depressed atmosphere, when a young artist came forward with bright and cheerful colors, it was bound to be well received. Many people must have felt comforted by the peaceful images in my paintings." Two years later, when Kim held her second solo exhibition at the Sun Gallery, she presented abstract paintings using the shapes of thick written characters. This time she was "helped" by Mother Theresa. In May 1981, Mother Theresa, revered as the "saint of the age," visited Korea, and when an art exhibition was held at the same time by an artist of the same name, it produced a kind of halo effect. Theresa Kim now took her place, not as a new talent rising like a comet, but as an artist who had shown the Korean art world a unique and original style.

After the first exhibition, Kim's life became like a dream. She took part in an overseas artists' exhibition at the National Museum of Contemporary Art, Korea, and the Joong Ang Daily newspaper held an invitation exhibition for her in New York. Her 1984 exhibition at the Kong Chang Gallery was in the nature of a charity show to raise money for Father Mun Jeonghyeon and the construction of the Jeonju Geumam Catholic Church. Kim also painted The Fourteen Stations of the Cross for the church, showing the end of Jesus's life on earth and the sadness of his mother. (This painting was later moved to a new branch church,

째 이어지는 이 서커스단은 매해 서너 차례 공연을 하면서 뉴욕 시민들에게 꿈을 선물하는 곳. 서커스 단원 중에서 선발되는 피에로는 공연 시즌에 뉴욕 시내를 돌며 서커스를 알리는 광대이자 엔터테이너였다. 다이아몬드 무늬의 알록달록한 옷과 고깔모자, 외발자전거, 그리고 수다스럽고 과장스런 몸짓…. 피에로의 얼굴에 인생의 희로애락이 축약돼 있음을 발견했다. 그것은 춤과 음악, 연극, 회화가 어우러진 종합예술의 표현이었던 것이다.

서커스단에서 추억과 현실의 이미지를 축조해낸 작가는 신들린 듯 붓질에 빠져들었다. 워터컬러를 버리고 오일컬러를 썼다. 피에로의 의상은 형태적 구성에서 한국의 전통적인 조각보를 연상케 했다. 패턴으로는 기존에 그려 왔던 수채화와 일맥상통한 것이었다.

조각을 모으듯 컬러를 모아 표현한 피에로 그림은 1988년 조선화랑에서 일반에 선보였다. 당시 조선화랑은 서울 소공동 조선호텔 안에 있어 외국인 컬렉터도 많이 찾았다. 그의 작품이 국제적 명성을 얻는 기회이기도 했다. 피에로 그림에서 보듯, 테레사는 움직임을 포착하는 데 유능하다. 동작의 미세한 순간을 분절한 뒤 회화적 원리에 따라 재배치하는 것이다.

1990년에는 스페인 마드리드 여행 길에서 만난 투우가 또다시 그의 예민한 미적 감수성을 건드렸다. 투우장에 내리쬐는 햇볕과 시원스레 가로지르는 바람, 땅을 차고 오르는 투우의 박력, 바짝 올라붙은 투우사의 엉덩이…. 투

the Pyeonghwa-dong Catholic Church.)

The beauty of things that live and move

Success in Seoul put Kim in the easy chair for a while. But if art stays still, it dies. Returning to New York, Kim stood in the open plains again. To whip her indolent self into finding a new path, she walked in the wilderness looking at the stars.

What came to her eye now like a blinding flash was the figure of pierrot. At Ringling Brothers and Barnum & Bailey's Circus in New York's Madison Square, the image of pierrot taking the role of a clown made her feel a strong expressive impetus. This circus troupe, now in its third generation, had given New Yorkers something to dream of with its three or four performances each year. The pierrot was a clown and entertainer selected from the members of the troupe who went around New York City during the performance season to advertise the circus. Kim found that with his colorful costume of diamond pattern, his conical hat, his unicycle, and his garrulous and exaggerated gestures, all the joys and sorrows of human beings are condensed in pierrot's face. This was the face of a composite art combining dance, music, theater, and painting.

With a store of memories and images of reality from the circus, Kim immersed herself in painting as if possessed. Instead of watercolors she used acrylics. The pattern of pierrot's costume reminded her of traditional

우장은 예술적 요소를 두루 갖추고 있었다. 이듬해에는 멕시코 칸쿤Cancun 투우장을 찾아가 스케치를 완성했다.

김테레사에게 투우는 춤이었다. 시간에 따라 드라마틱한 장면을 연출했고, 작가는 그런 즉흥적 순간을 드로잉을 하듯 명쾌하고 단순한 형태로 잡아 나갔다. 표현력을 극대화하기 위해 유화, 파스텔화, 스케치 등 다양한 재료를 사용했다. 투우사가 소의 귀를 자른 뒤 두 팔을 치켜들며 승리를 구가하는 동안에 쓰러졌던 소가 일어나 투우사의 몸을 공중에 날려 버리는 장면은 얼마나 극적이었던지…. 그는 투우장을 긴장감 넘치는 대결의 장소라기보다 인간과 동물이 추는 이인무pas de deux로 해석한 것이다.

조선화랑에서 투우전이 열린 1992년은 바르셀로나 올림픽이 열리는 해였다. 스페인 열풍이 불면서 투우를 그렸으니 운이 좋다고 할까, 머리가 좋다고 할까. 그를 기억하는 팬들은 사 년 전의 피에로와 비교하며 작품들 간의 극적 연관성을 즐겼다. 평론가 이구열李龜烈은 "미소년과 야성적 소의 장쾌하고 극적인 춤판"이라고 풀이했다.

사실 피에로나 투우사 모두 일련의 동작은 안무적 요소에서 비롯됐고, 그 동세를 예리하게 포착하는 것은 테레사의 영역이었다. 사실을 바탕으로 재구성한 면이 그랬고, 옷의 컬러나 동작 등 다채로운 볼거리를 담았다는 면에서 더욱 그러했다.

Korean patchwork wrapping cloths, and made a connection with the watercolors she had painted up to now.

Built up by assembling colors like motley patches of cloth, Kim's pierrot paintings were shown to the public at the Chosun Art Gallery in 1988. At the time, Chosun Art Gallery was located inside the Westin Chosun Hotel in Sogong-dong, Seoul, and was much visited by foreign collectors. This provided an opportunity for Kim's works to win international renown. The pierrot paintings show that Kim is good at capturing movement. She divides up the detailed moments of movement and then rearranges them on artistic principles.

In 1990, while traveling in Spain, Kim's delicate aesthetic sense was touched once more when she saw a bullfight. The strong sunlight shining on the bullring, the refreshing wind blowing through it, the power of the bull as it charged across the ground, the tight buttocks of the toreador.... the bullring had all the elements of art. The following year, Kim went to a bullring in Cancun, Mexico, and completed some sketches.

To Kim, the bullfight was a dance. It presented dramatic scenes according to time, and Kim captured those spontaneous moments with forms as lucid and simple as a line drawing. To maximize the expressive force, she used a variety of media including oils, pastels, and sketches. How dramatic was the scene in which the toreador, having cut off the bull's ear, raises his hands in victory, only to be tossed in the air by the bull that has risen to fight again! Kim has interpreted the bullfight, not as a tense confrontation, but as a pas de deux

야생의 위엄과 순수

피에로와 투우 등 구상작업을 하면서 큰 그림을 그려 왔던 김테레사는 많은 화가들의 경로가 그렇듯 추상의 다리를 건넌다. 투우 연작에서도 대상의 형태를 뭉그러뜨리는 부분에서 이미 추상의 기미를 보였지만, 아크릴릭이라는 매체와 친해지면서 본격적인 추상의 세계를 걷기 시작했다.

작품의 내용은 역시 율동이었다. 붓질은 더욱 빠르고 경쾌했다. 그의 추상작업에는 파도처럼 넘실대는 모양 속에 질주하는 말의 갈퀴, 피에로의 익살스런 동작, 바람에 흩날리는 조각보의 이미지를 숨겼다. 색상은 세련됐고, 형태는 고급스러웠다.

이때 사용한 원색의 퍼레이드에 대해 작가는 "색이 형상을 보조하는 것이 아니고, 스스로 추상을 달성한다"고 말했다. 피카소P. Picasso가 〈아비뇽의 여인들〉에서 검은색을 얼굴에 쓴 것이나, 마티스H. Matisse가 창가의 붉은 석류를 황금색으로 그린 것과 마찬가지라는 것이다.

그의 추상화는 1996년 박영덕화랑에서 선보이면서 서울 강남의 미술시장과 연결됐다. 당시 테레사의 작품은 화사한 아름다움과 예술적 깊이를 동시에 지녔다고 해서 혼수품으로 인기를 끌었다. 이전에는 건설업자들 사이에 "테레사의 컬러에서 에너지가 나온다"는 소문이 퍼져서 컬렉터들이 몰렸다는 이야기도 있었다. 즐거운 에피소드

between man and beast.

In 1992, when Kim held her bullfight exhibition at the Chosun Art Gallery, the Olympic Games were held in Barcelona. In painting bullfights during the mania for Spain, Kim was either lucky or smart. The fans who remembered her enjoyed the dramatic correlations between works, comparing her bullfight paintings with her pierrots of four years before. Art critic Lee Ku-Yeol described them as "a thrilling and dramatic dance between a handsome young man and a wild bull."

In fact, the movements of pierrot and the toreador both originated in the choreographic element, and to capture such movements incisively was Theresa Kim's métier. That was true of her penchant for rearranging things on the basis of reality, and it was even more true of her tendency to provide a variety of things to see in such aspects as clothing color and movement.

The dignity and purity of the wild

After producing large figurative paintings of such subjects as pierrot and the bullfight, like many artists before her Theresa Kim crossed the bridge into abstract art. Already in the bullfight series, she had given a hint of the abstract by breaking down the forms of the subject, but as she became more familiar with the medium of acrylics she began to walk the path of abstract art in earnest.

가 아닐 수 없다.

작품은 2000년 이후 말馬 그림으로 이어졌다. 대학시절 승마를 통해 처음 만난 말이 그에게 인간과 커뮤니케이션 하는 존재임을 알려 주었다면, 미국에서 다시 만난 말은 생명의 힘을 가르쳐 주었다. 다만 그가 그리는 말은, 우리 속에 갇힌 말이 아니라 들판의 야생마다. 야생마는 사람의 눈치를 보지 않는다. 거기에는 미처 길들여지지 않은 순수가 있고, 그 순수가 빚어내는 움직임은 자연스러워서 더욱 아름답다. 그것은 정주定住와 구속을 싫어하는 작가의 삶과도 닮았다.

회화 대상으로서의 말은 멋진 오브제였다. 존재 자체가 위엄있고 기품이 있다. 서 있으면 준수하고, 움직이면 우아하다. 달릴 때 드러나는 근육의 움직임이 섬세하면서도 관능적이다. 투우장의 소가 인간과 싸워서 존재감을 드러내는 데 비해, 야생마는 스스로 살아 움직이는 것 자체가 예술이자 조형물이다.

서울 마주협회馬主協會가 발간하는 월간지『달리는 말』에 2009년 한 해 동안 표지화를 그렸지만, 그려야 할 말이 아직도 많이 남아 있다. 덴마크 초원에서 뉴욕 인근 뉴저지의 농장에 이르기까지 야생말에게 바치는 경의는 아직도 식지 않은 채 계속되고 있다.

The content of these works was still rhythm. Kim's brushwork became even more brisk and energetic. In her abstract paintings, images of a galloping horse's mane, pierrot's comical movements, or patchwork wrapping cloths fluttering in the wind, lie hidden within shapes that undulate like waves. The colors are sophisticated, and the forms are refined.

On the parade of primary colors that she used at this time, Kim remarked, "color doesn't help shape, it achieves abstraction by itself." It was like Picasso's use of black for the women's faces in *Les demoiselles d'Avignon*, or Matisse's use of gold for the red pomegranates by the window.

When Kim's abstract paintings were shown at the Galerie Bhak in 1996, they entered the art market of Seoul's Gangnam area. Kim's works of this period, combining cheerful beauty with artistic depth, became popular items for newlyweds setting up house. Before this, there had been a story that collectors were buying up Kim's works as a rumor spread among those in the construction industry that her colors gave a special energy. It was certainly a happy episode.

After 2000, Kim's oeuvre continued with paintings of horses. Having first encountered horses through horse-riding while at university, Kim thought of the horse as a being that communicated with humanity, but the horses she saw in America taught her the power of life. The horses that she painted were not domesticated horses shut up in a stable, but wild horses in the plains. Wild horses care nothing for what humans

발레와 고전, 원초적 그리움

이제 김테레사에게 그림의 대상으로서 어떤 것이 기다리고 있을까. 삼십 년 화력畵歷, 사진을 포함하면 사십 년 세월을 거치면서 수많은 작품을 그렸지만 그에게 남은 것이 두 가지가 있다.

먼저 고전을 향한 그리움이다. 서양미술의 근간이 되는 그리스 로마 신화는 끊임없이 예술적 상상력을 자극했다. 고전은 마르지 않는 아이디어의 저수지다. 이전에 단테Dante A.의 『신곡La Divina Commedia』을 읽으면서 지옥In-ferno의 모습을 벽화 혹은 테라코타 방식으로 표현할 때의 기억도 좋았다. 또 실버 프린트 기법도 사용했다. 은판에 에칭을 하거나 린넨에 오일을 두껍게 바른 뒤 파내는 방법으로 여신들의 사연을 담아냈다. 코발트빛 천에다 악기를 연주하는 뮤즈의 모습을 새기면서 역사와 신화의 이랑 사이를 산책하는 식이다.

마지막이 발레 그림이다. 예술의 출발점이었던 발레를 마지막 종착점으로 삼는 것은 과거와 굳은 악수를 나누는 것이다. 실제로 작가의 작업실에는 발레 그림이 많다. 잘 다듬어진 신체의 발레리나가 튀튀를 입고 무용 동작을 취하고 있는 그림이 곳곳에 있다. 혹자는 드가E. Degas의 작품과 비교하지만, 화풍도 다르거니와, 커튼 뒤의 남자도 없다.

그의 발레 그림은 오랜 기다림의 대상이기에 더욱 절실하다. 「라 실피드La Sylphide」에서 어깨에 날개를 단 요정이

think. They have the purity of the untamed, and the movement that springs from this purity is all the more beautiful for being natural. This was like the artist's life, which shuns domestication and confinement.

As a subject for painting, the horse is an attractive object. In its very existence it has dignity and class. When standing, it is distinguished, and when moving, it is elegant. When galloping, the visible movement of its muscles is delicate yet sensual. If the bull in the bullring shows its presence by fighting with humans, the wild horse living and moving by itself is already an art work and a sculpture.

Kim painted the cover pictures for *Galloping Horse,* the monthly magazine of the Seoul Equestrian Association, for the whole year of 2009, yet she still has many horses left to paint. From the grassy plains of Denmark to the farms of New Jersey near New York, her respect for wild horses shows no sign of cooling off.

Ballet and classics, a deep-rooted craving

What else awaits Theresa Kim as a subject for her paintings? Over thirty years of painting, or forty including photography, she has produced many works, but two things still remain for her.

First is her passion for the classics. The Greek and Roman legends on which Western art is founded continue to stimulate the artistic imagination without end. The classics form a reservoir of ideas that never dries up. Kim already has happy memories of reading Dante's *La Divina Commedia* and reproducing scenes from the

나, 「돈키호테Don Quixote」에서 검은 부채를 든 키트리는 그의 로망이나 다름없다. 작가는 그 작품 속 주인공의 캐릭터를 치밀하게 파고든다.

따라서 작품은 단순히 발레의 아름다운 장면을 그리는 데 머물지 않는다. 신체표현의 극적인 순간을 잡는 것이다. 그것은 발레리나가 한 동작의 완성을 위해 한계치의 노력을 기울이는 모습이다. 이동과 정지, 도약과 착지 등 일련의 동작을 통해 골반과 등선 등 미세한 신체의 움직임까지 드러낸다. 그림 속 장면을 본 발레리나 김인희가 동작의 정확성과 구체성에 찬탄했다고 한다.

이같은 작업은 작가가 발레 동작의 본질을 알고 있기에 가능하다. 어린 시절의 경험이나 브로드웨이 관람만으로는 성에 차지 않아 해부학 서적을 보면서 신체의 움직임을 공부했고, 그런 지식과 기억을 엮어 하나의 작품을 완성한다. 테레사의 삶을 '춤→사진→그림' 으로 연결 지을 때 춤과 그림이 캔버스 속에서 하나가 된다는 것은 '순환의 완성' 이라는 상징성이 있다.

자유와 열정의 예술 동선動線

김테레사의 예술세계는 아티스트로서의 보편성 속에 그만의 고유한 특수성이 있다. 먼저 작품세계는 무대예술과

Inferno in murals or terra cotta.

Kim is also using silver prints. She tells the stories of goddesses by etching silver plates or covering linen with a thick layer of oil paint and then carving it out. Engraving images of the Muses playing their musical instruments on cobalt-colored cloth, she walks among the furrows of myth and history.

Finally there are the ballet paintings. Ballet was Kim's artistic starting point, and in taking it as her final destination she is shaking hands firmly with the past. In fact, she has many ballet paintings lying around her studio, showing shapely ballerinas making dance movements in their tutus. Some people compare these with the works of Edgar Degas, but the style is different, and there is no man behind the curtains.

Kim's ballet paintings are all the more heartfelt for being long awaited. The fairy with wings on her shoulders in *La Sylphide*, or Kitri with her black fan in *Don Quixote*, seem like fantasy figures for Kim herself. The artist has delved deeply into the character of the subjects in these works.

As a result, the works are more than just beautiful scenes of ballet. They capture the dramatic moment of bodily expression. They show the ballerina making her utmost effort to perfect the movement. Motion and stillness, take-off and landing, the whole sequence of movements appears in the precise control of the pelvis, spine, and body. When the ballerina Kim Inhui saw these paintings, she was impressed by the accuracy and vividness of the movements.

시각예술을 결합하면서 독창적인 영역을 구축하는 데 성공했다. 작품은 다른 작가가 흉내내기 어려운 역동적인 공간을 자랑한다.

여기에는 작가 특유의 안무적 감성이 내재되어 있다. 안무는 춤이라는 동작을 디자인하는 기술임을 감안하면, 그의 그림은 이미 무대공간이 빚어내는 미학을 고스란히 수용하고 있다. 피에로와 투우가 그러하고, 야생마와 발레 그림이 모두 공간을 연출한 결과물이다. 이는 어릴 적의 스포트라이트를 기억하는 작가로서 단순히 먼 객석에 머물지 않고 직접 무대를 점령한 승리의 면류관이기도 하다.

또 하나, 김테레사가 견지하고 있는 것은 순수예술에 대한 신념이다. 그것은 곧 "그림은 그려야 그림"이라는 생각이다. 파인 아트의 최고이자 최후의 영역은 손으로 그리는 그림이고, 자신이 그 보루가 되겠다는 생각이 확고하다. 그 순수예술을 향한 열정은 삶의 중심으로 자리 잡고 있다.

이에 비해 삶을 바라보는 작가의 시선은 분명하면서도 따뜻하다. 절대자를 향한 자세는 겸손하고, 인간과 자연을 보는 시선은 온유하다. 모든 것을 받아들이는 넉넉한 품을 가지면서 화풍에서는 엄격하다.

김테레사 미술에는 경계가 없다. 구상과 추상이 나란히 달리고, 역사와 신화, 전통과 현대가 공존한다. 삶과 예술을 사랑하는 작가는 이 모든 것을 순수미학의 이름으로 보듬는다. 그리고 스스로 넓은 강이 되어 유유히 흘러간

These works were possible because the artist knew the essence of ballet movement. Not content with her childhood experiences or with watching performances on Broadway, Kim studied the body's movements through books on anatomy, and completed her works by bringing this knowledge together with her memories. Kim's life has moved from dance to photography and on to painting, and in uniting painting with dance on the canvas she symbolically completes the cycle.

Art of freedom and passion, the moving line

Theresa Kim's art world contains her own unique individuality within the universality of an artist. In combining visual art with stage art, her oeuvre has succeeded in charting an original realm. Her works present a dynamic space that would be difficult for other artists to imitate.

In this, her distinctive choreographic sense is inherent. If choreography is considered as the art of designing dance movements, Kim's paintings are already imbued with the aesthetics of stage space. This applies to Pierrot and the bullfight alike, and her wild horse and ballet paintings are also the fruits of directing space. For an artist who remembers the spotlight of her childhood, this is the crown of her success in moving from the distant auditorium seats to occupy center stage herself.

Another thing to which Theresa Kim holds fast is her belief in pure art. This is the idea that a painting must

다. 주변의 풍경은 평화롭다. 들꽃이 피고, 풀벌레 울고, 달빛 부서지는 강변에서 무희가 춤춘다. 순례자들이 부르는 성가聖歌가 깊게 울려 퍼진다.

be painted. Kim is firmly convinced that the highest and ultimate expression of fine art is a painting painted by hand, and that she herself should be a bastion of that art. Her passion for pure art stands at the center of her life.

Compared to this, Kim's view of life is warm yet clear. She stands humble before her God, and looks kindly on people and nature. Her heart is generous enough to accept all things, but in art she is strict.

Theresa Kim's art knows no limits. Concrete and abstract stand side by side, history coexists with legend and tradition with modernity. Loving life and art, Kim embraces all these things in the name of pure aesthetics. She is like a wide river that flows on gently. The scenes around her are peaceful. Wild flowers bloom, insects chirp, and in the broken moonlight on the river, a girl dances. The air resounds with a pilgrim's hymn.

1

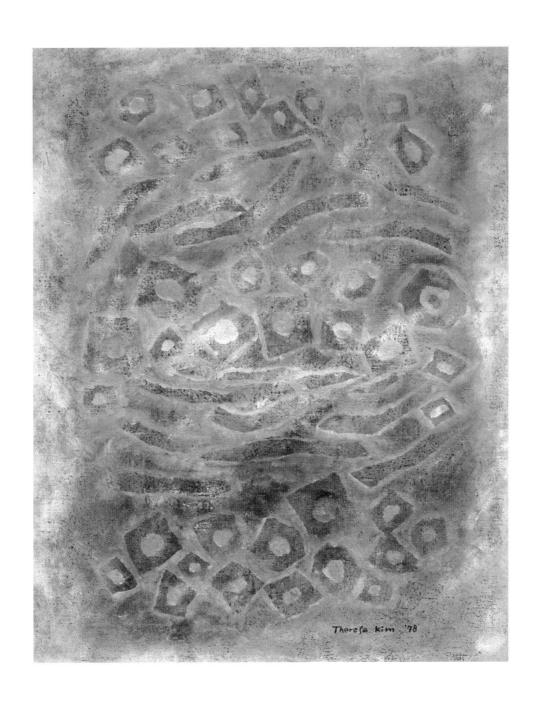

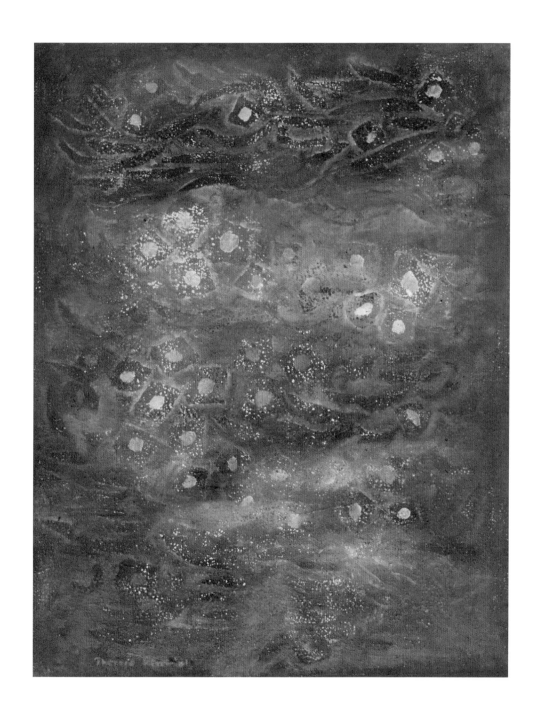

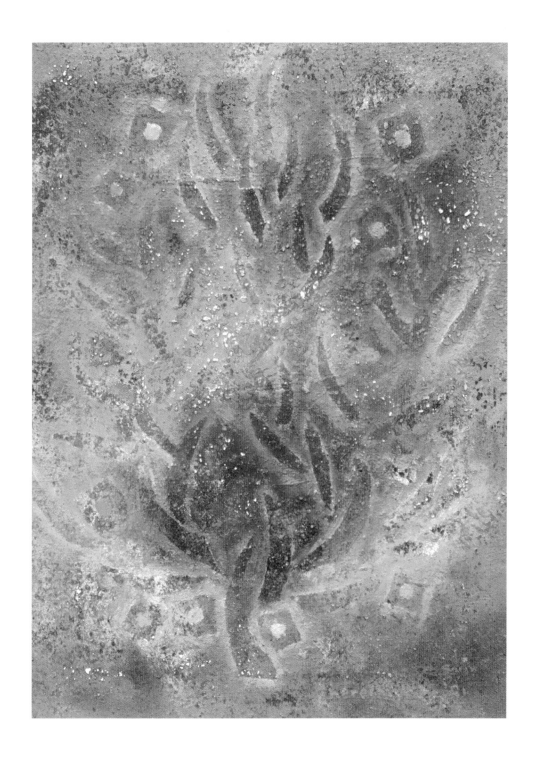

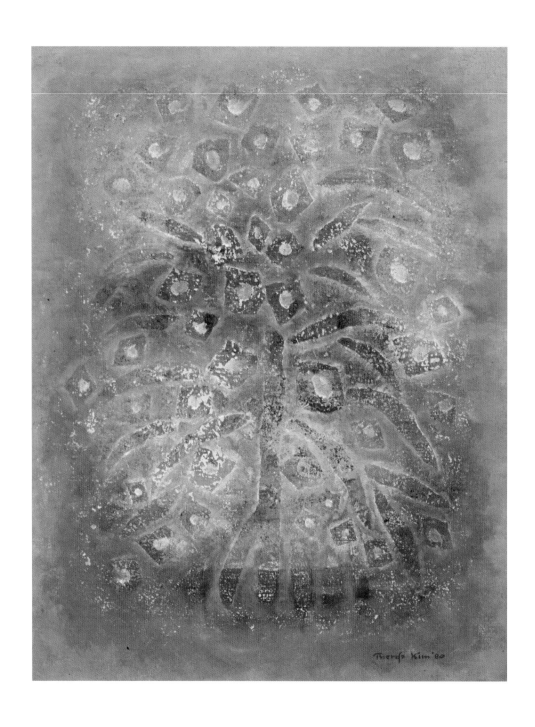

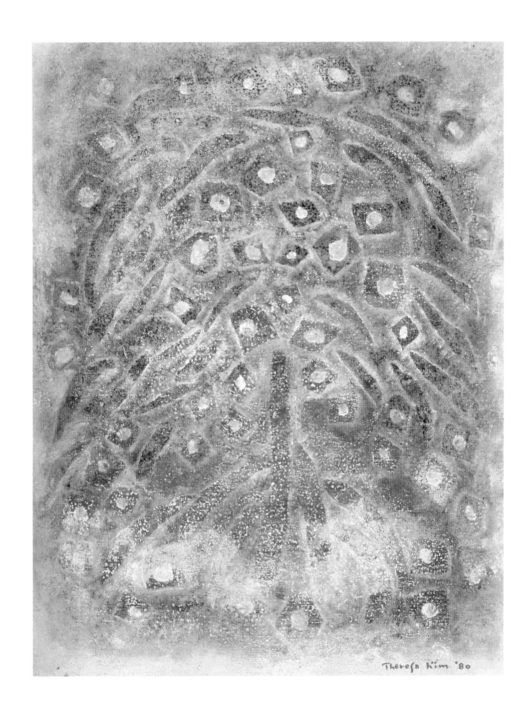

Theresa Kim '80

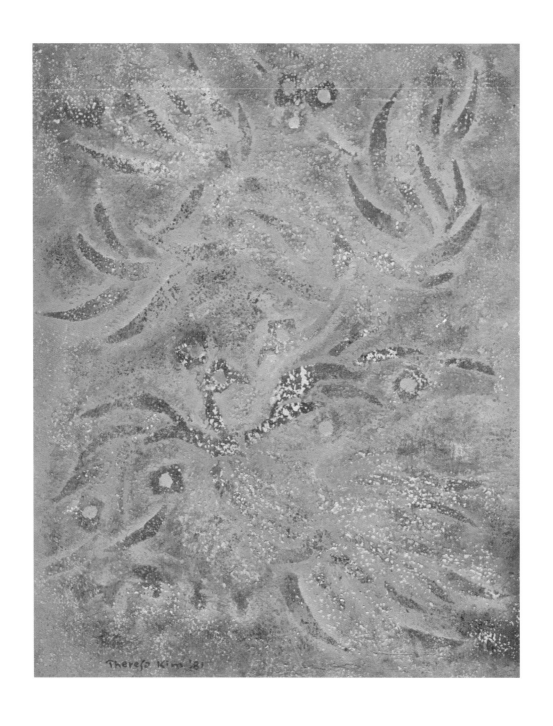

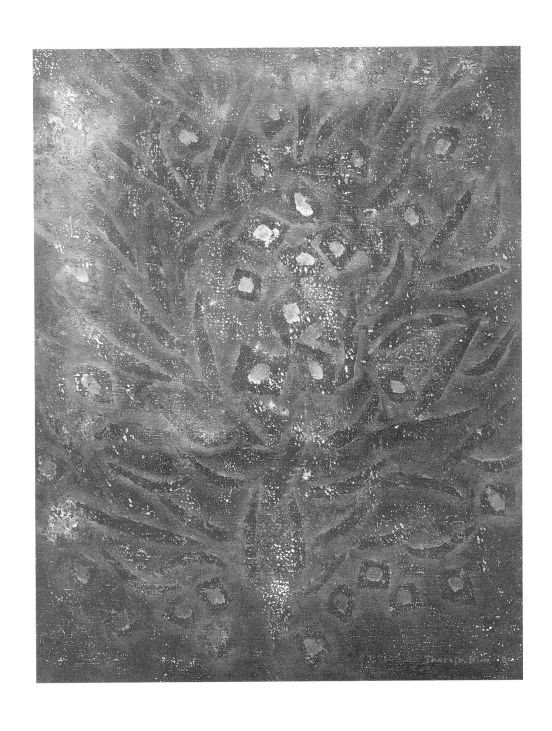

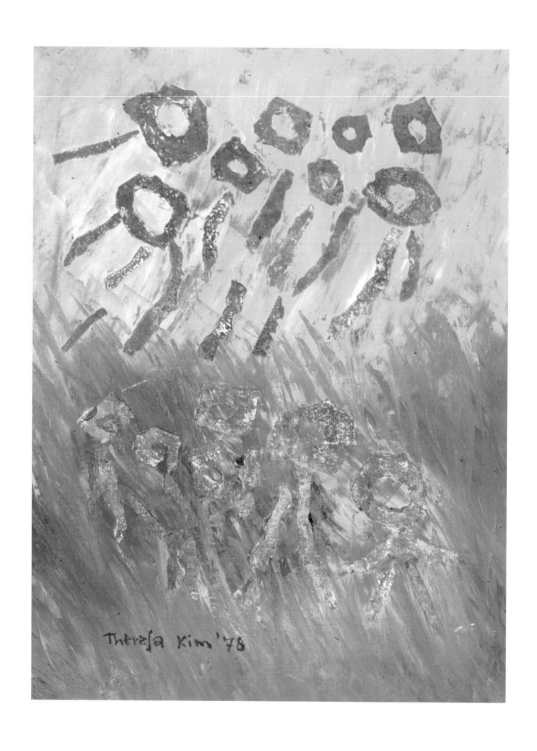

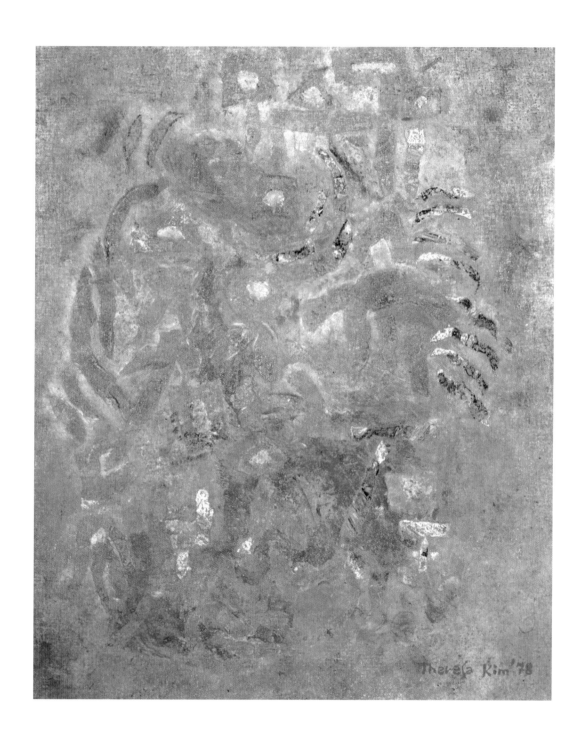

theresa kim '88

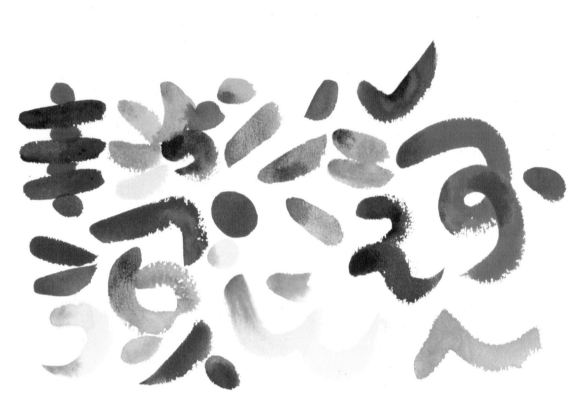

Theresa Kim '88

40

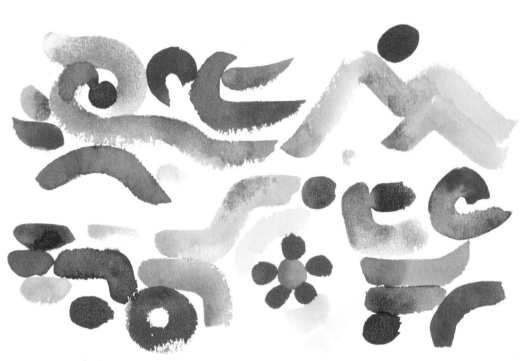

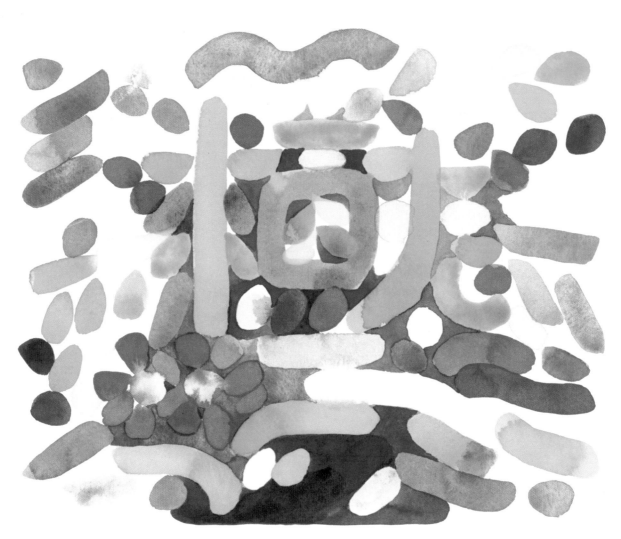

Theresa Kim '88

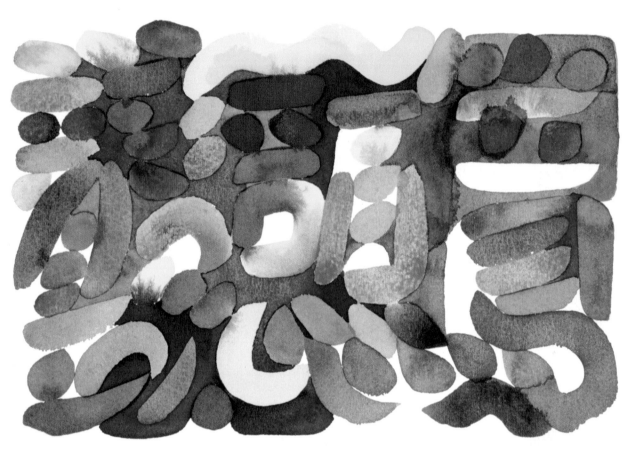

Theresa Kim '88

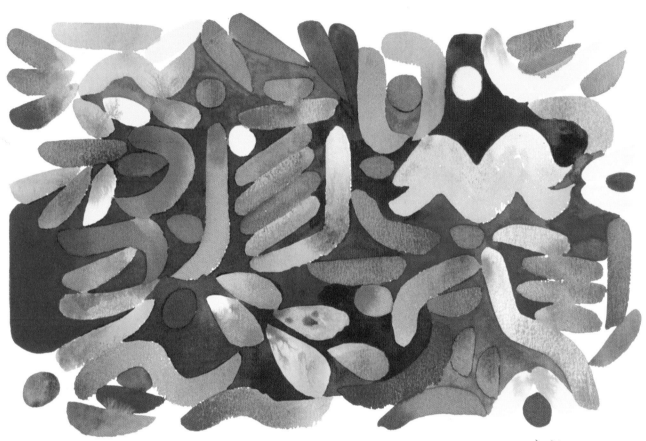

Theresa Kim '88

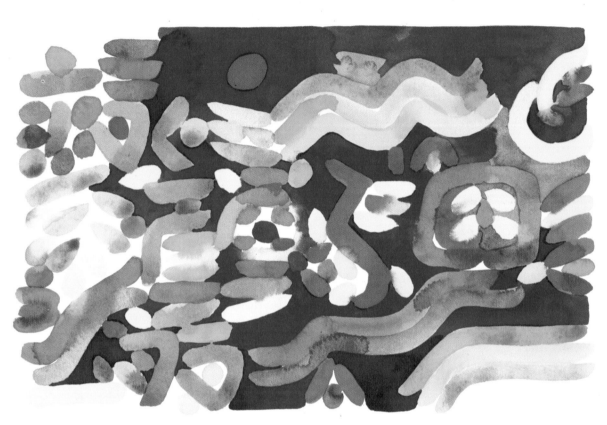

Theresa Kim '88

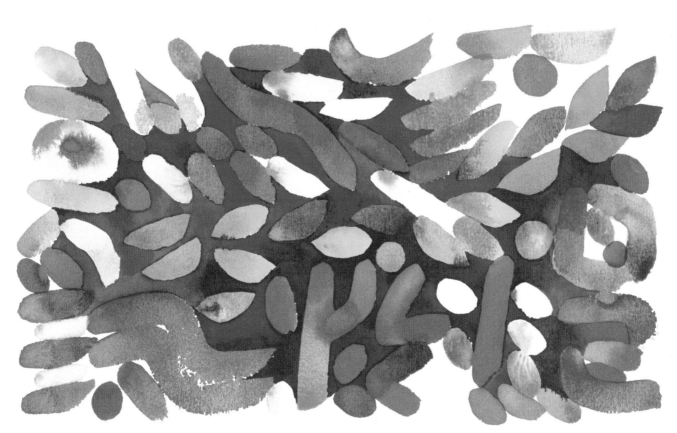

Theresa Kim '88

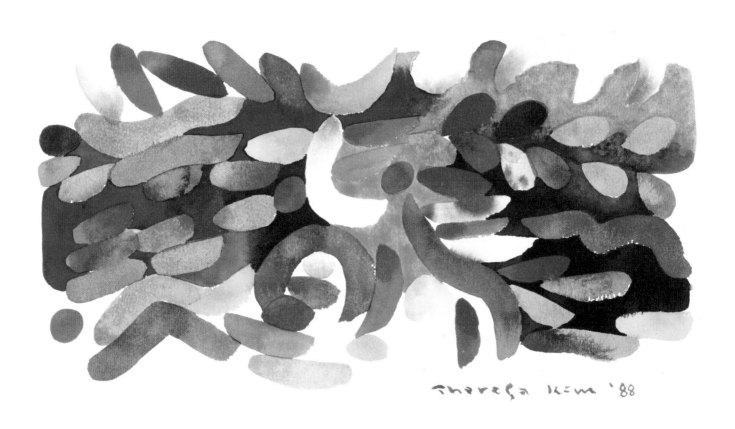

Thereća Kim '88

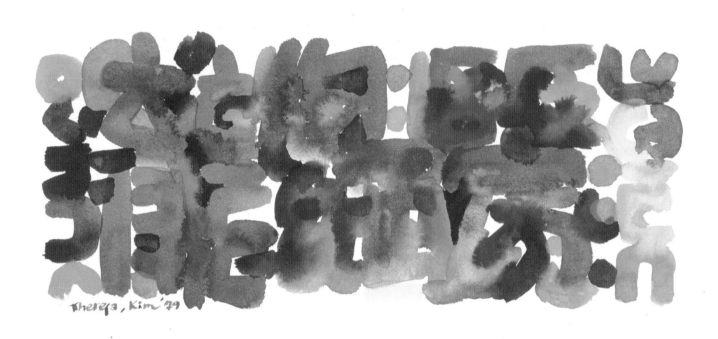

Theresa, Kim '79

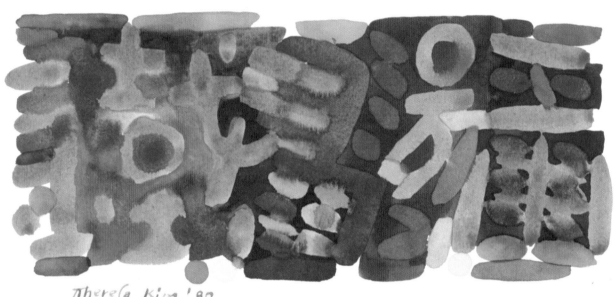

Theresa Kim '80

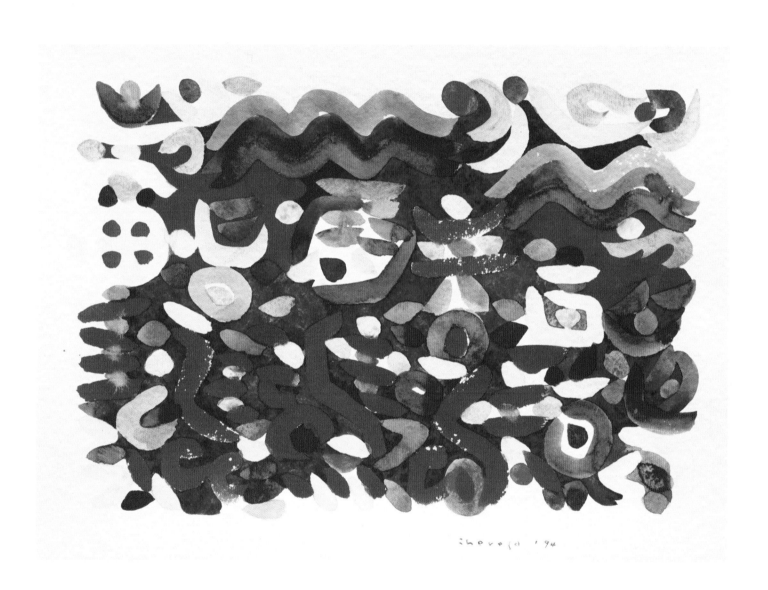

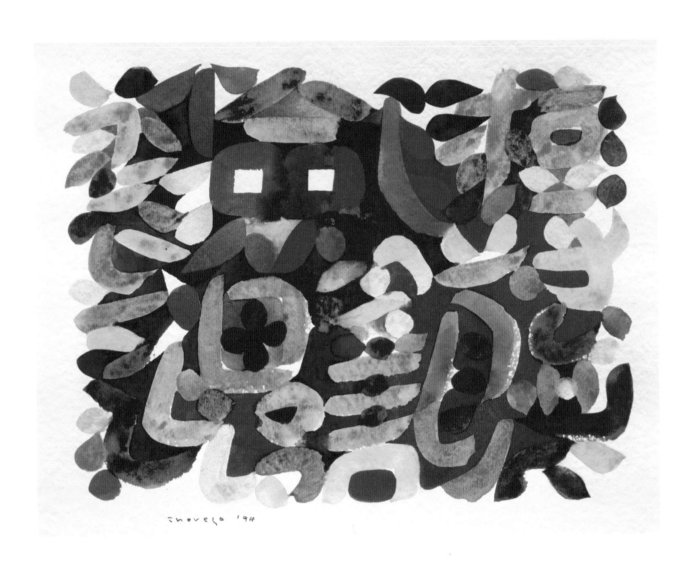

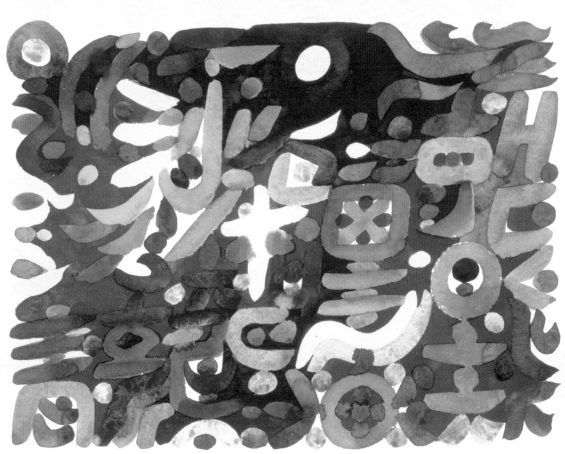

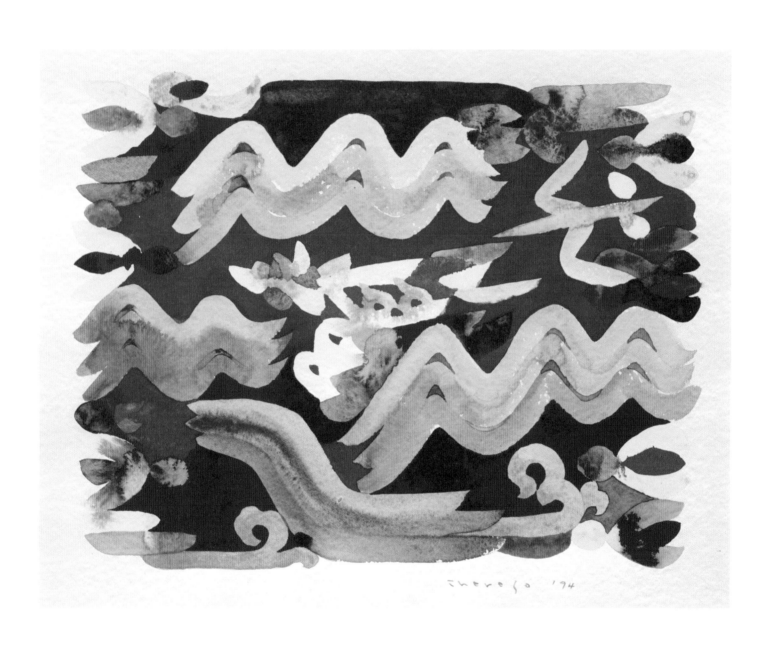

Therego '94

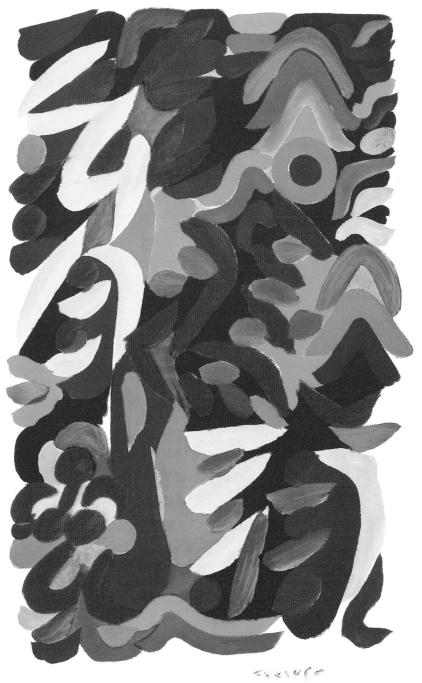

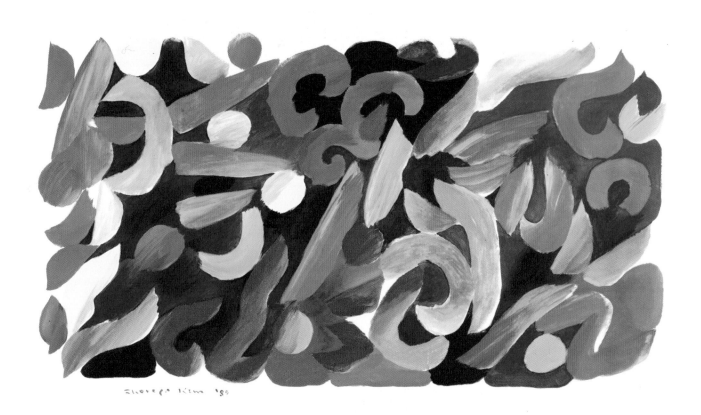

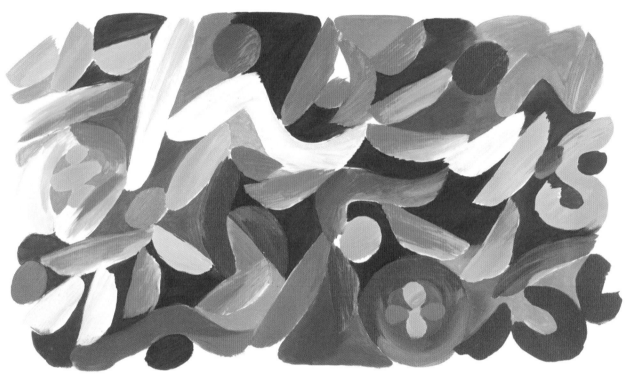

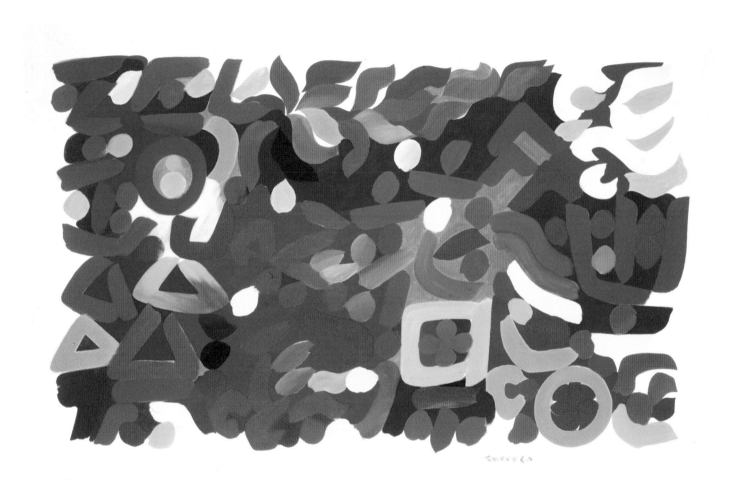

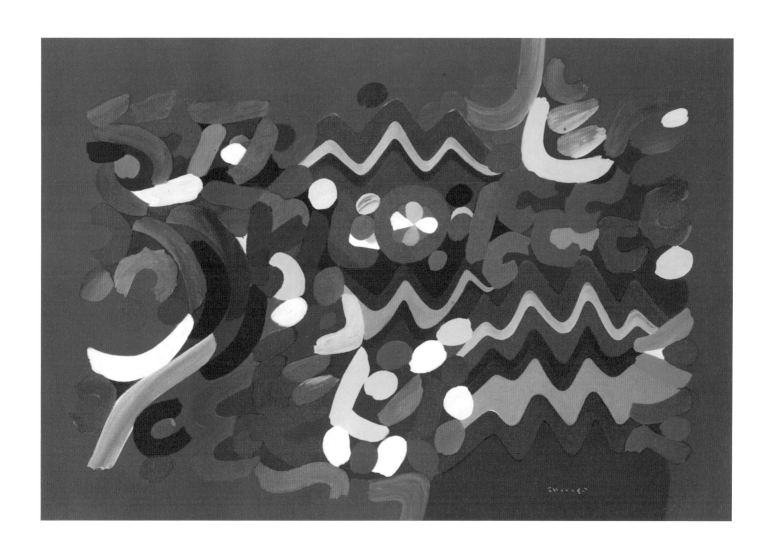

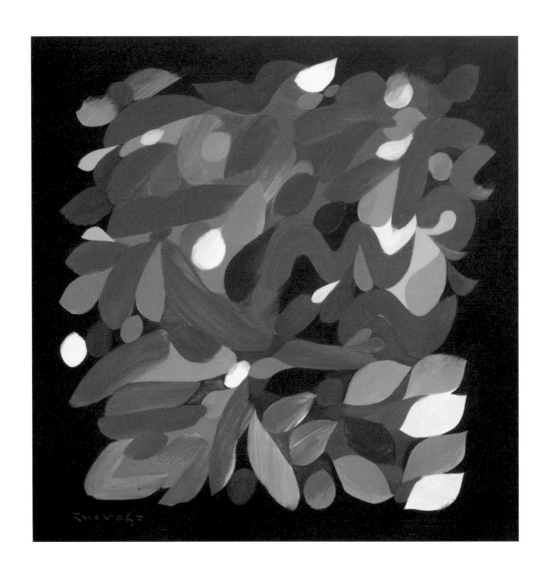

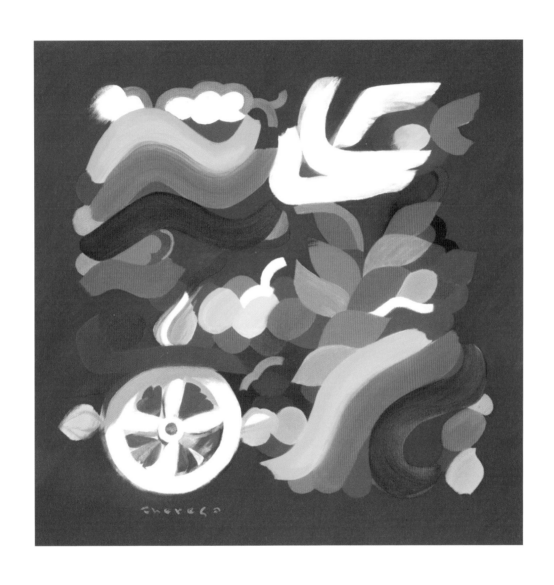

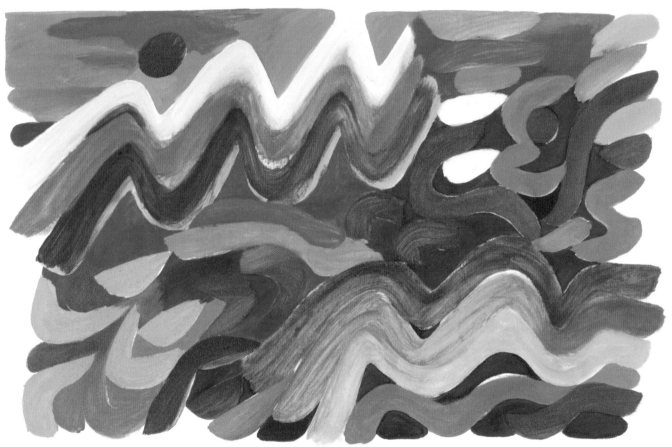

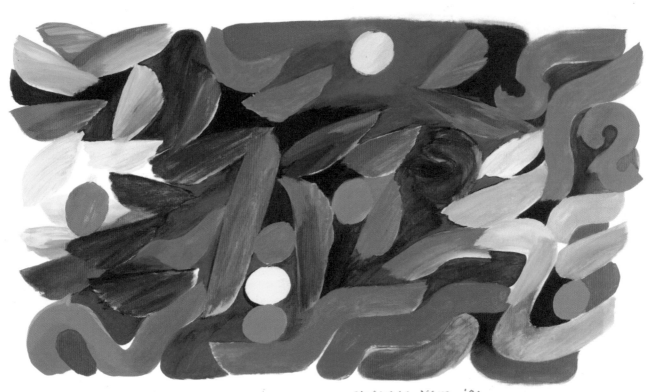

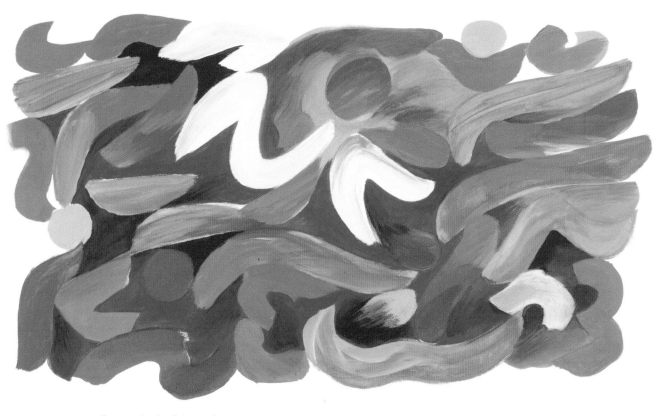

Theresa Kim '90

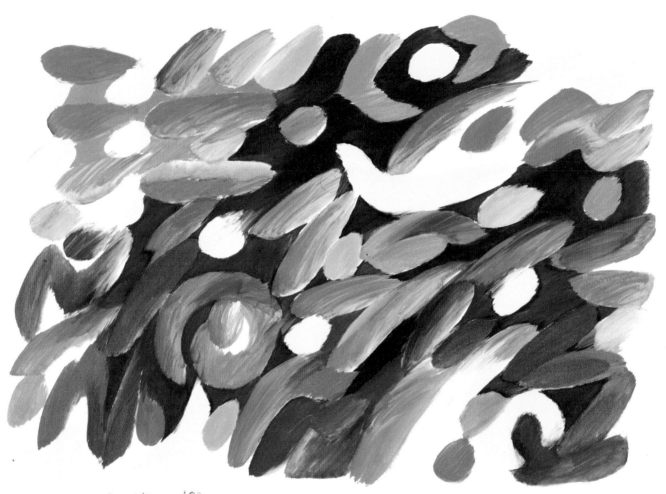

chwego kim '92

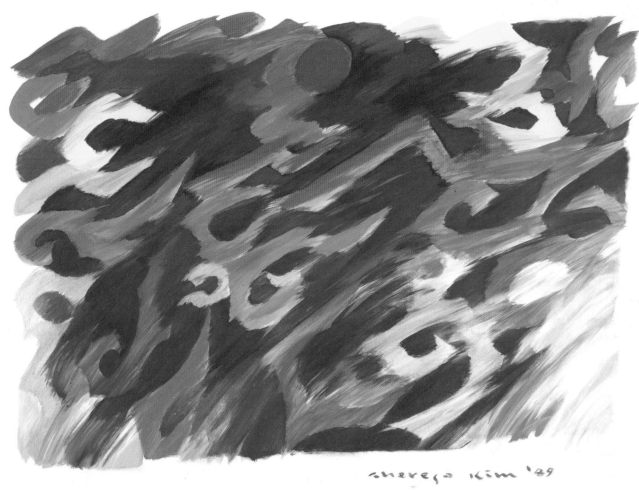

Theresa Kim '89

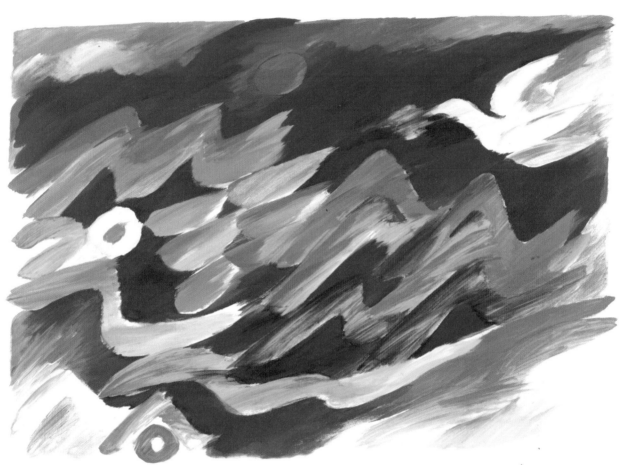

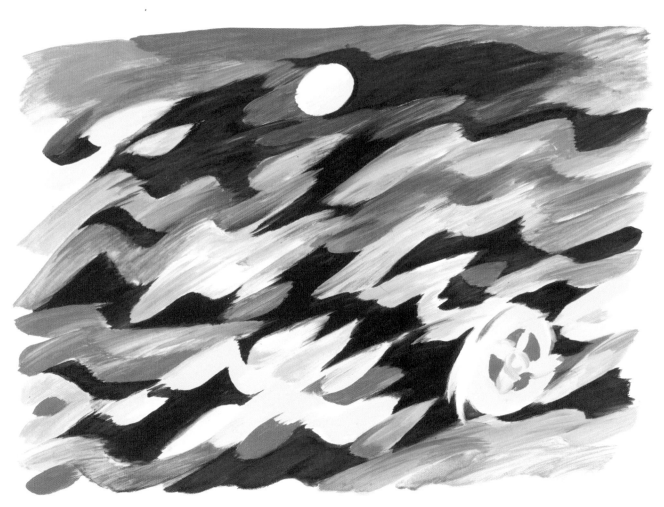

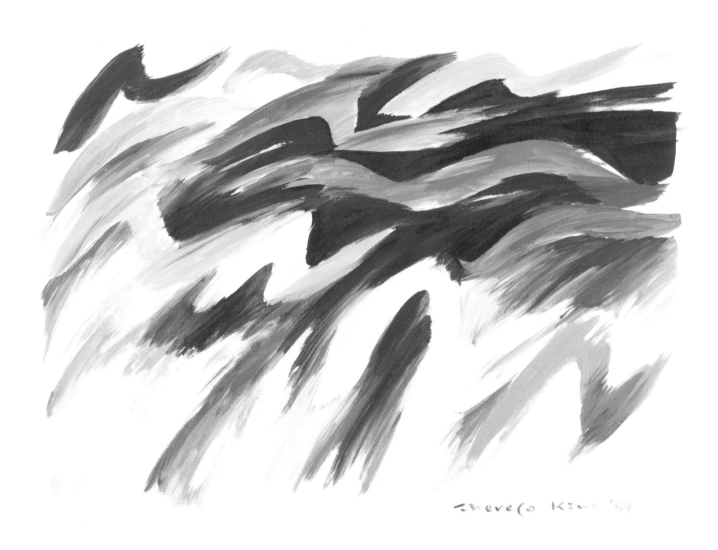

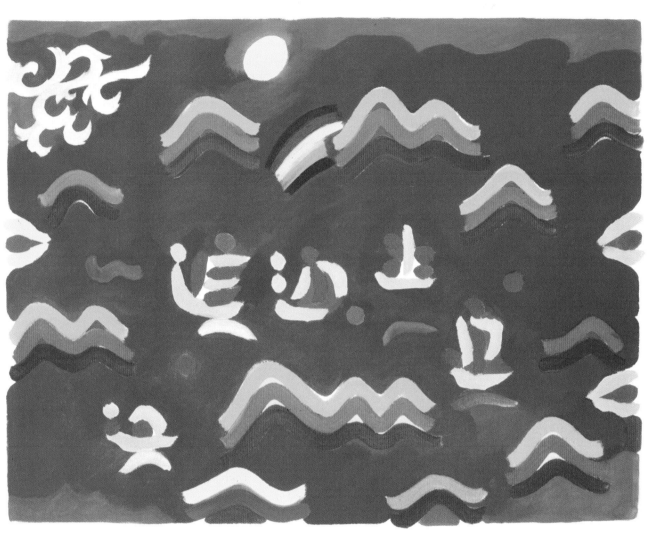

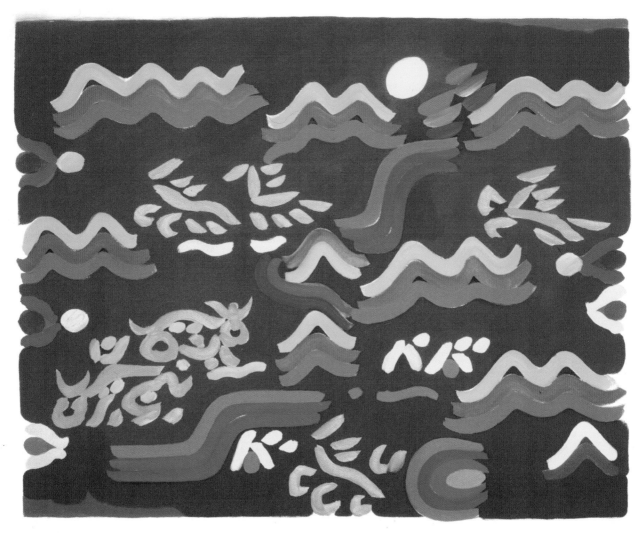

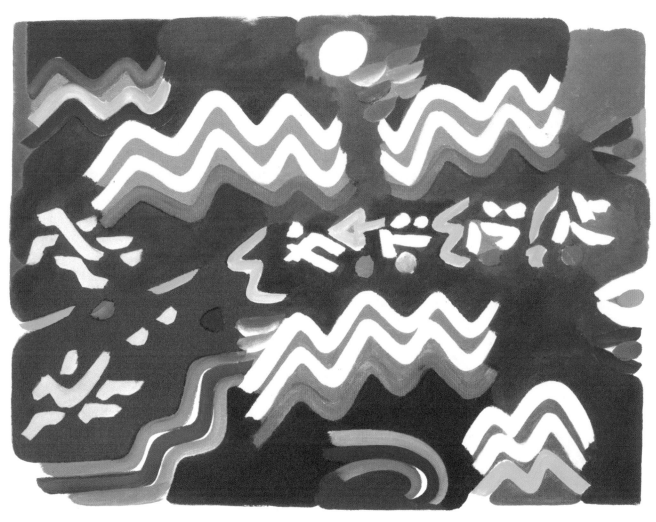

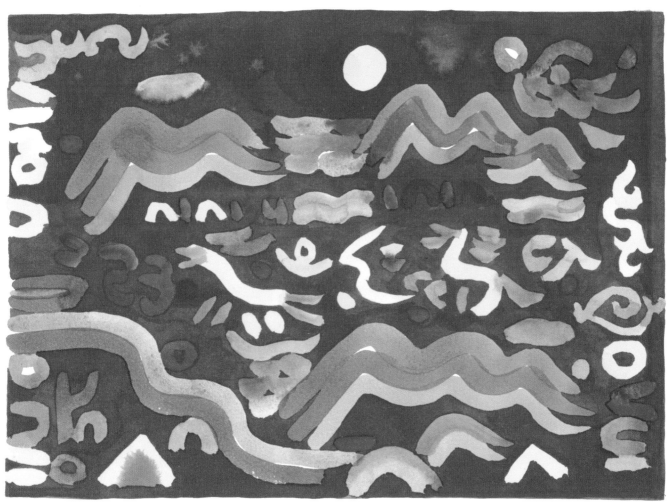

Theresa Kim '80

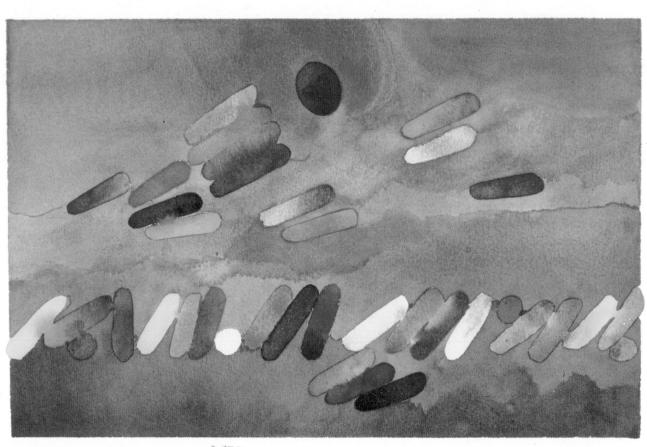

Theresa Kim '88

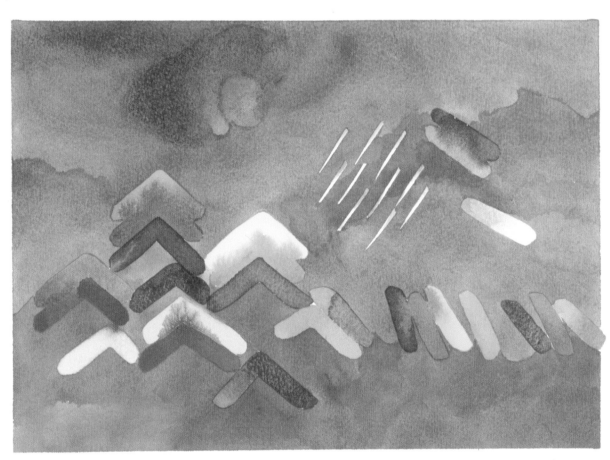

Theresa Kim '88

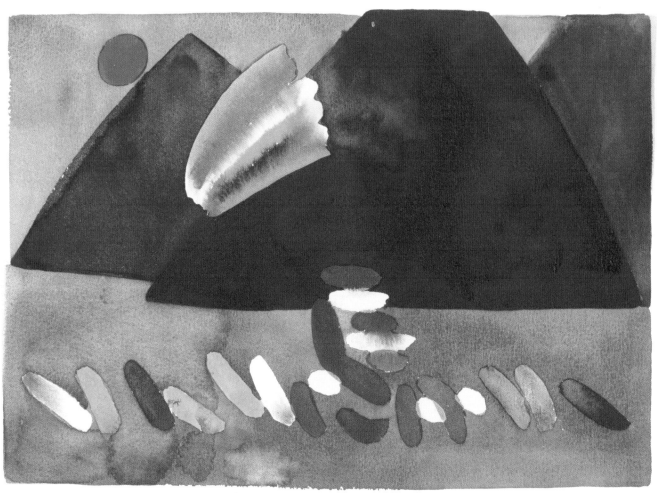

Theresa Kim '88

2

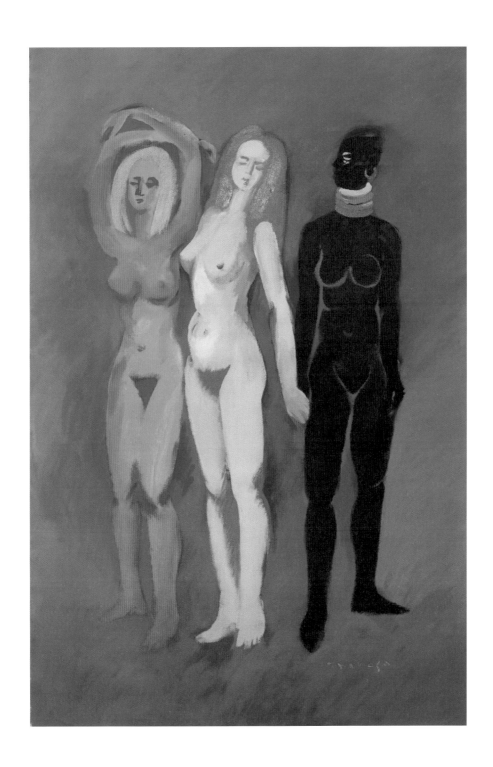

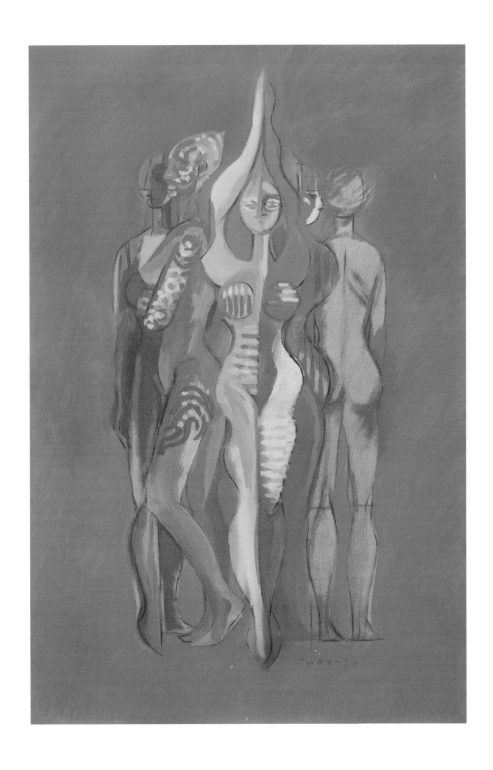

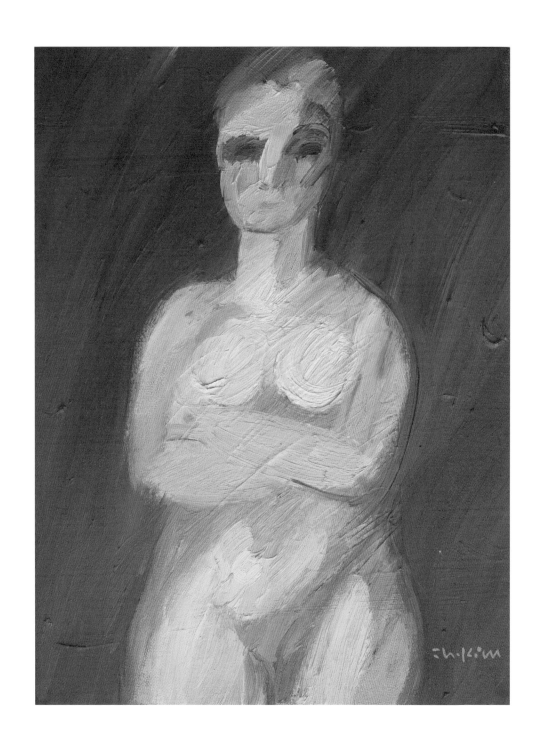

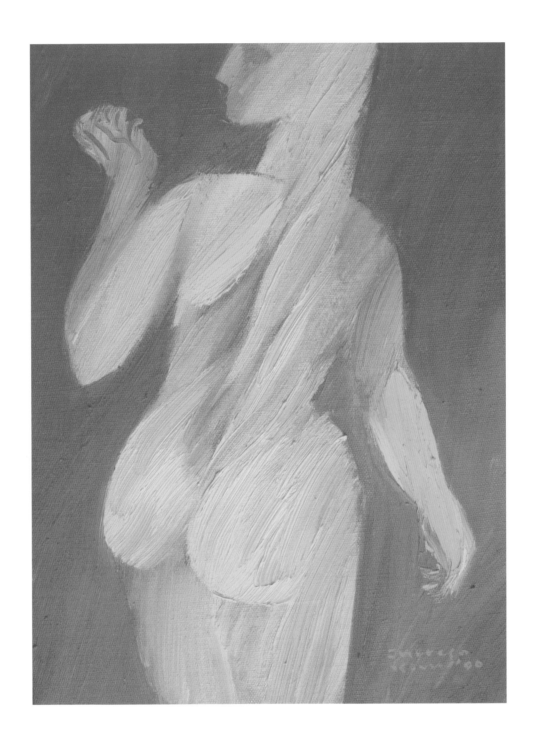

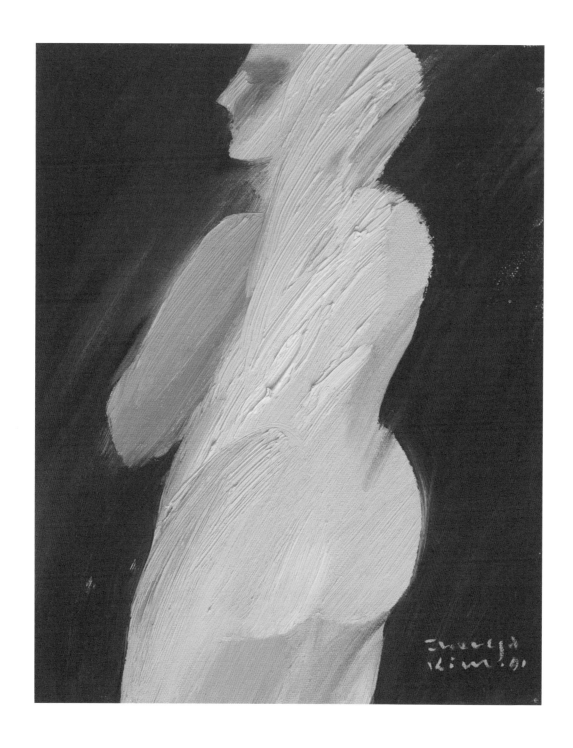

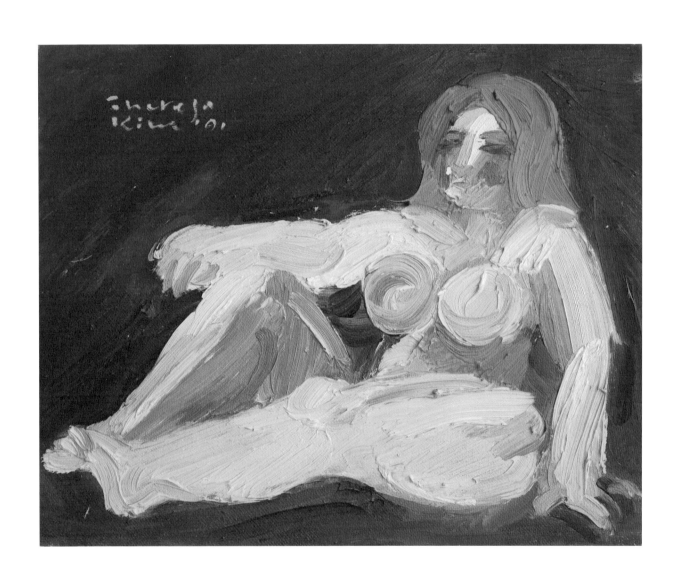

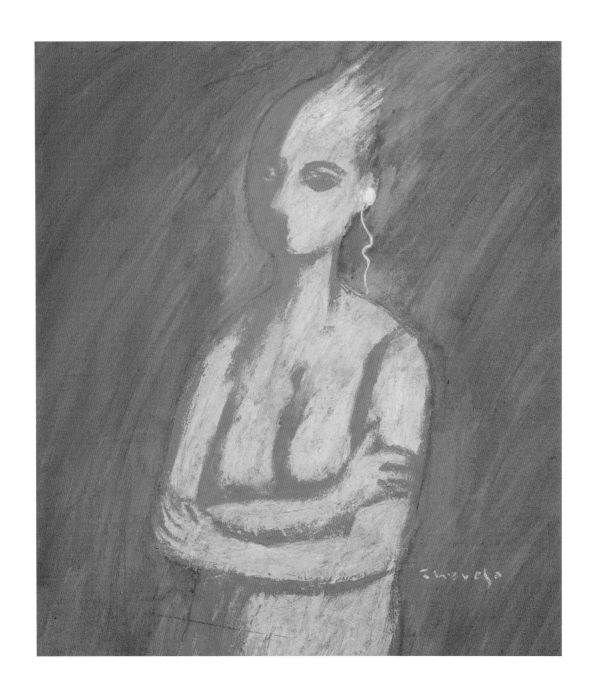

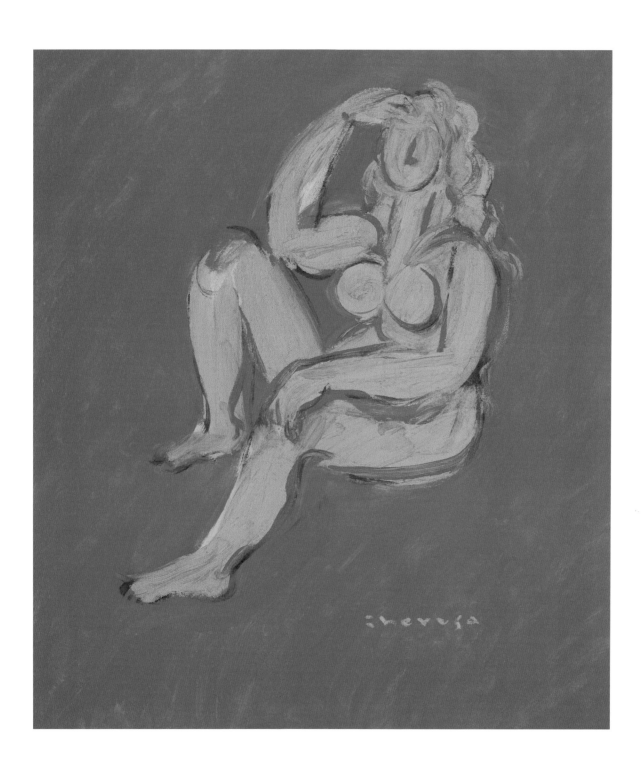

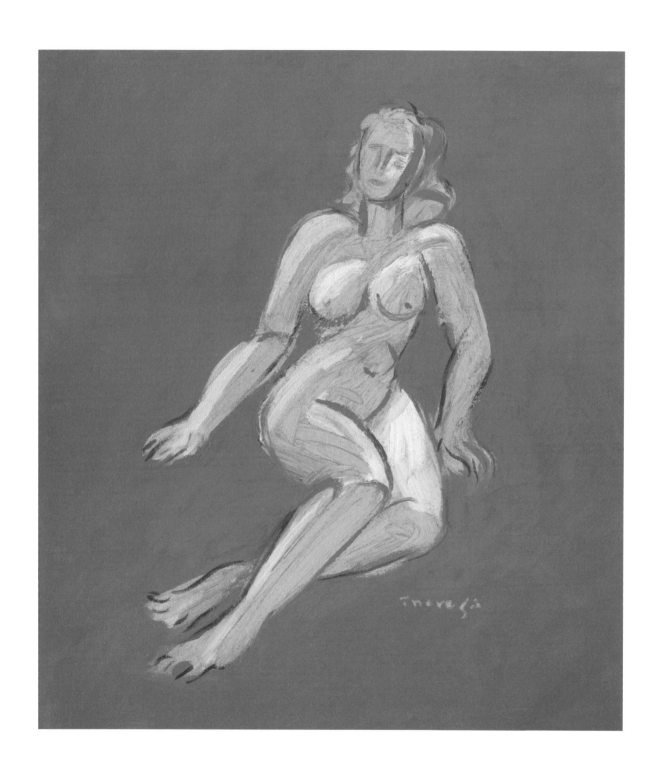

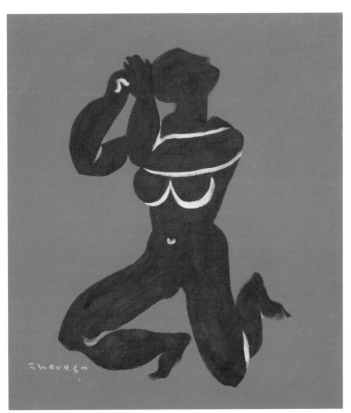
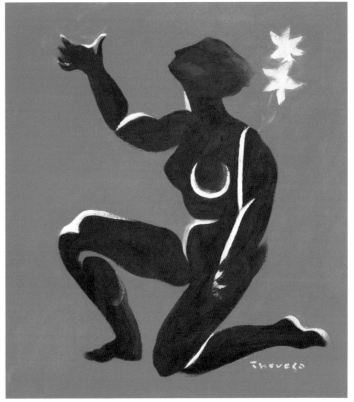

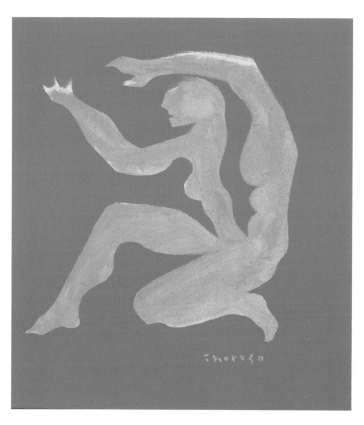

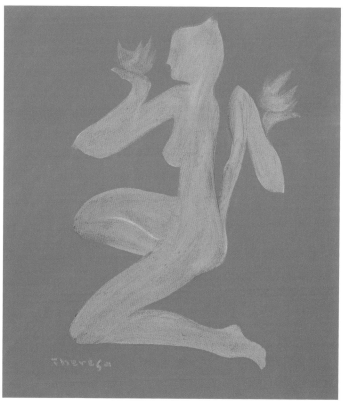

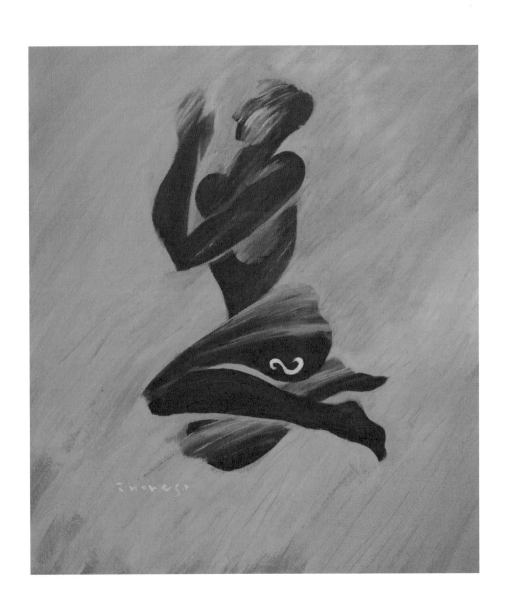

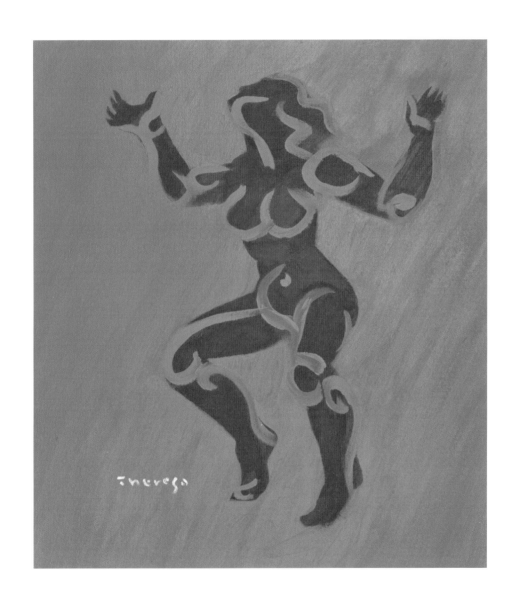

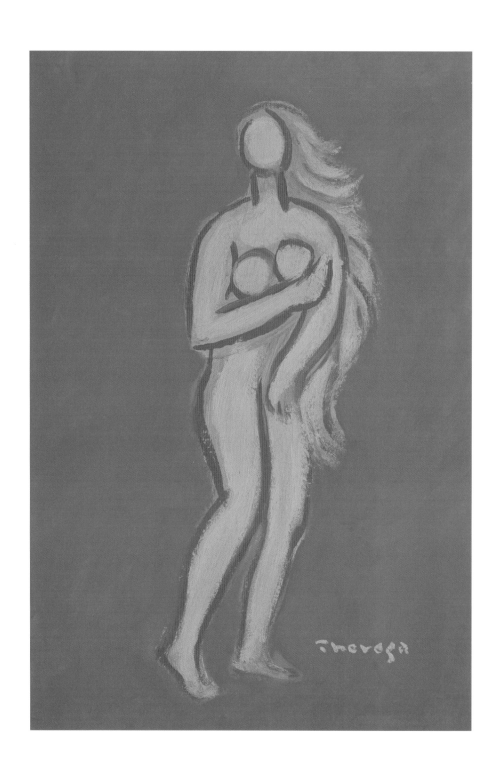

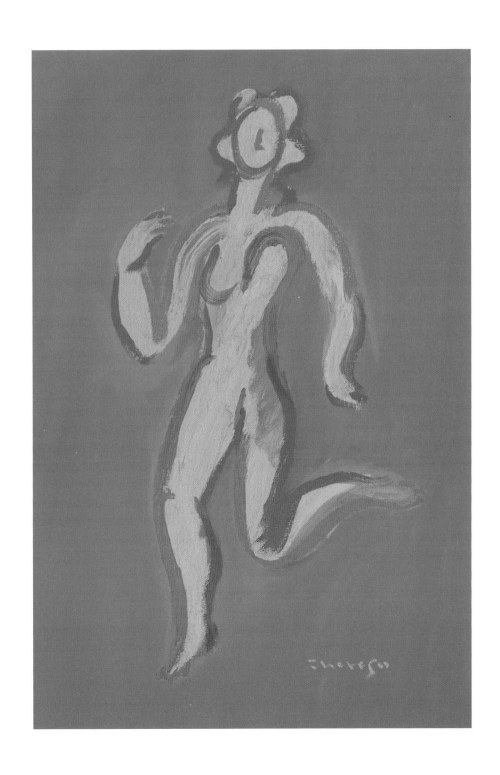

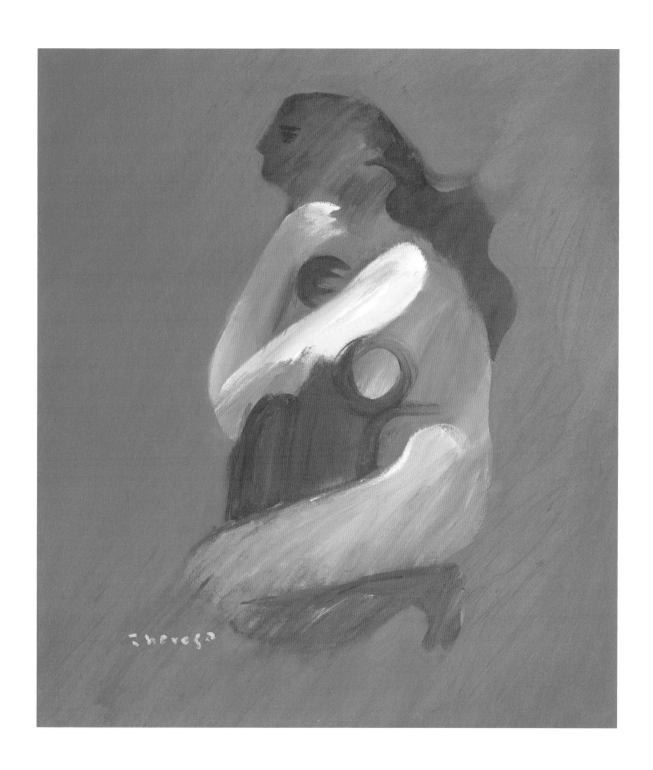

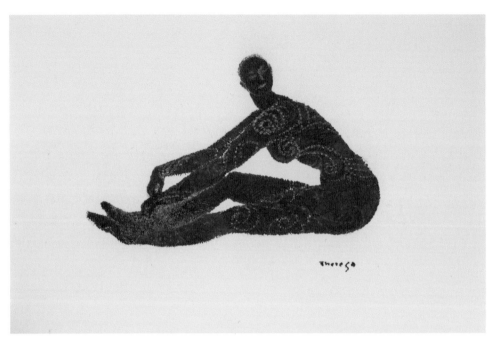

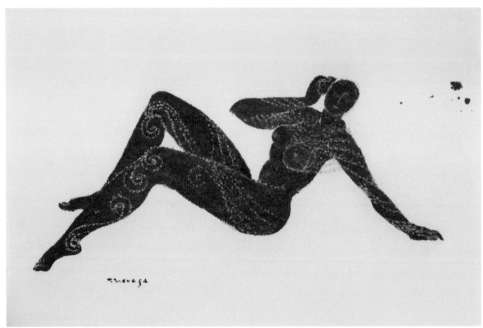

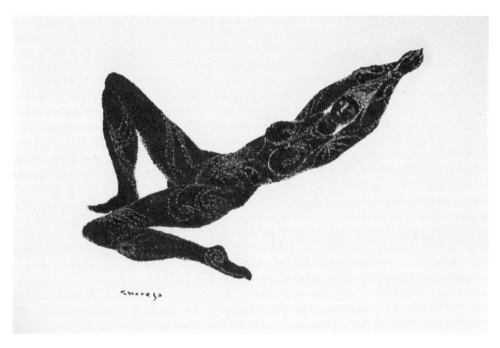

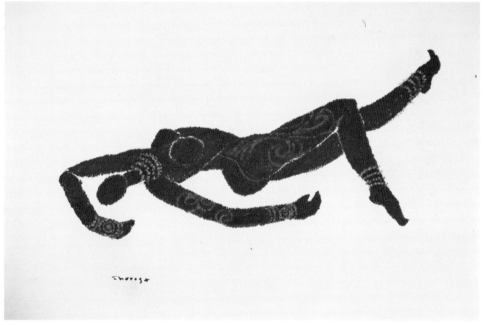

119

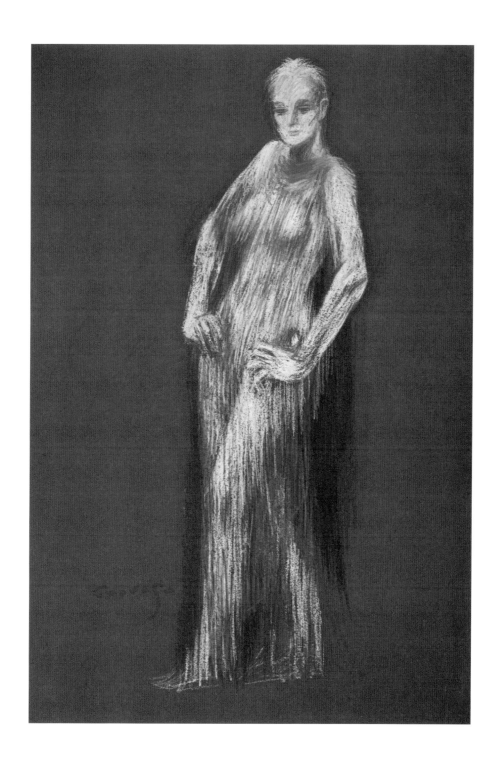

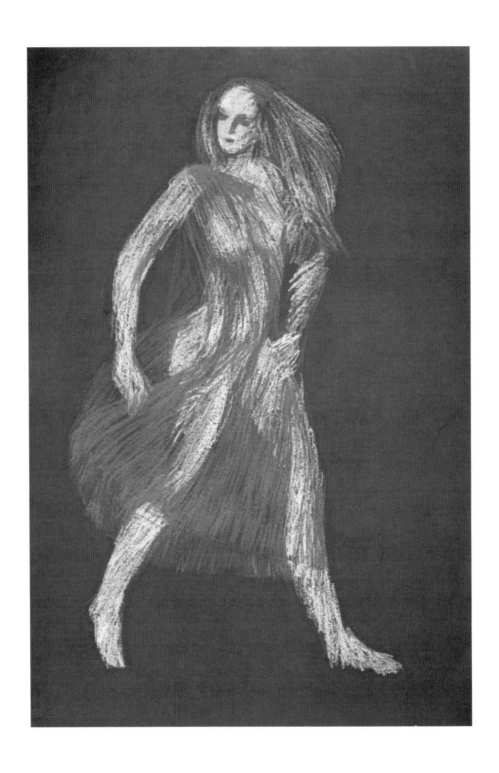

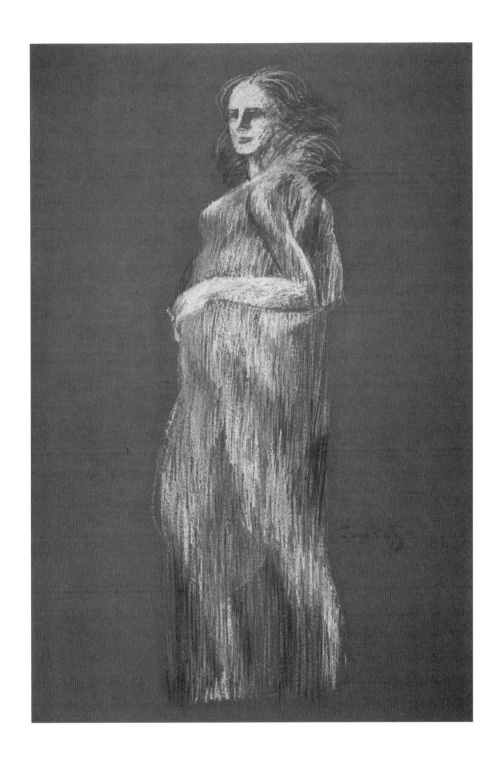

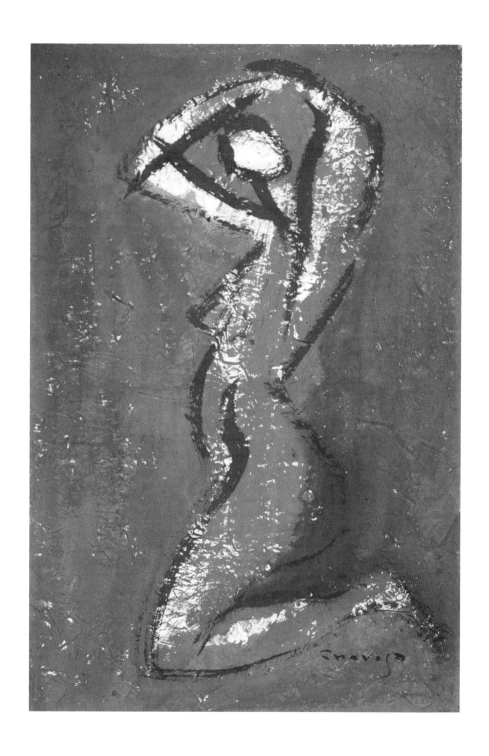

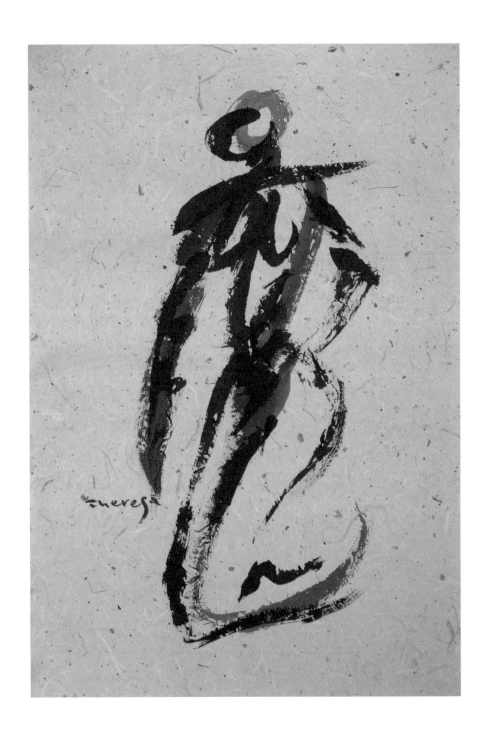

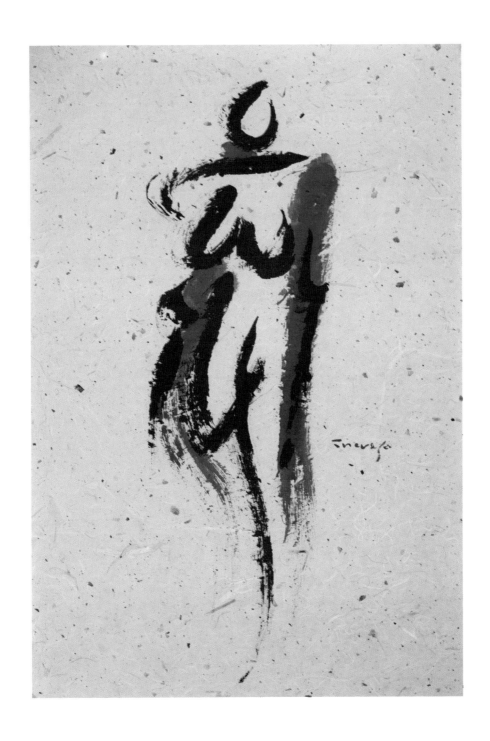

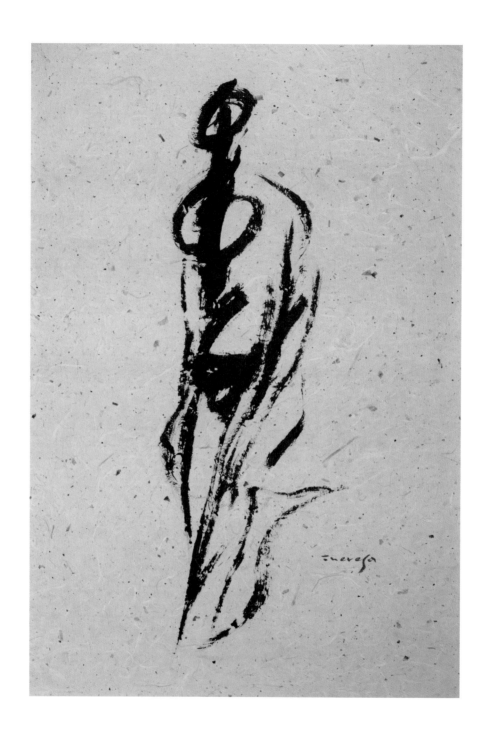

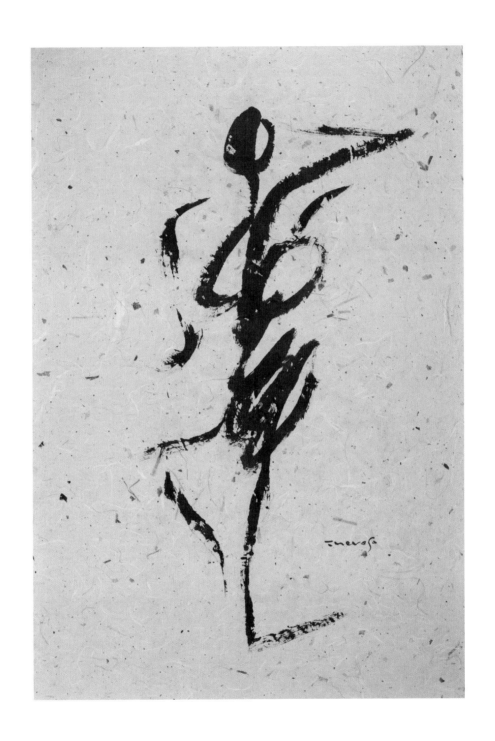

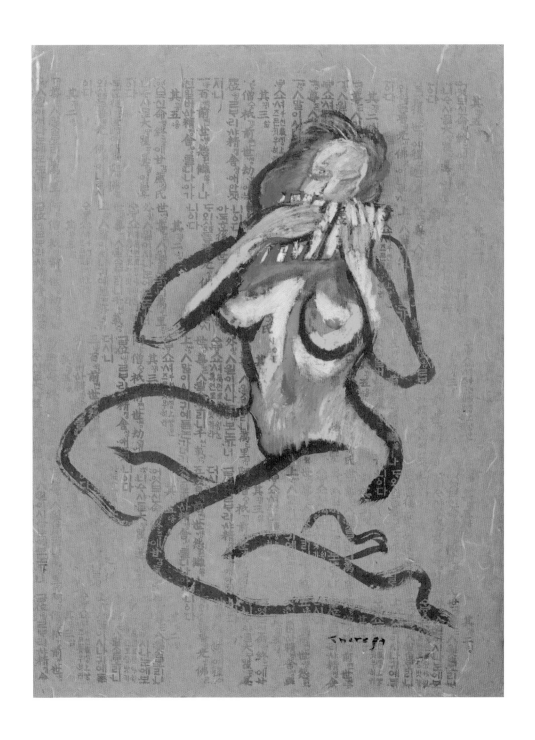

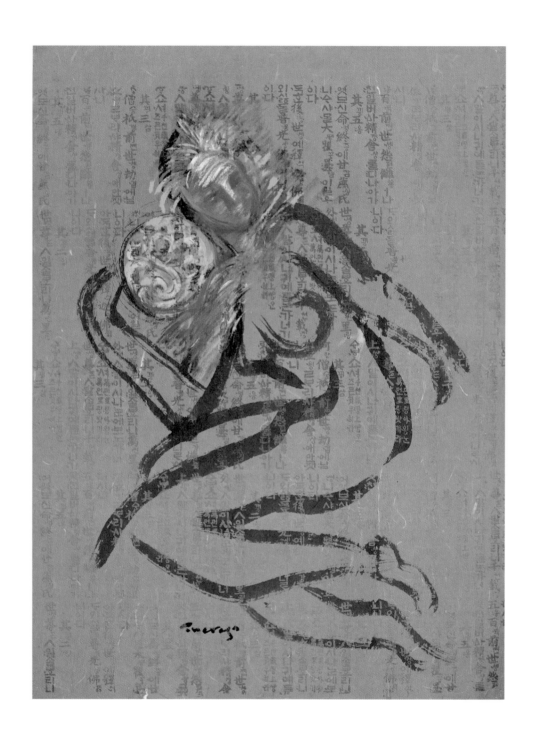

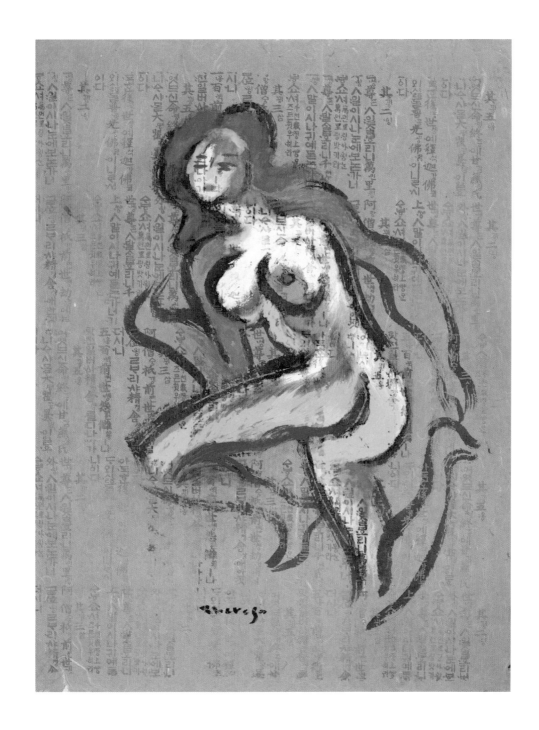

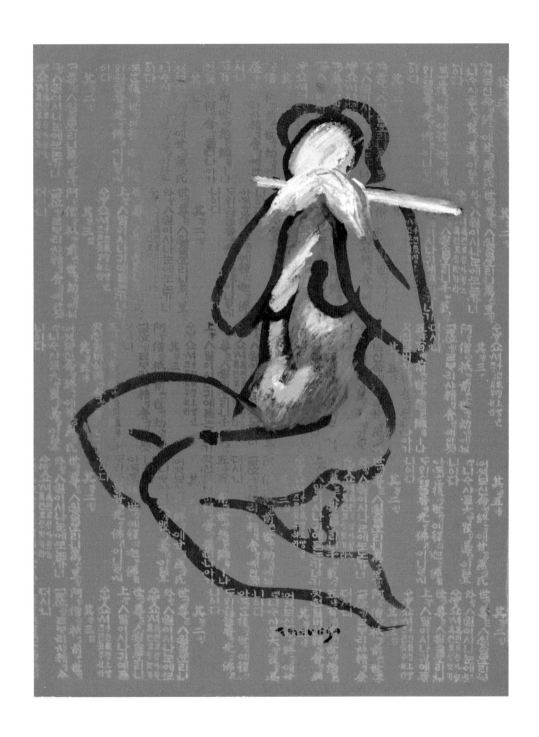

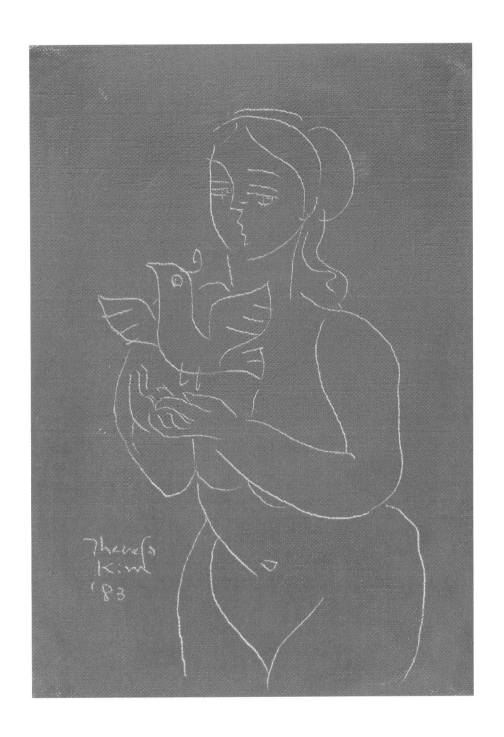

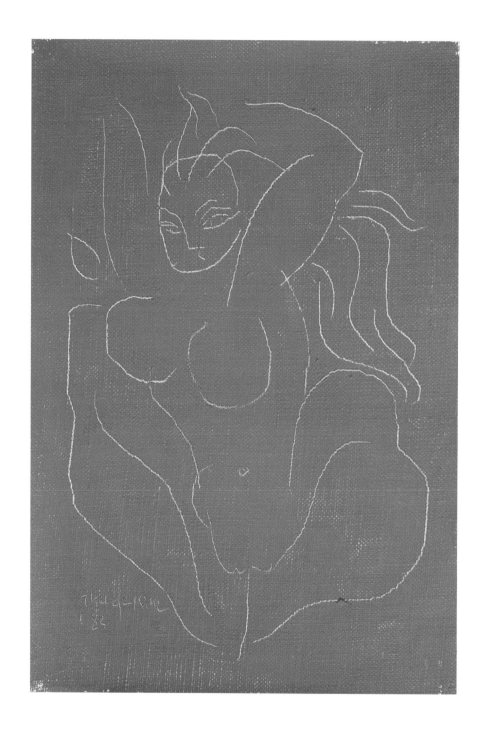

138

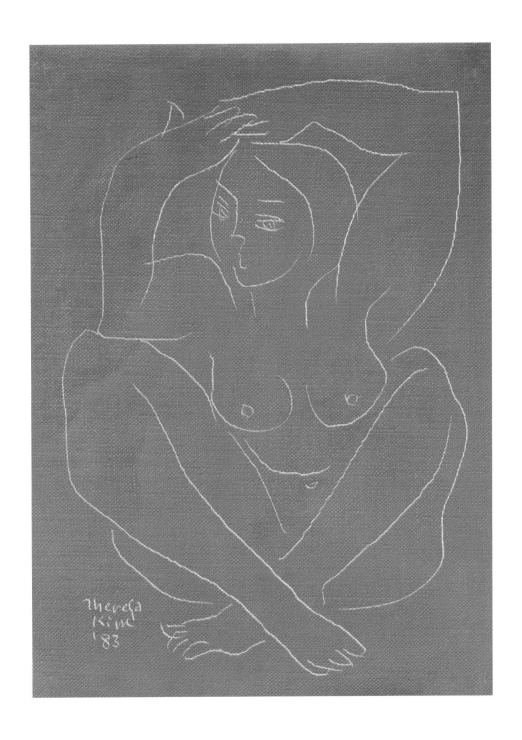

Theresa
Kim
'83

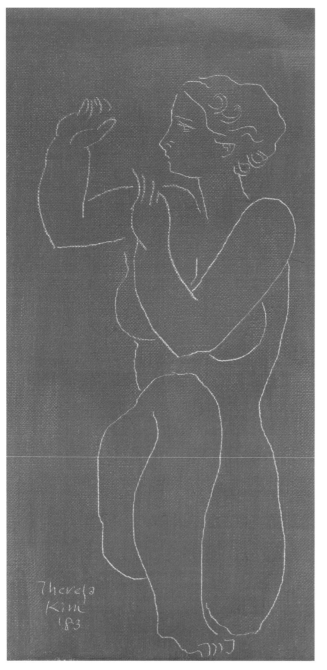
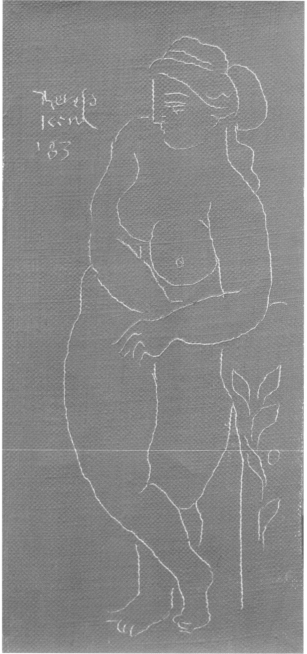

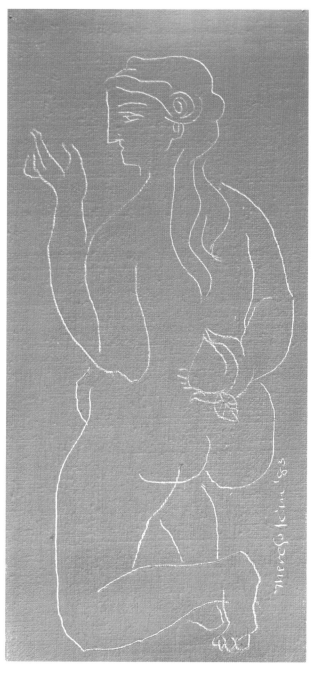
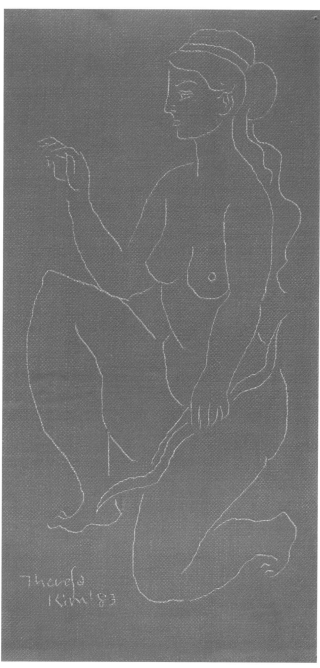

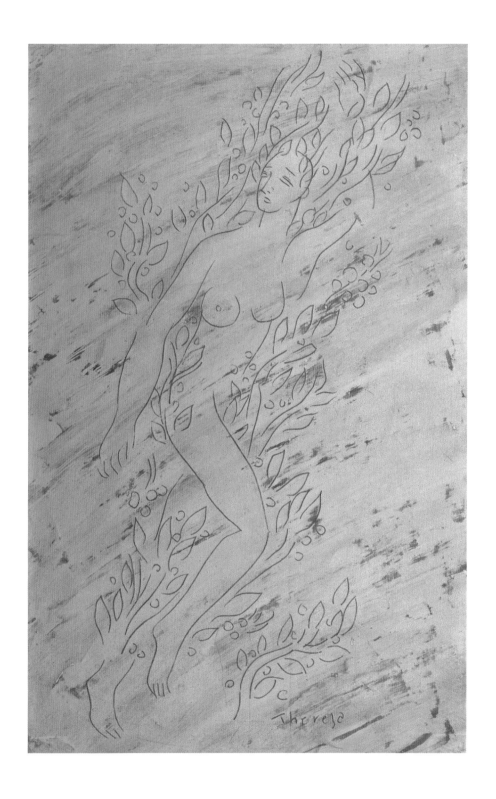

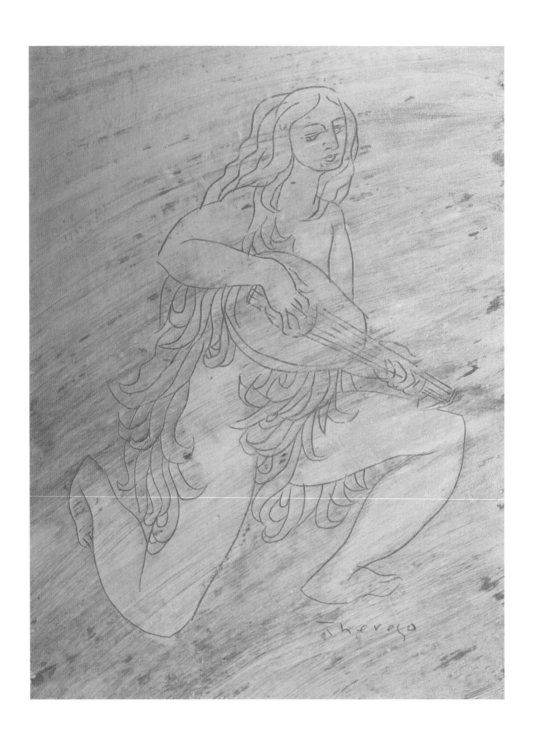

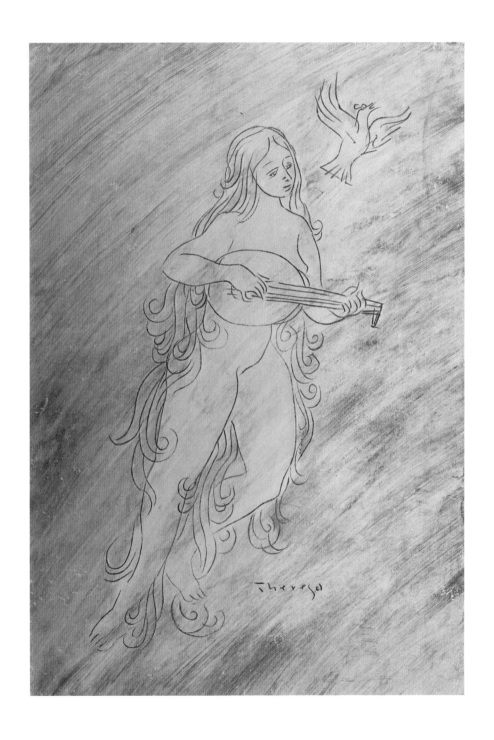

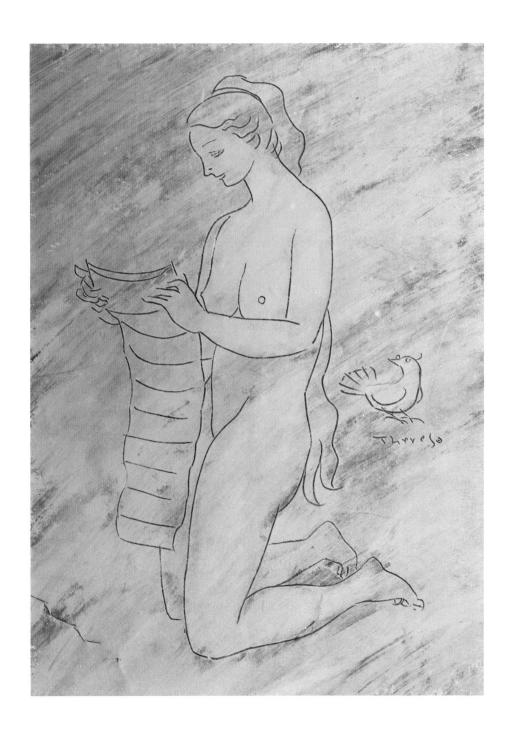

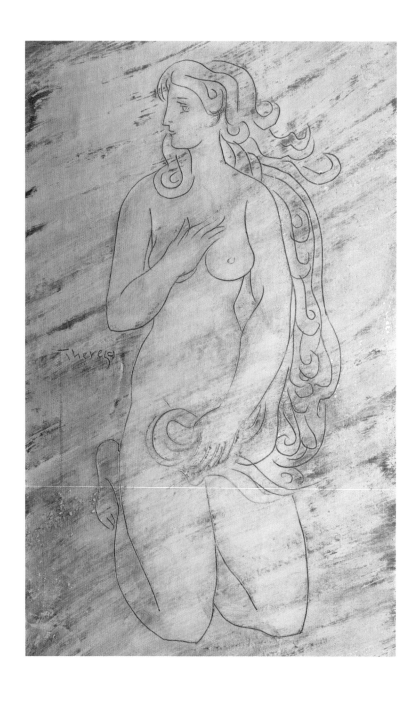

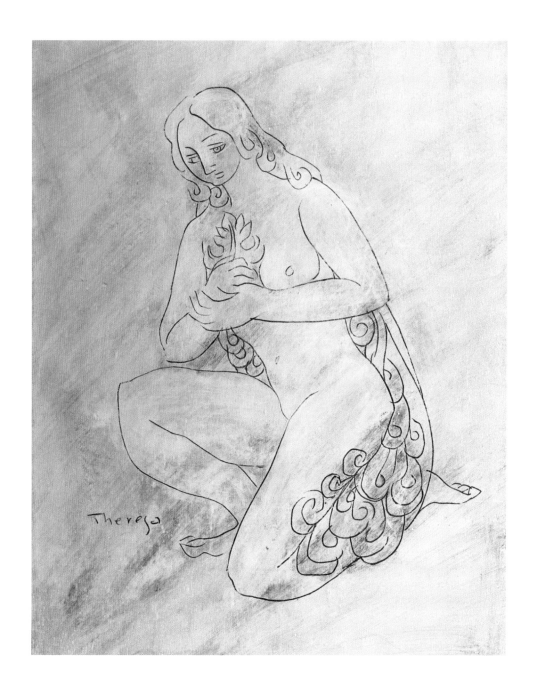

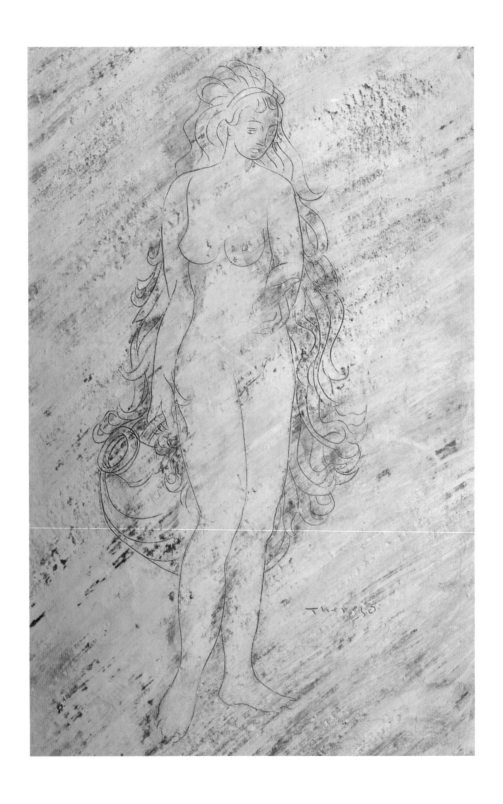

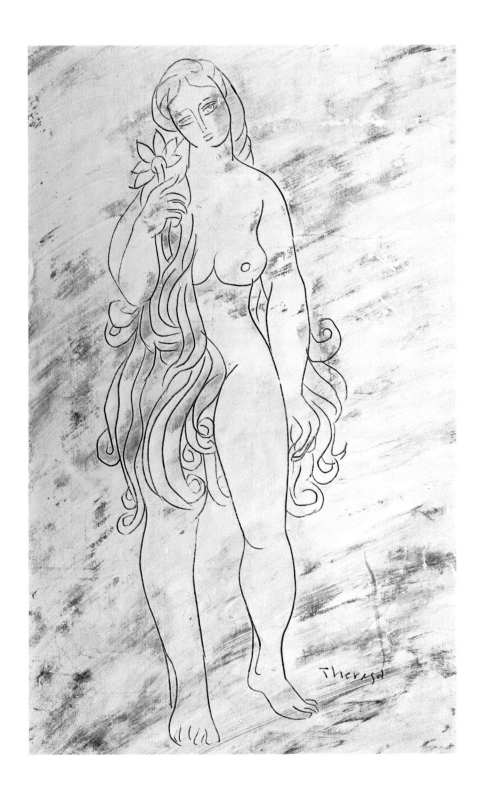

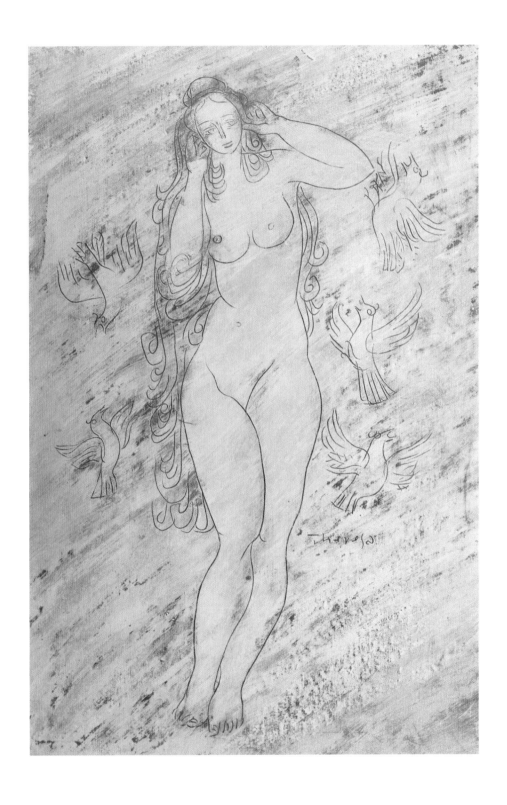

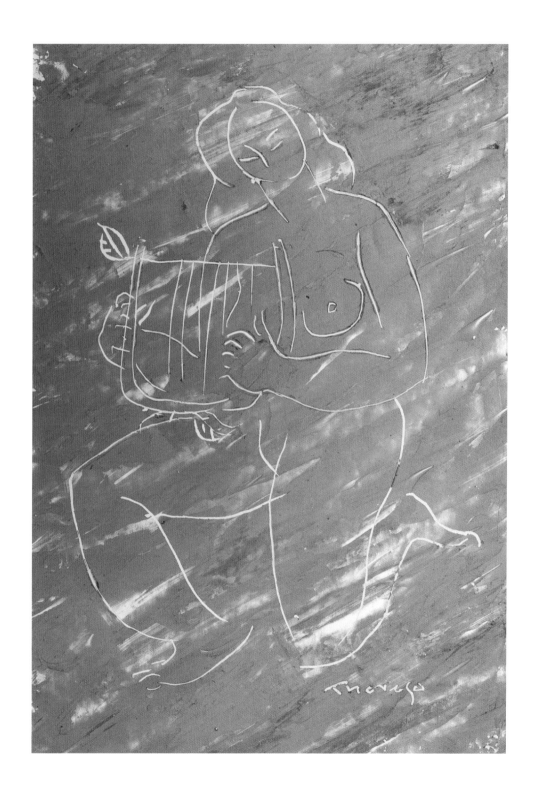

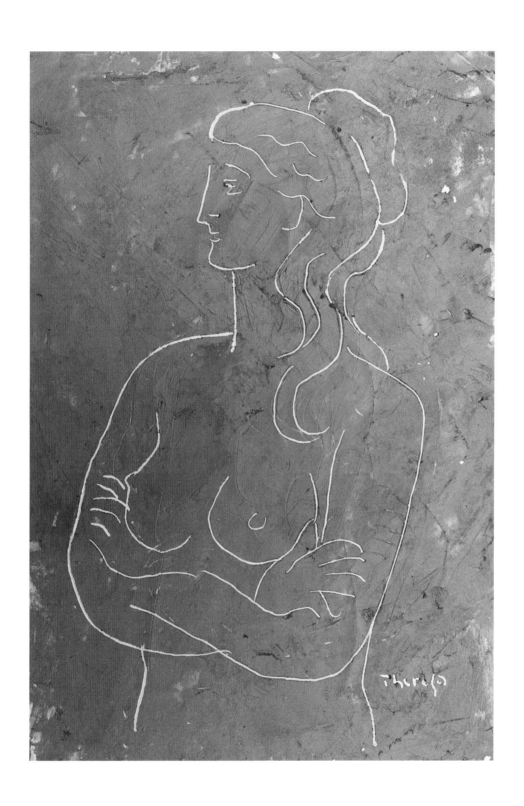

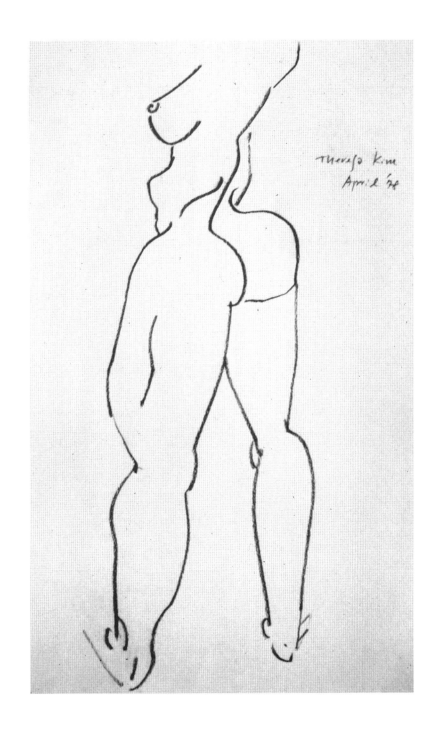

Theresa Kim
April '78

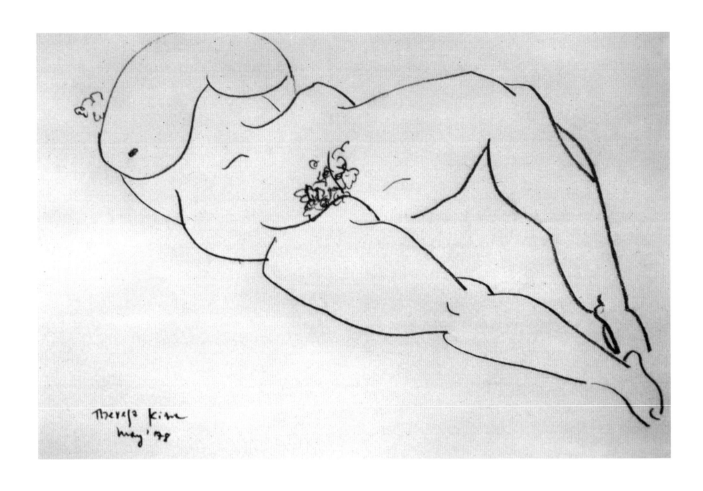

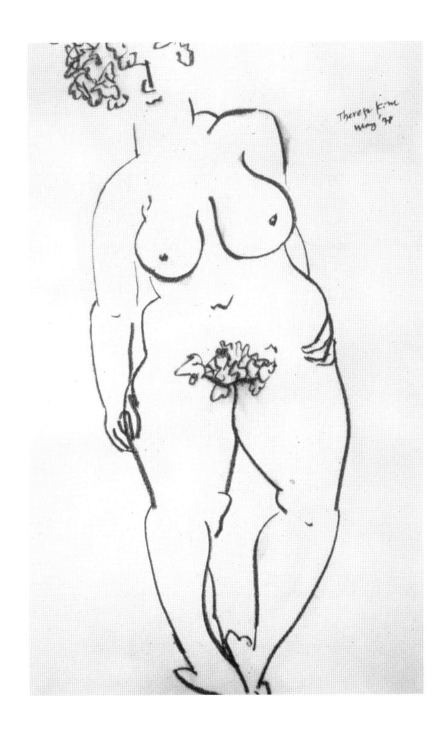

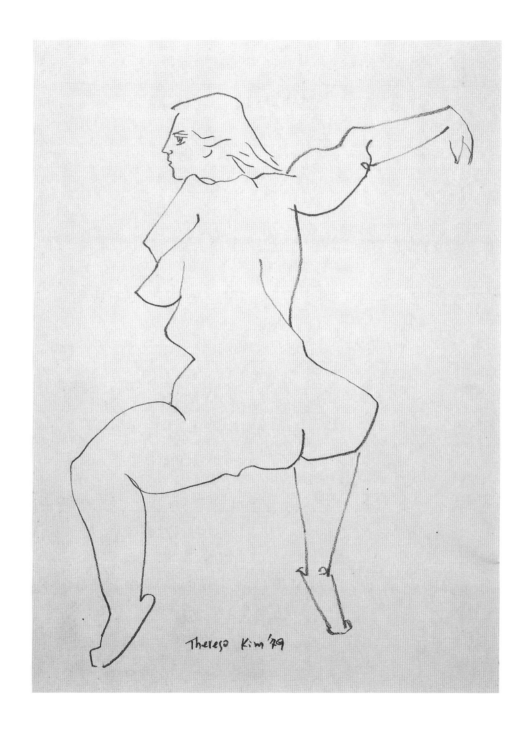

Theresa Kim '79

3

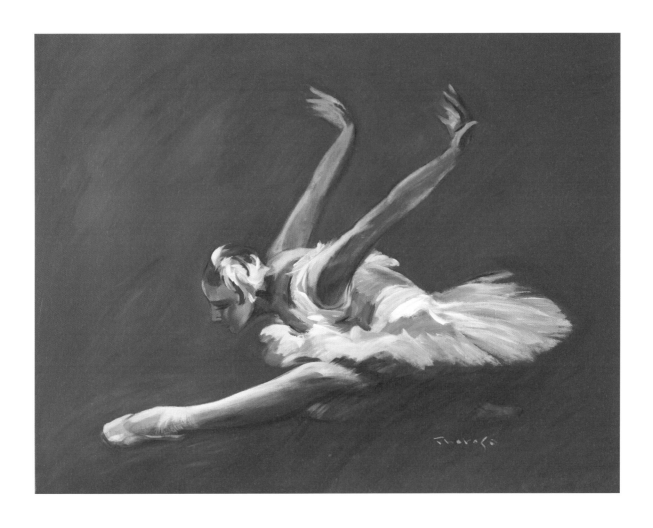

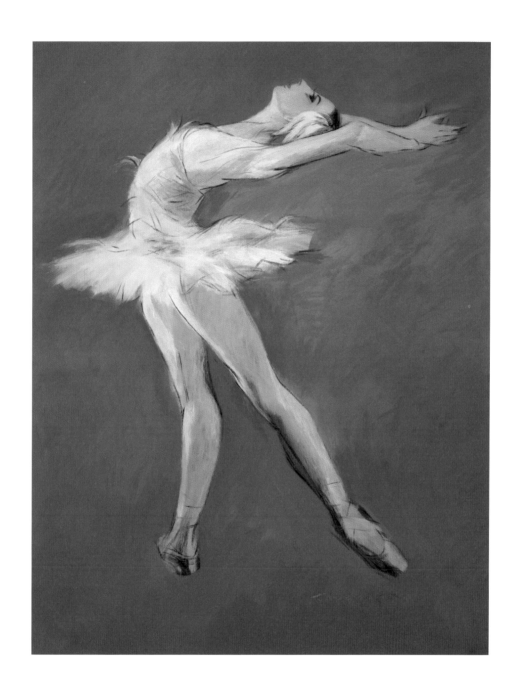

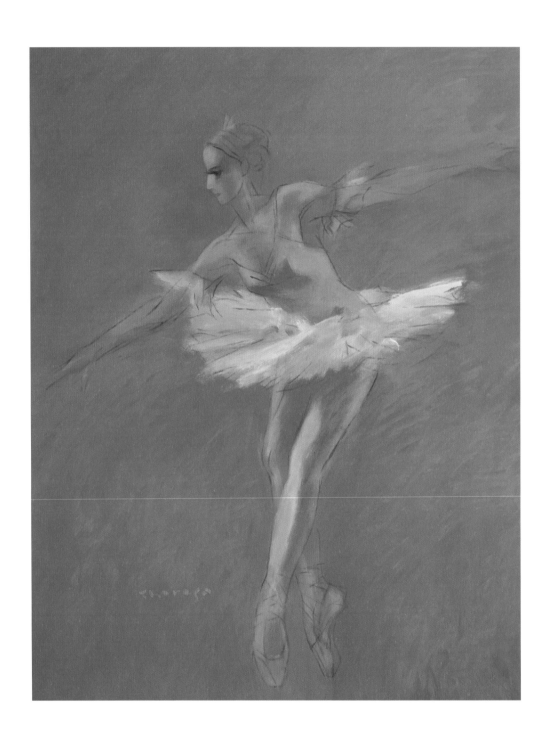

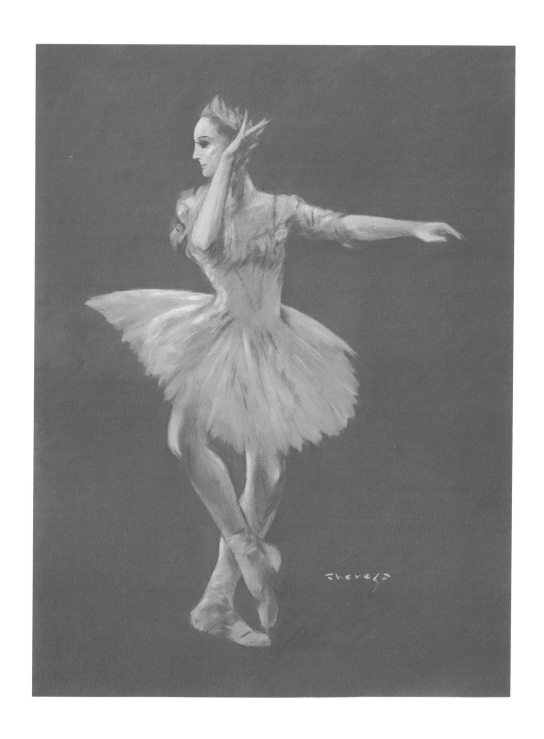

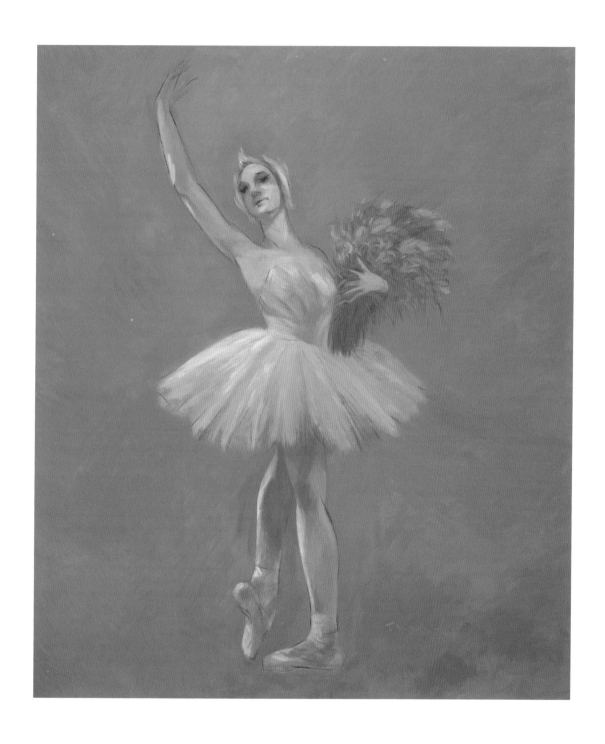

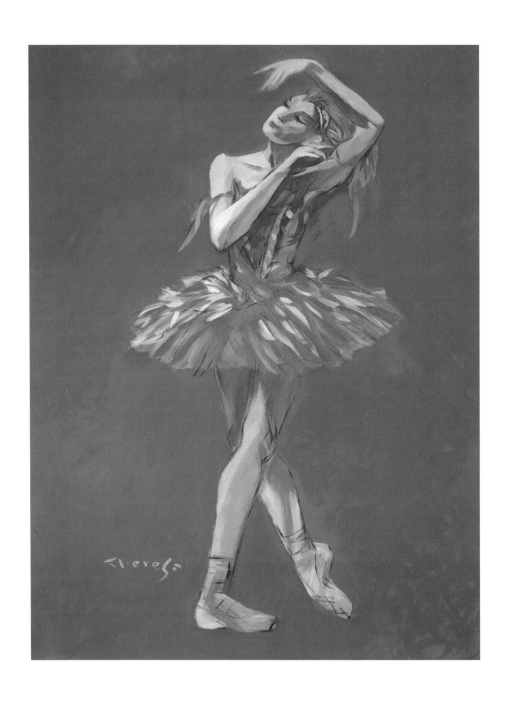

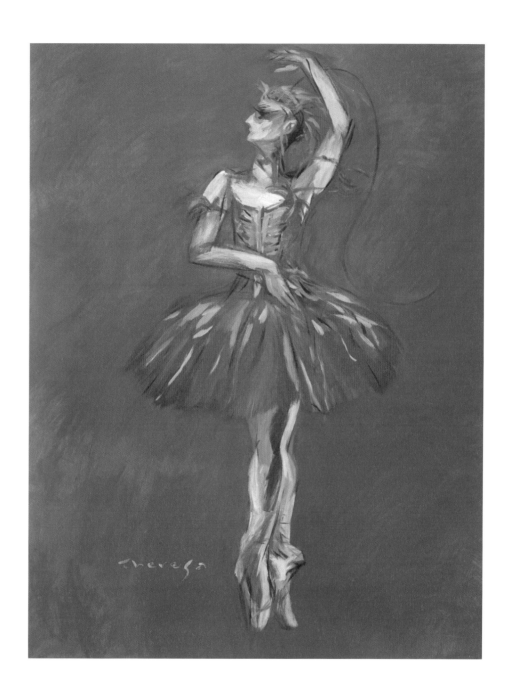

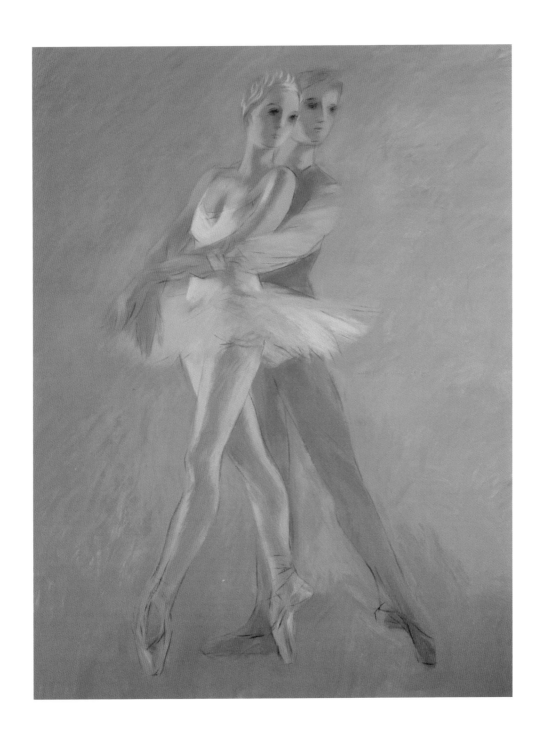

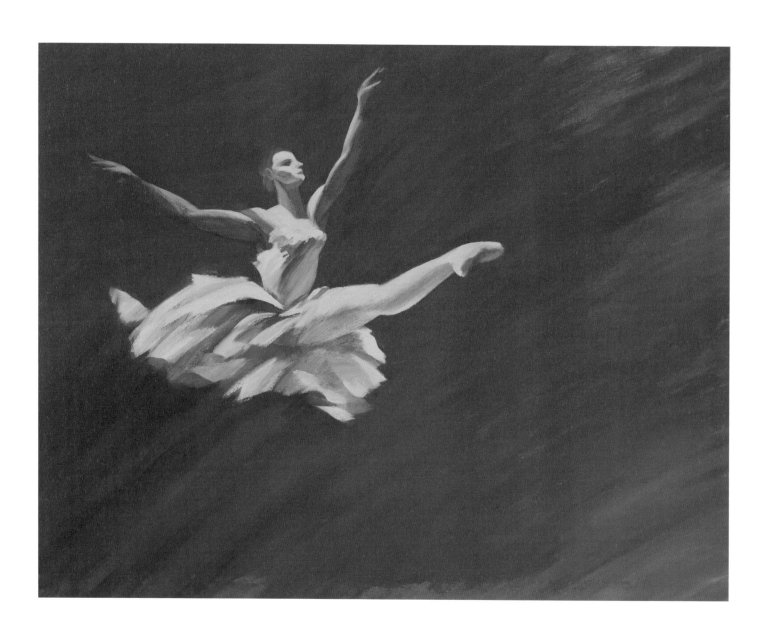

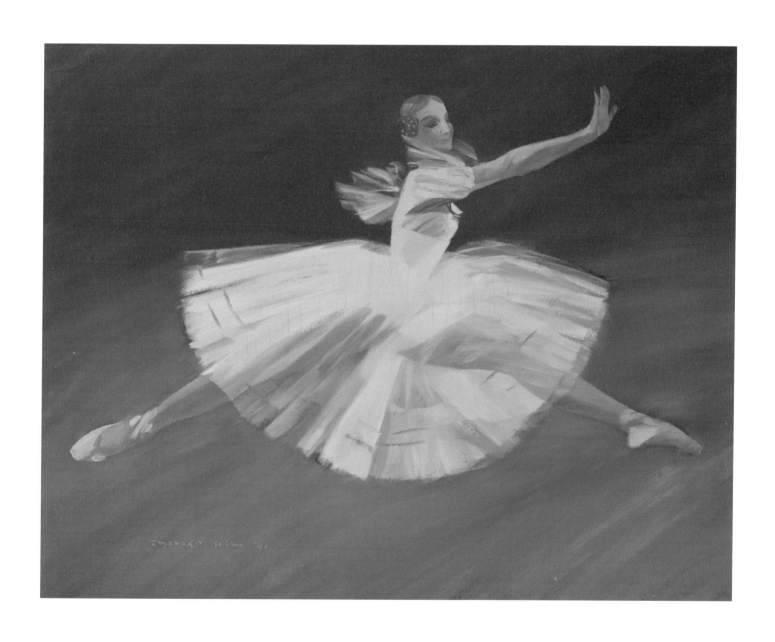

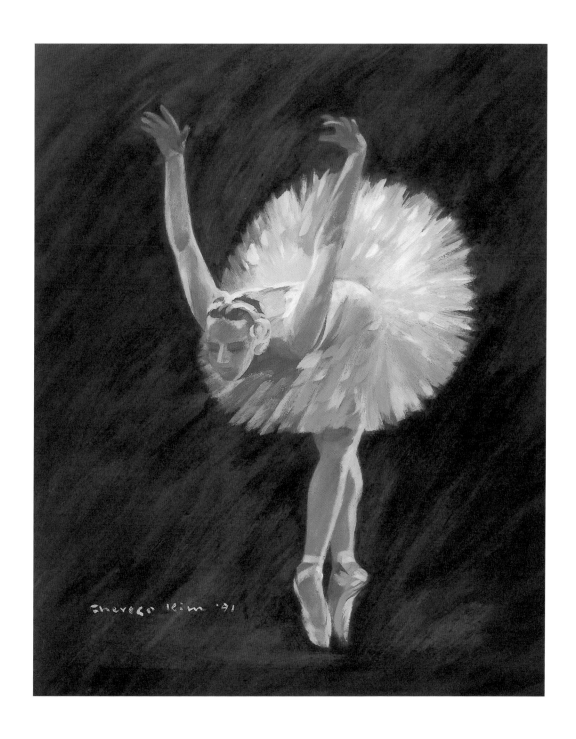

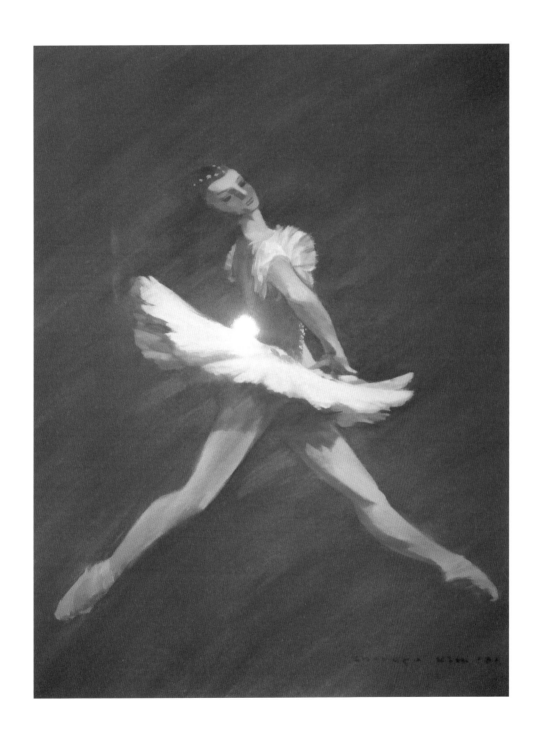

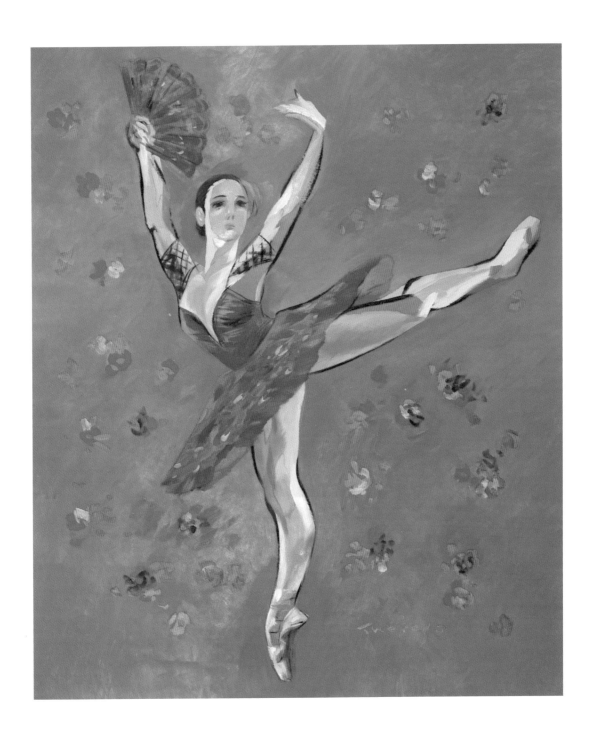

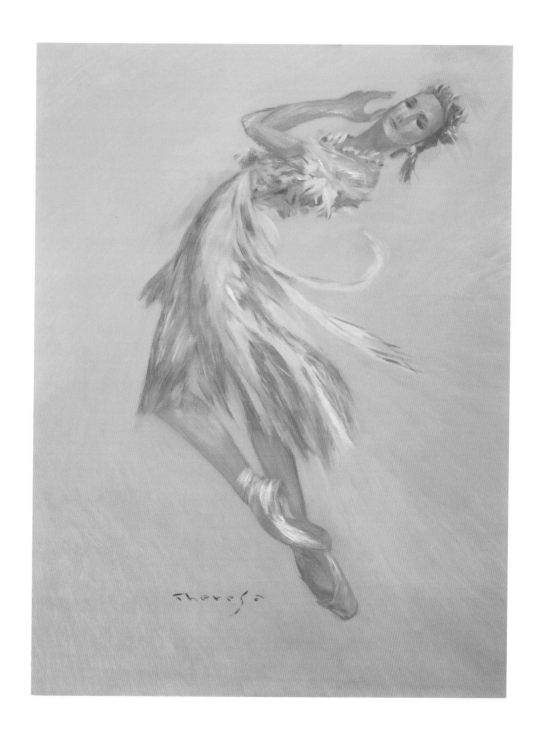

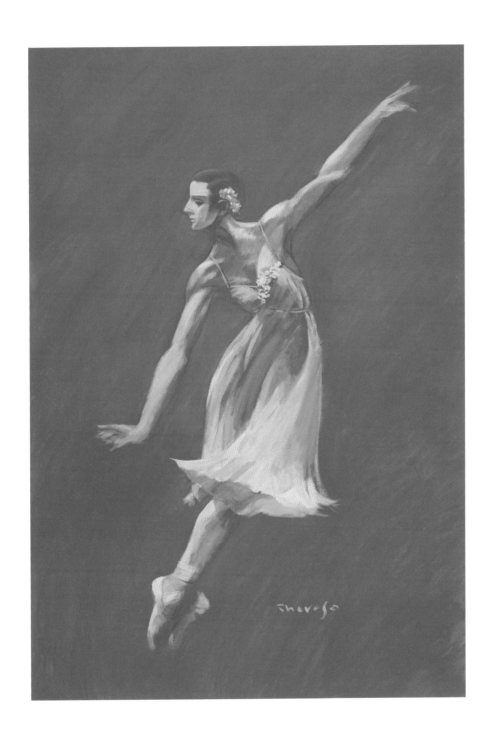

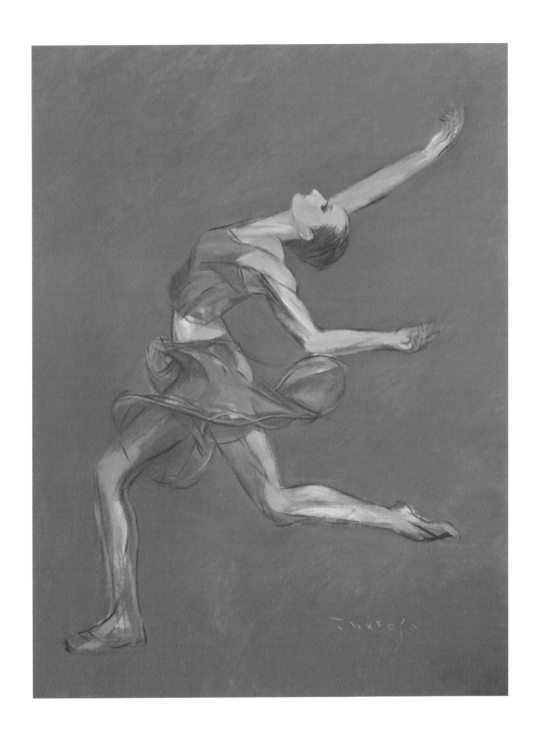

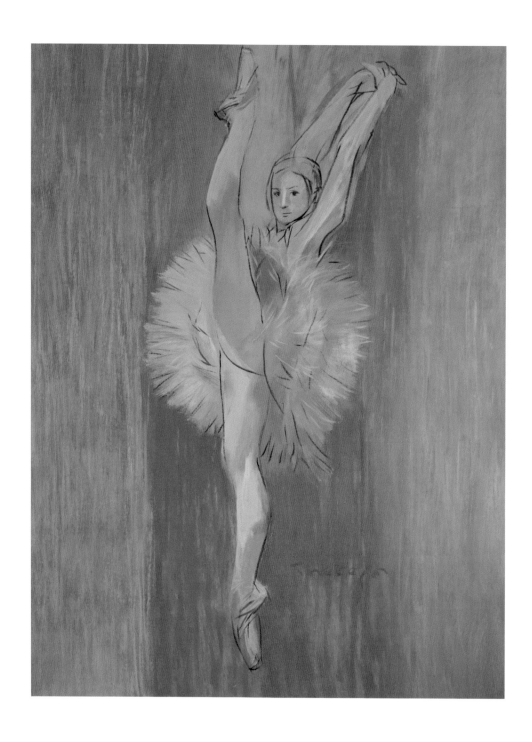

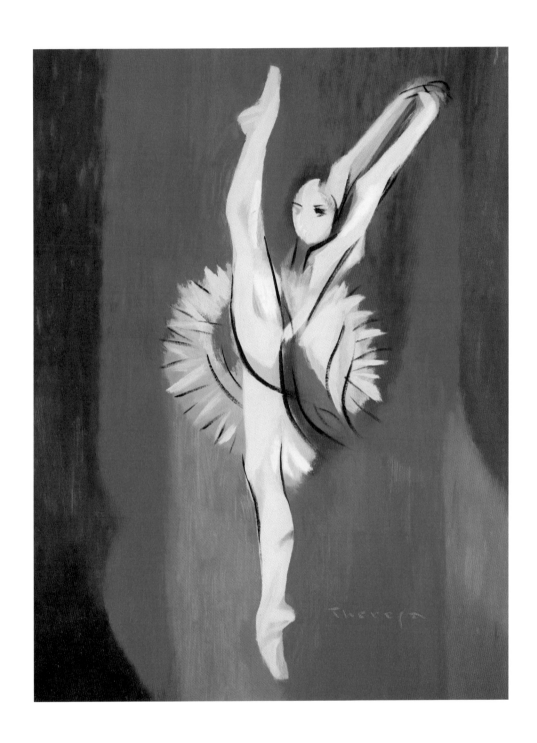

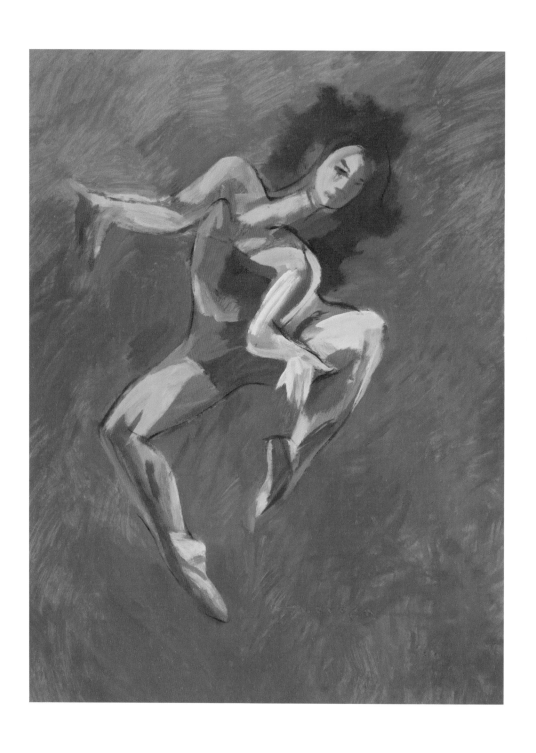

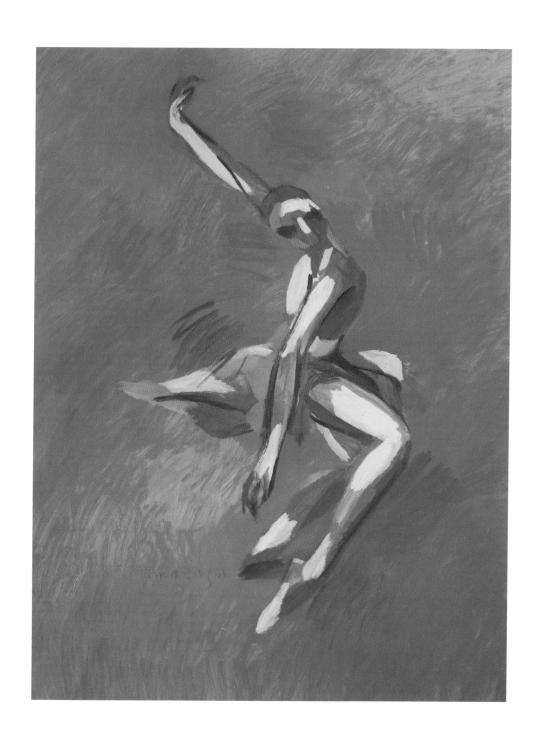

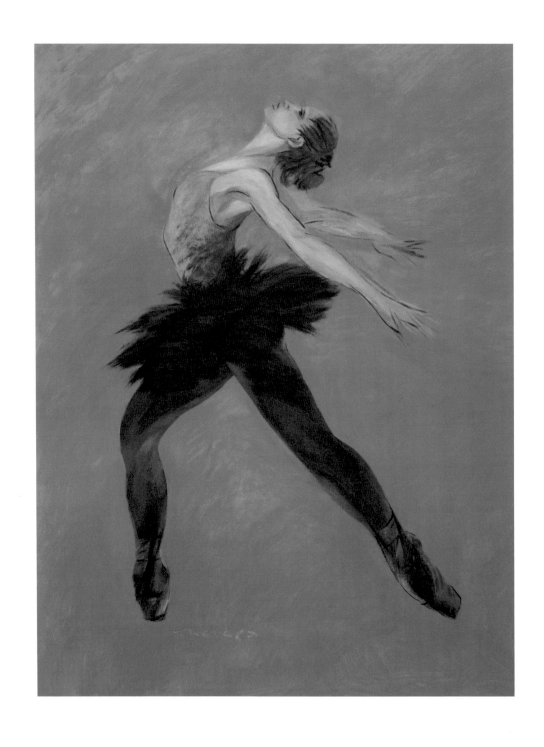

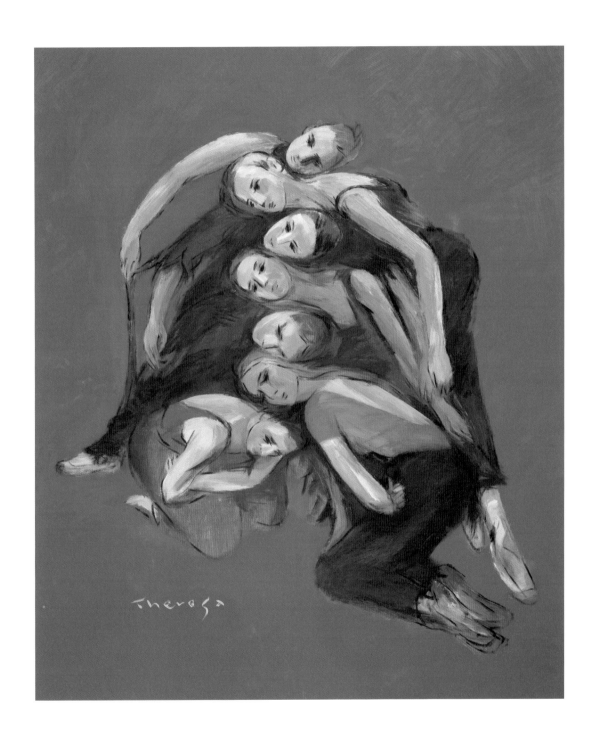

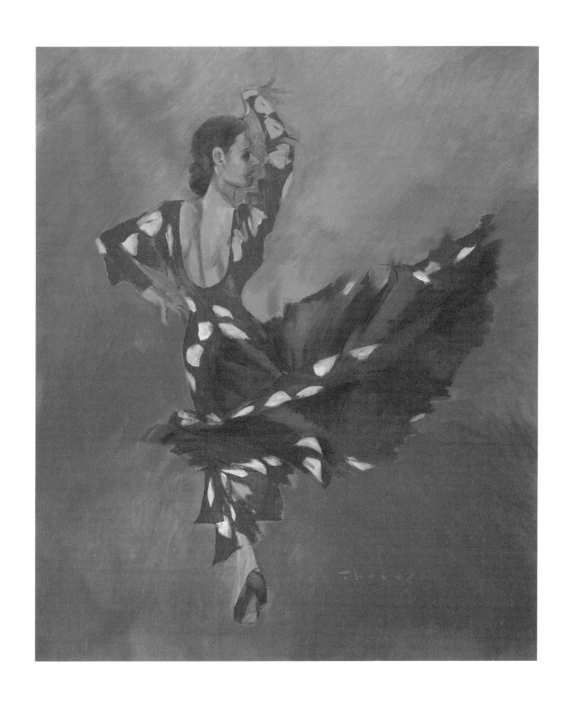

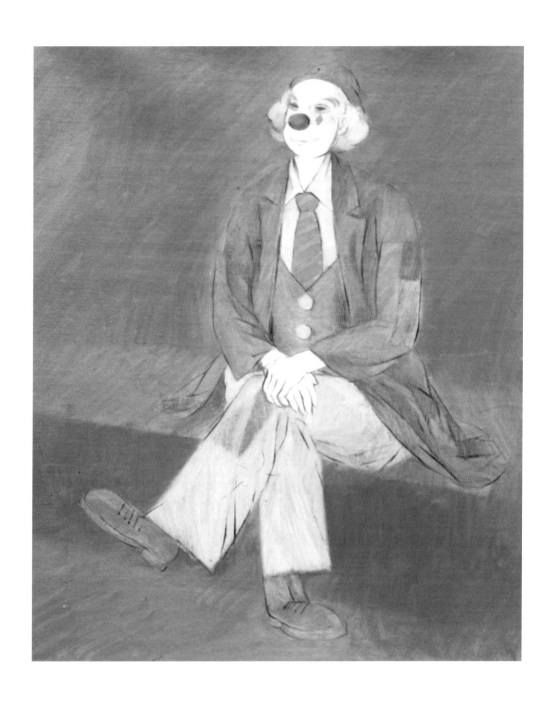

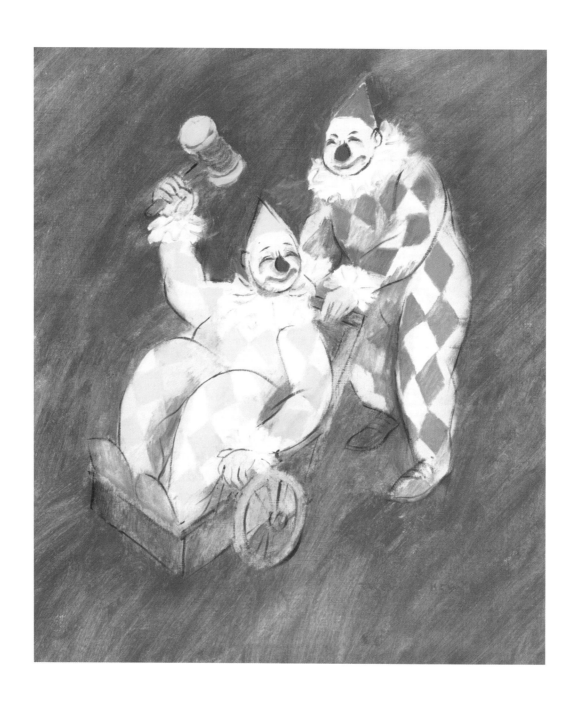

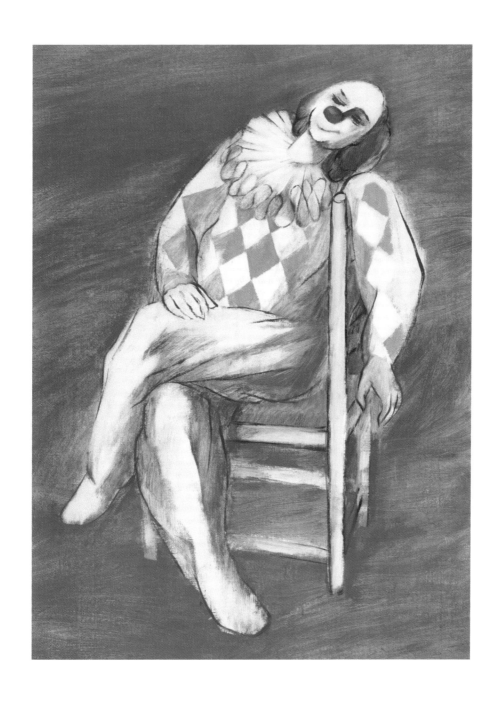

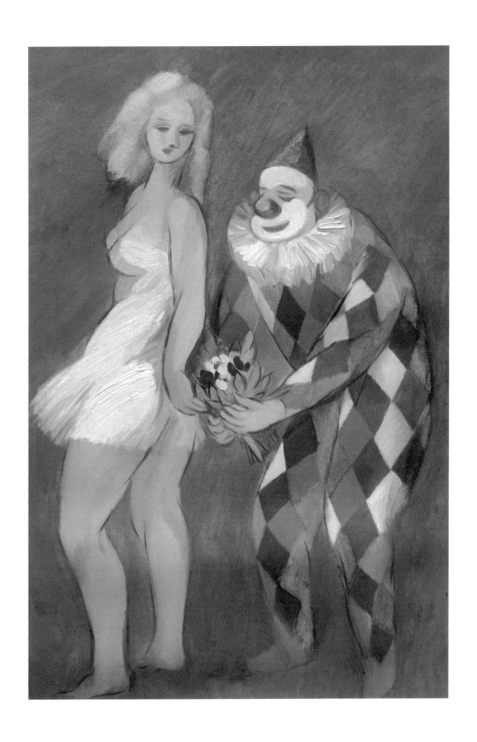

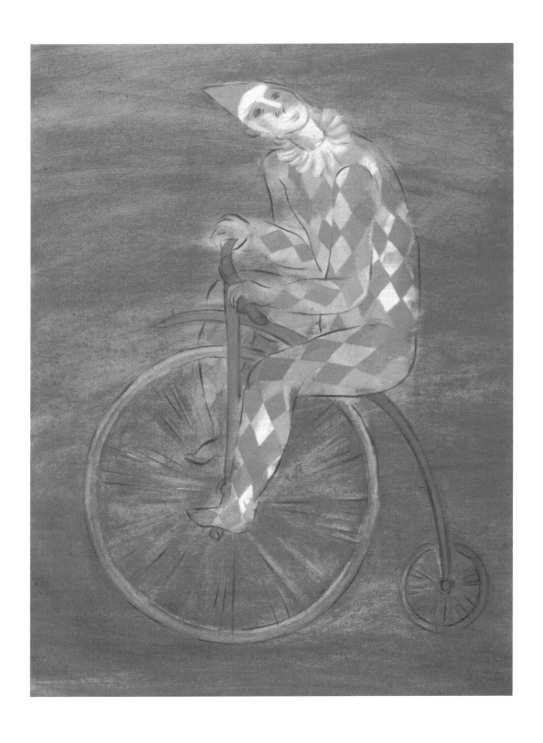

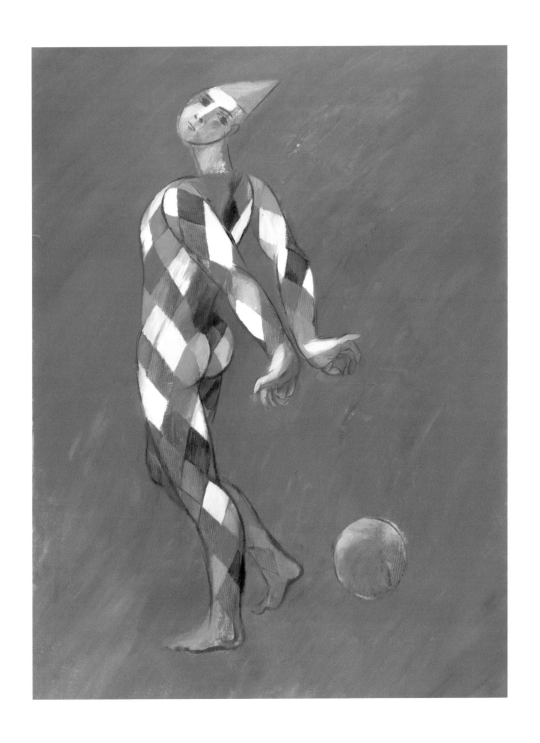

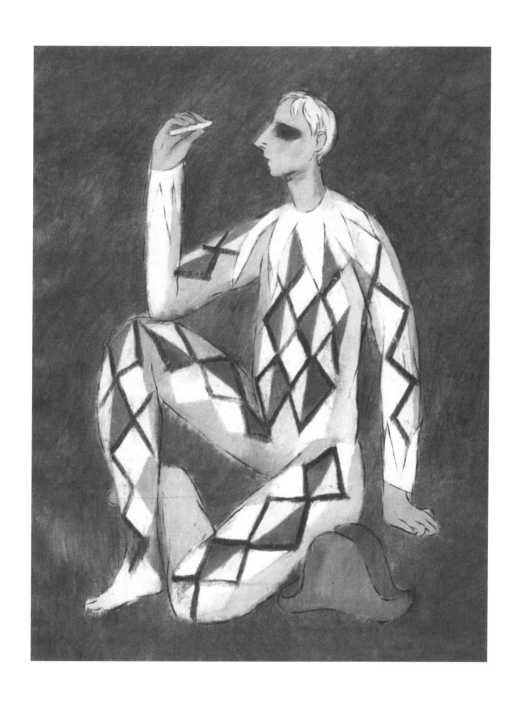

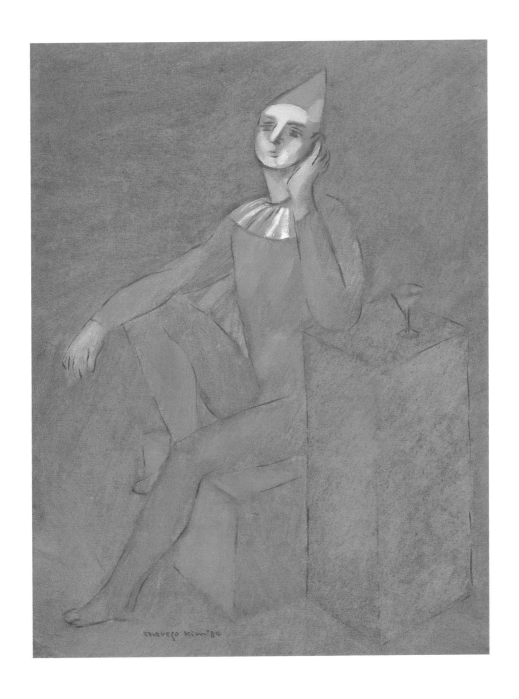

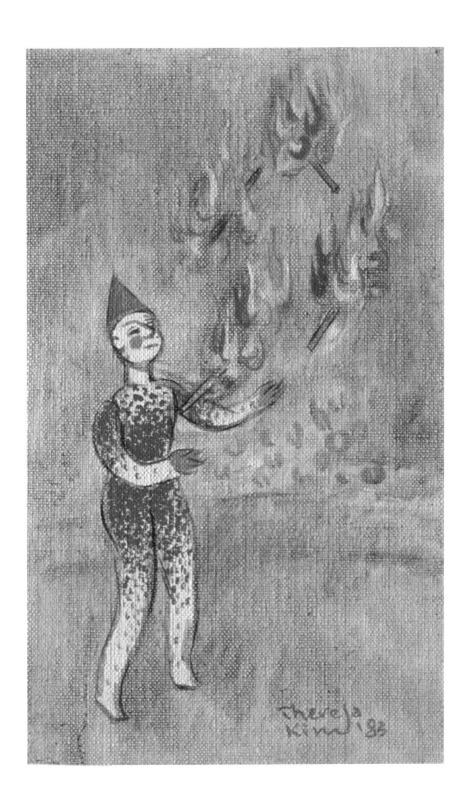

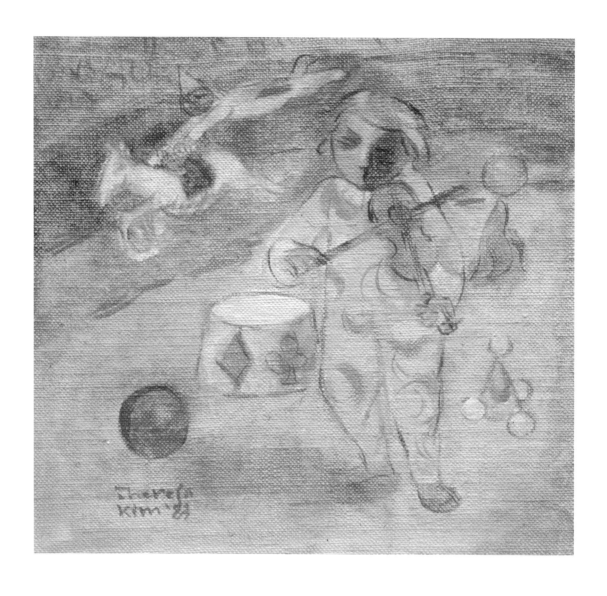

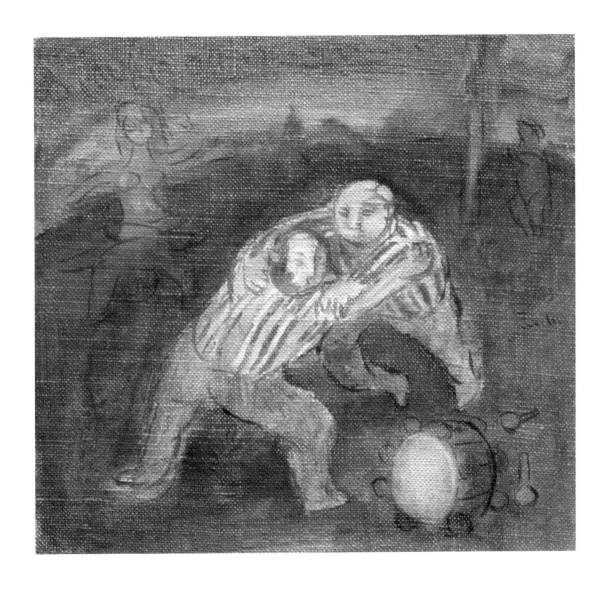

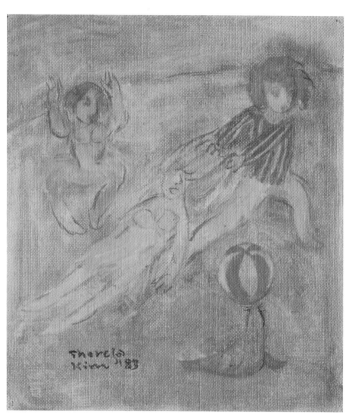
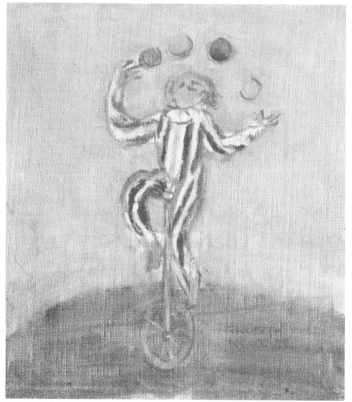

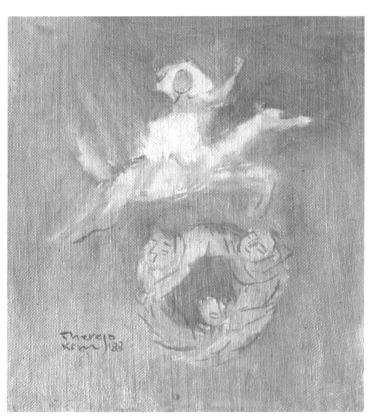
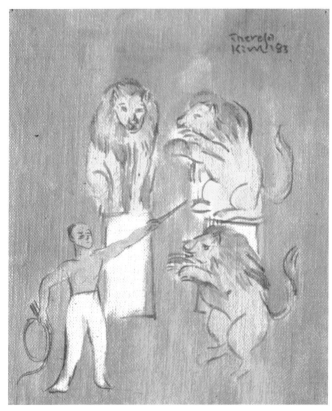

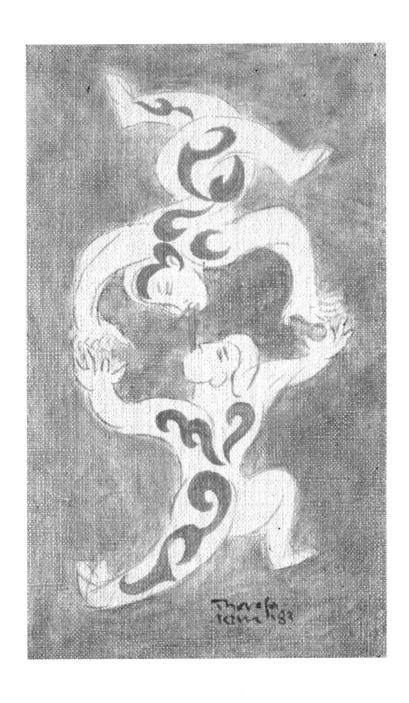

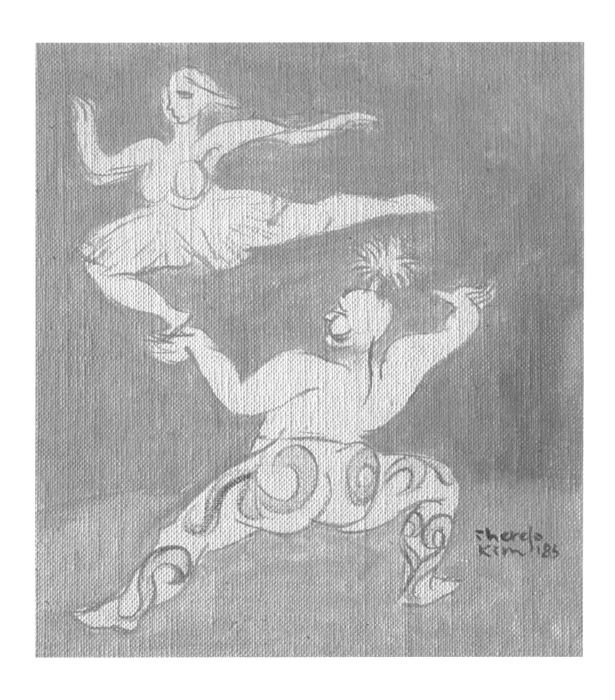

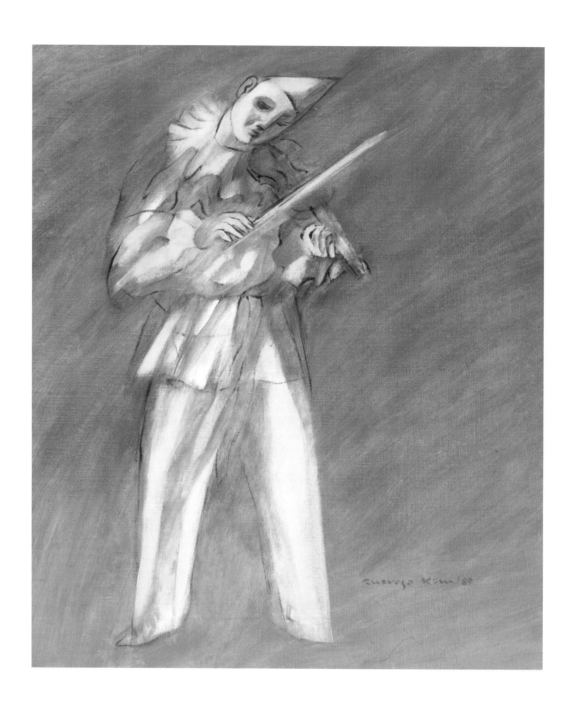

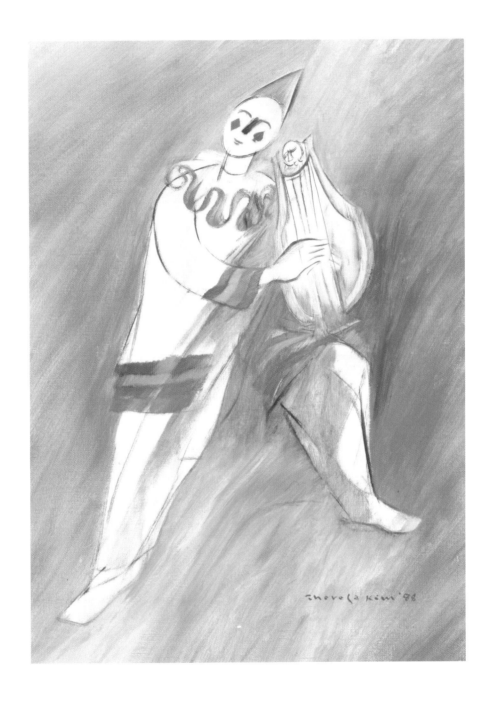

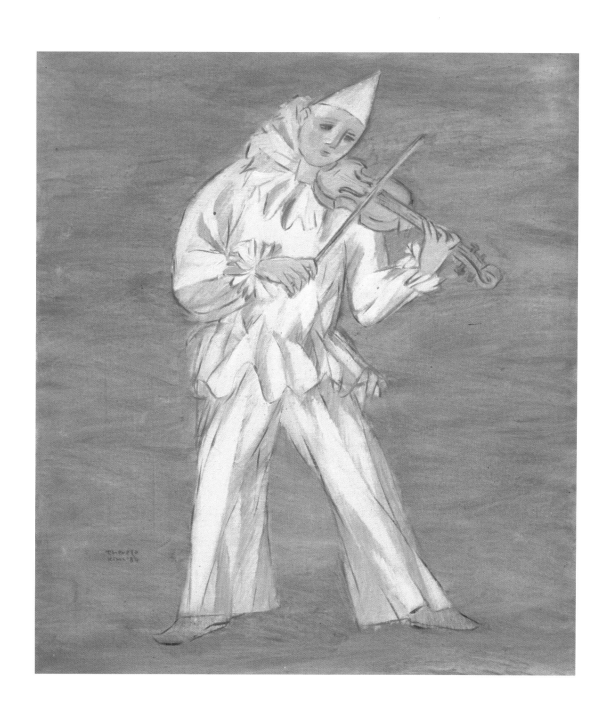

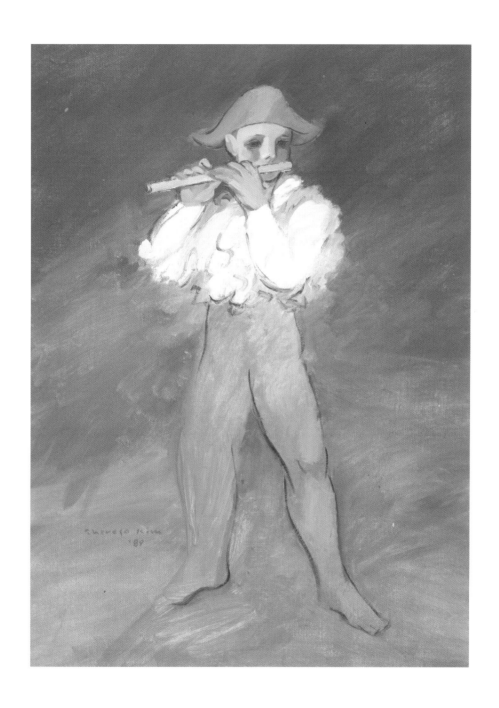

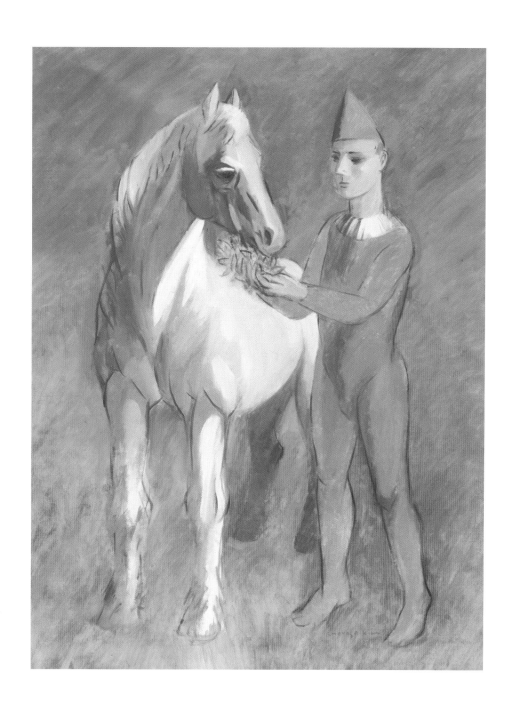

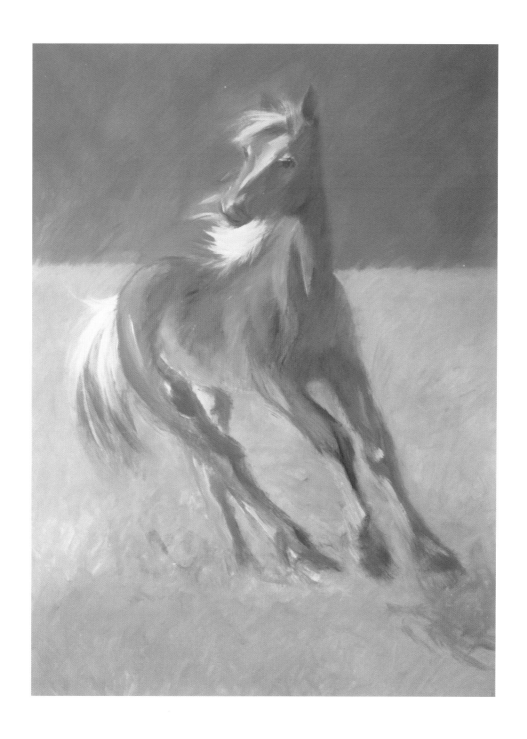

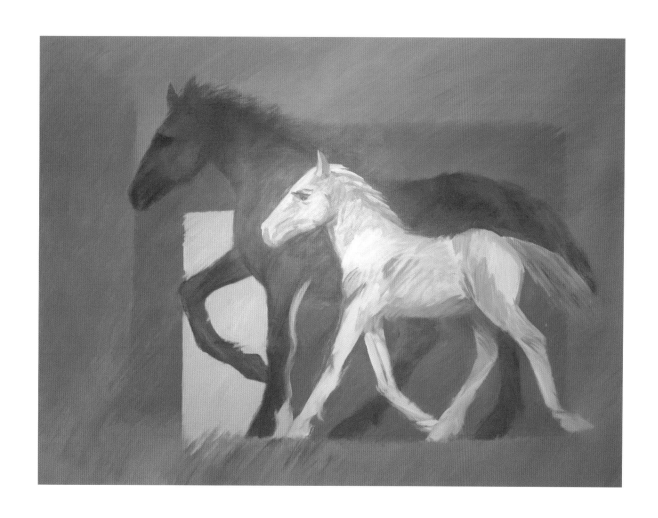

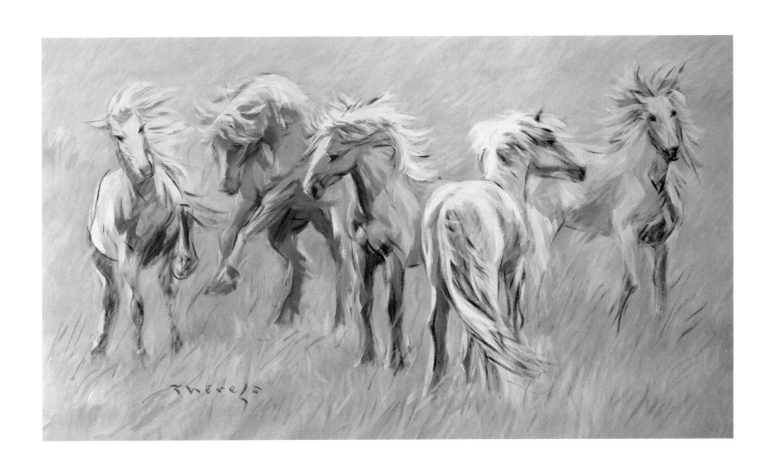

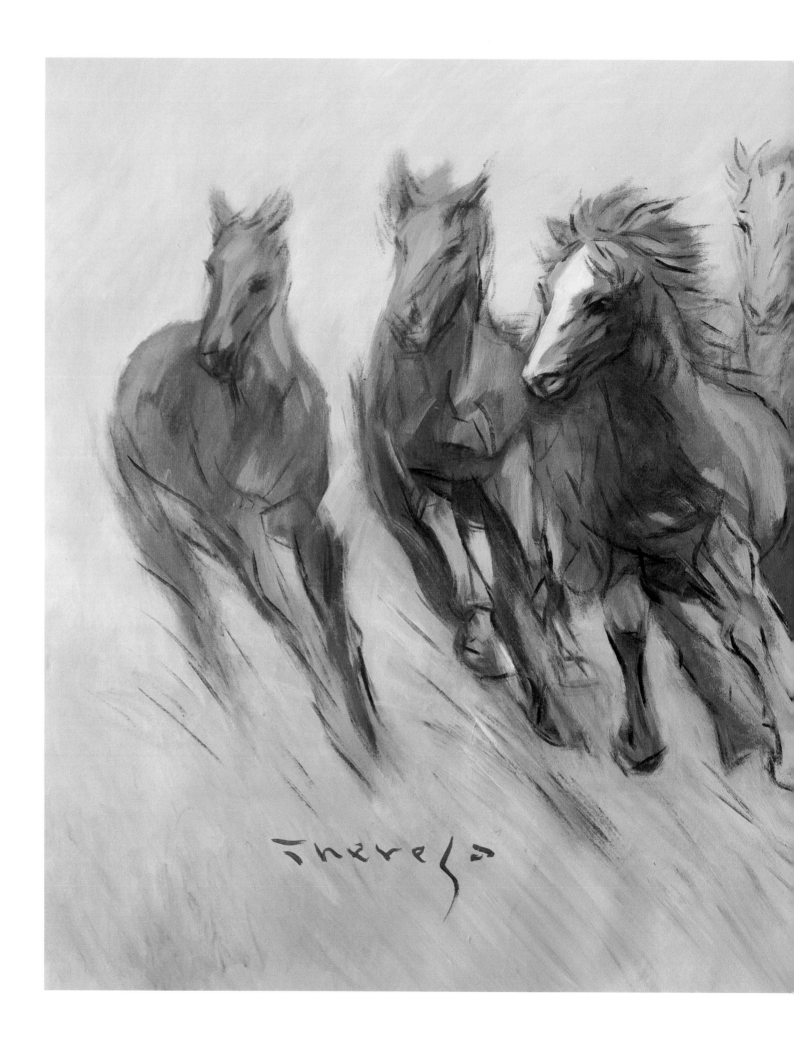

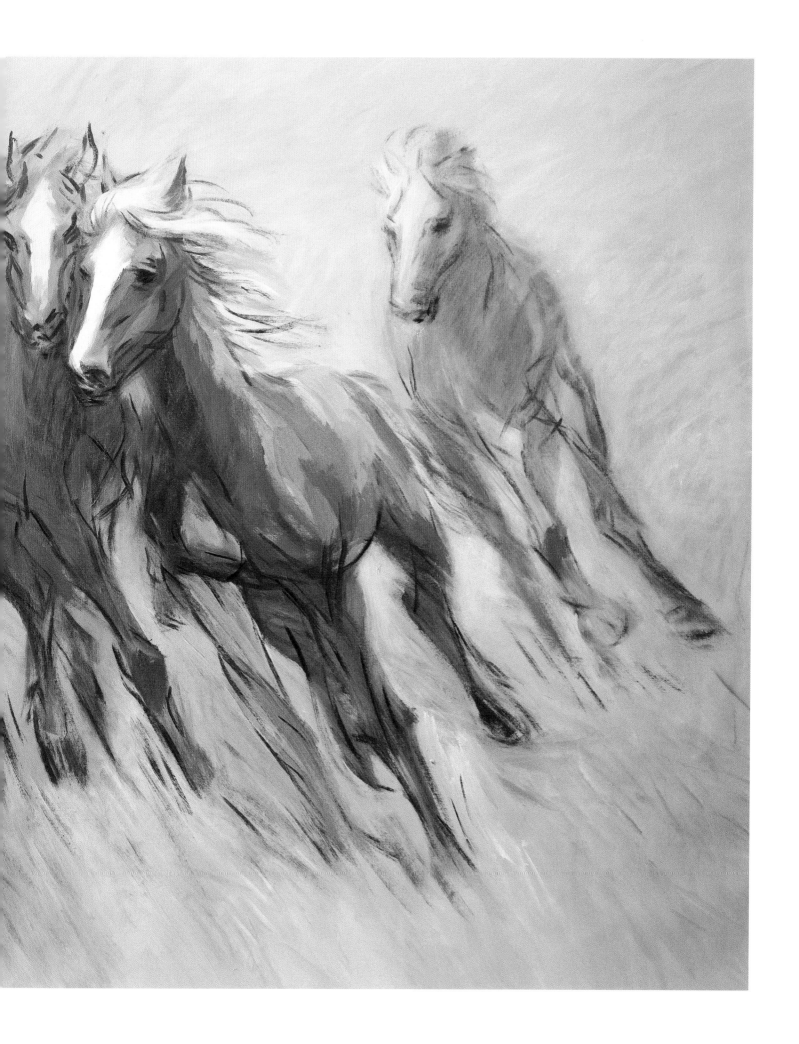

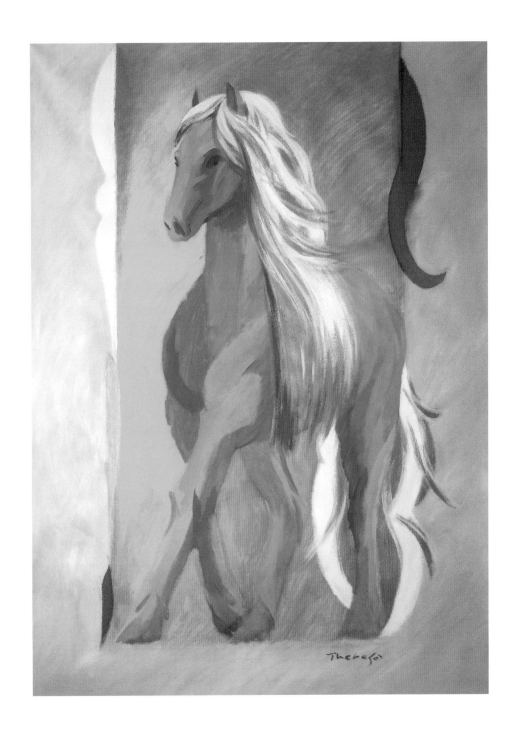

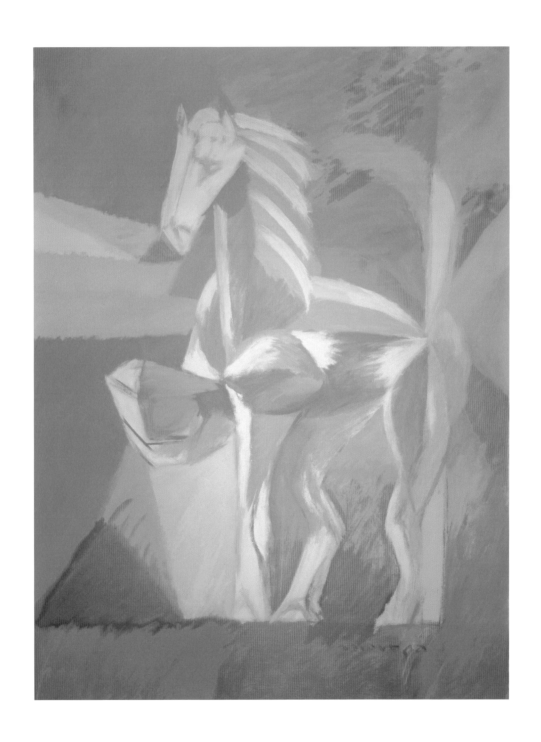

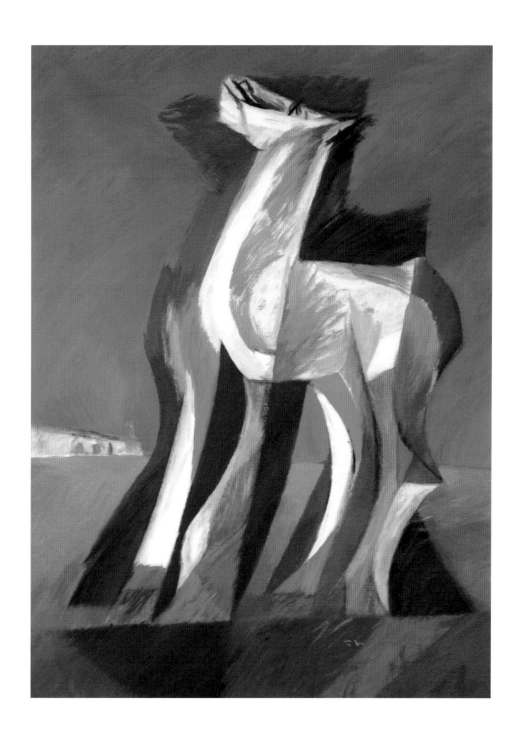

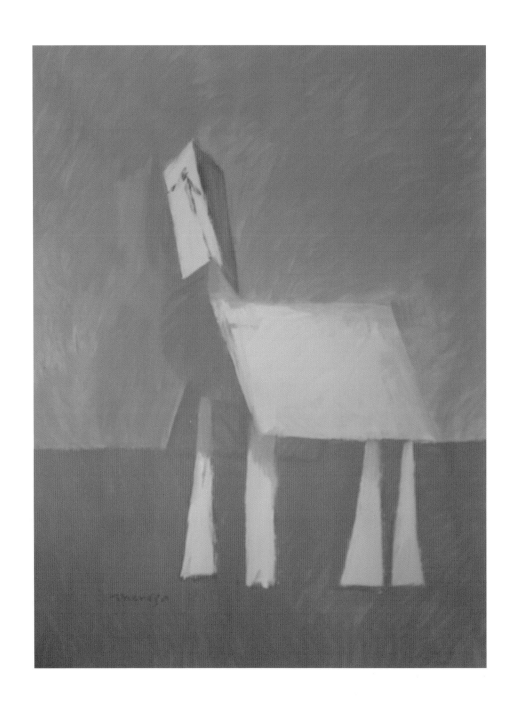

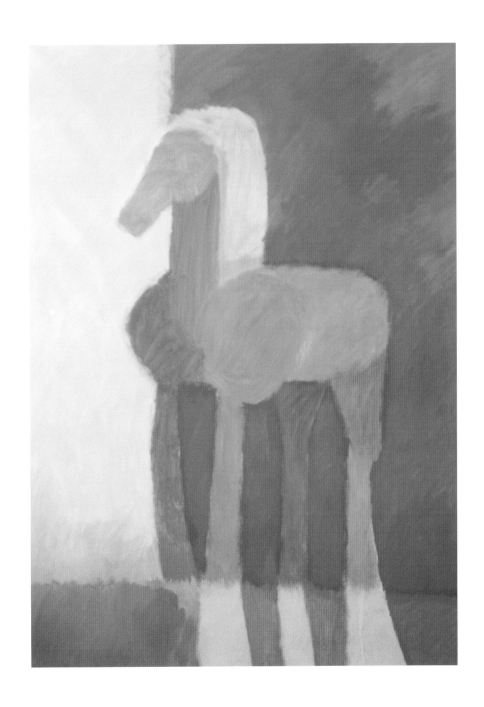

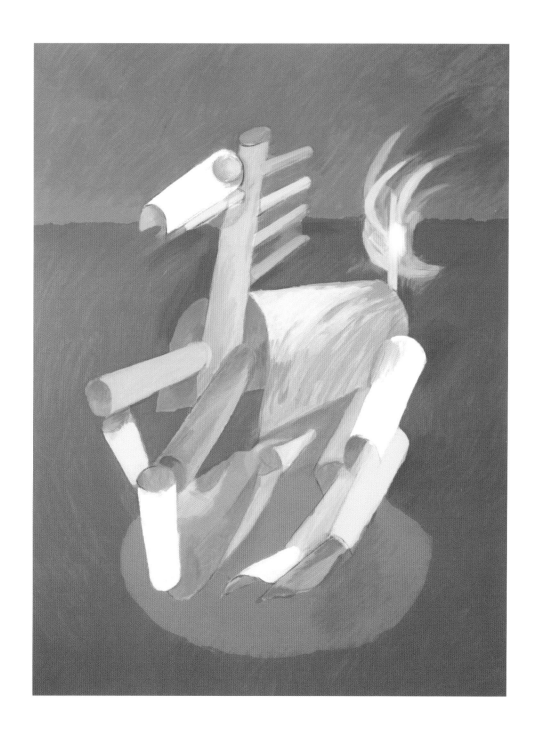

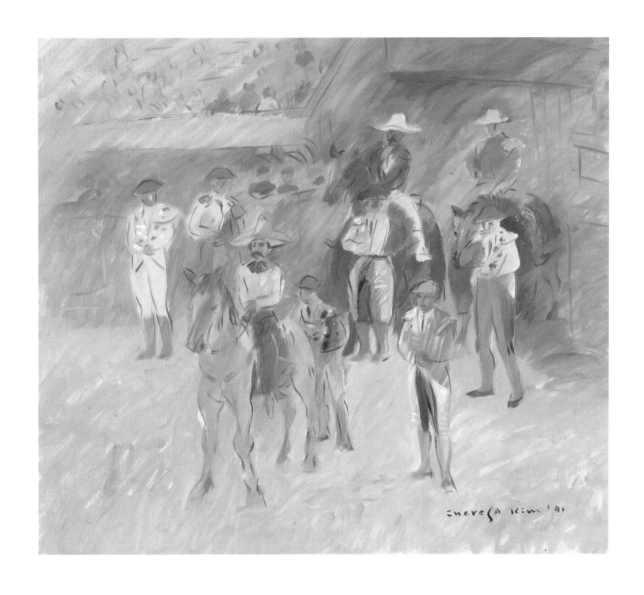

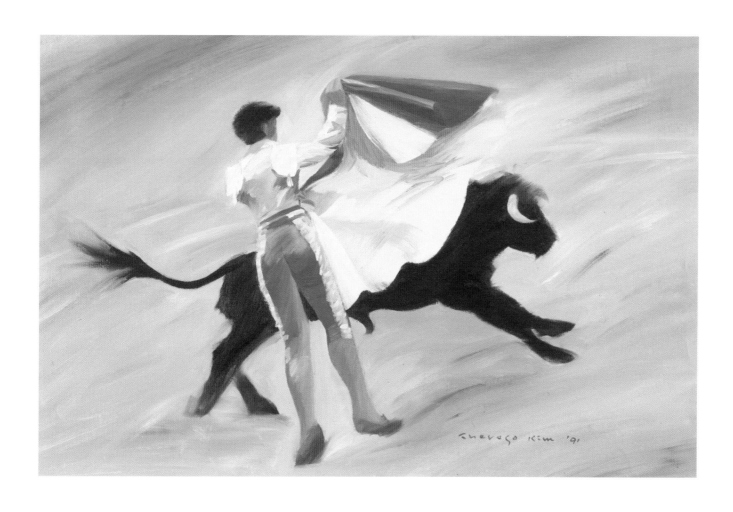

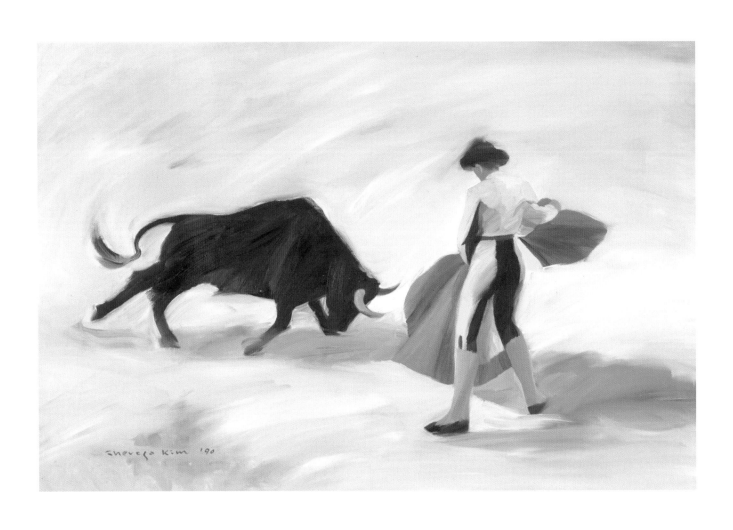

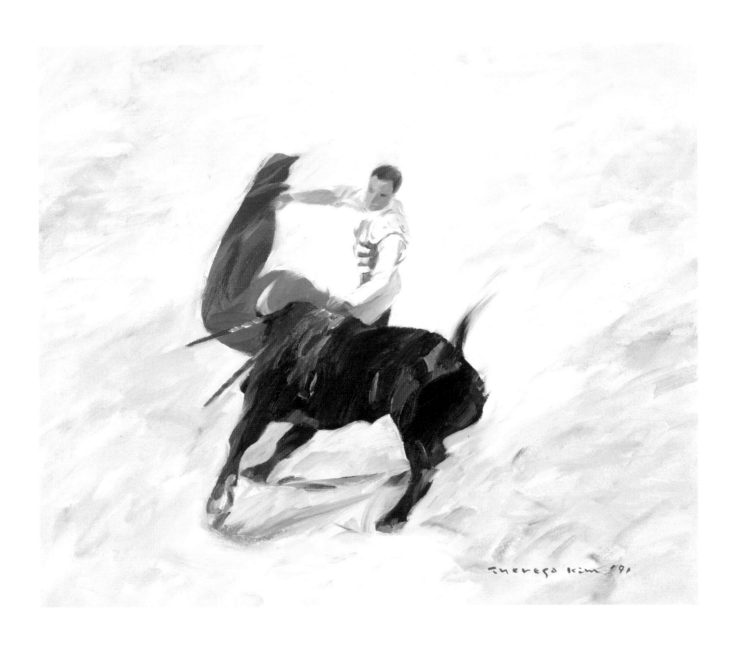

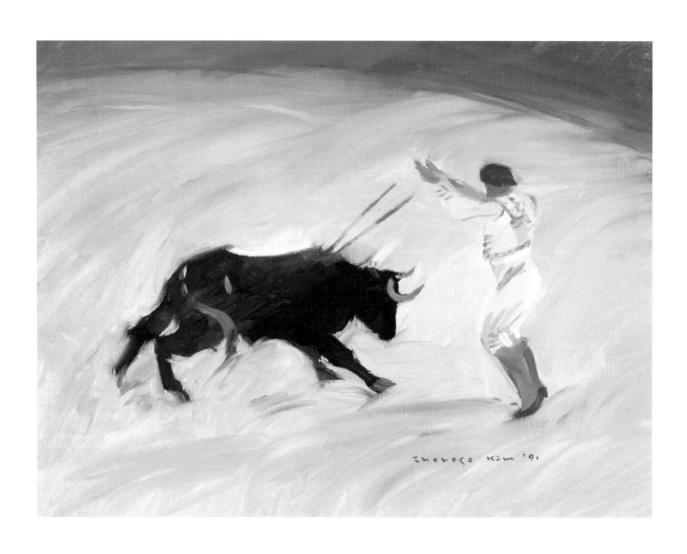

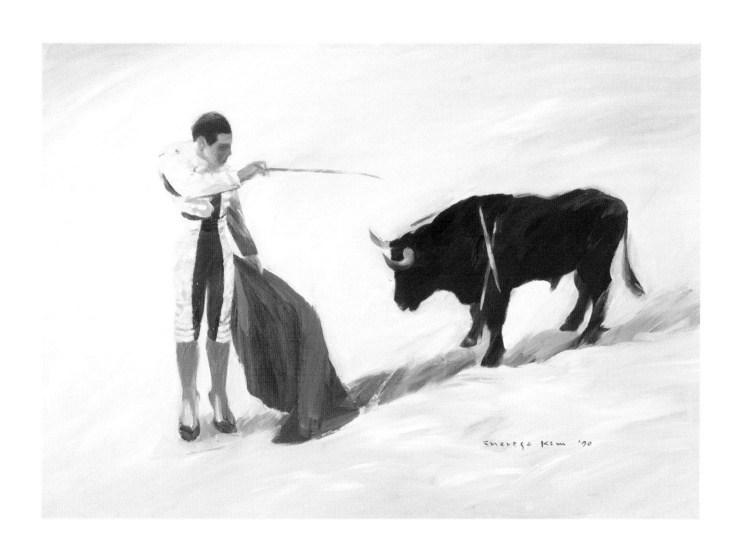

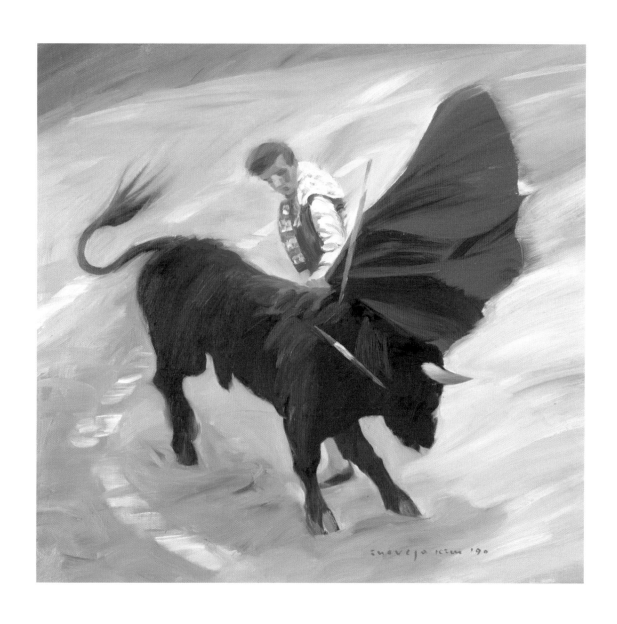

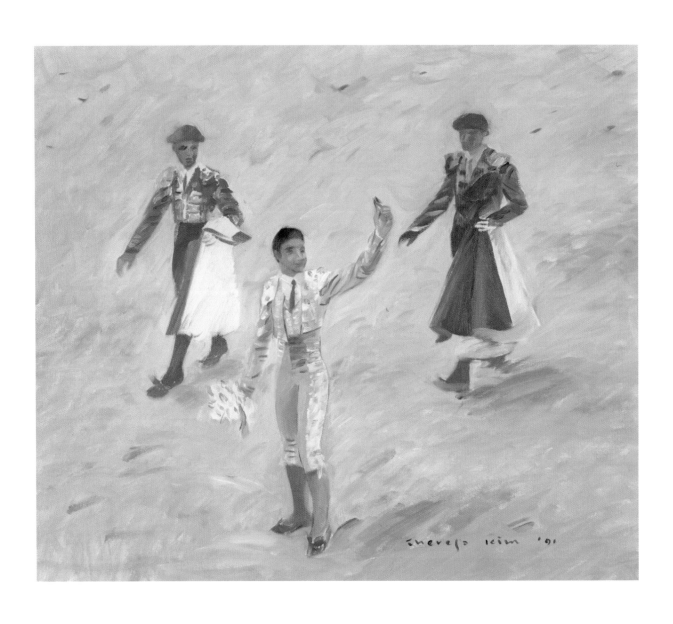

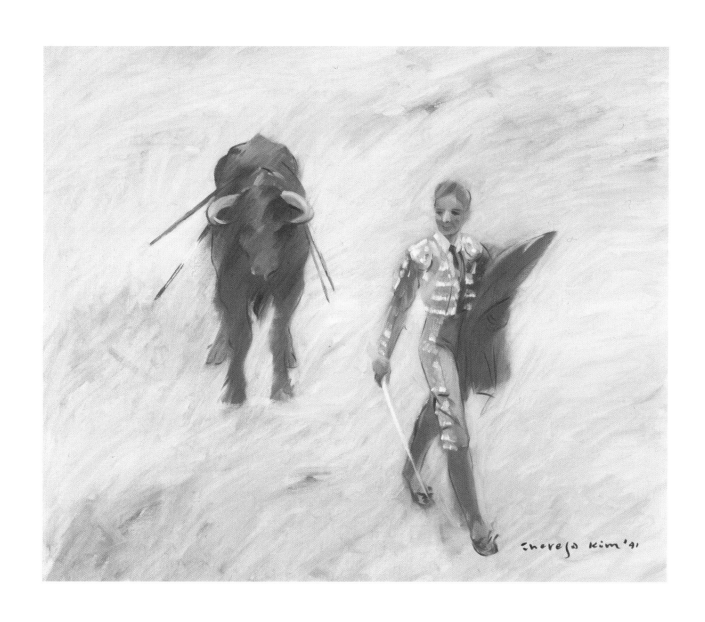

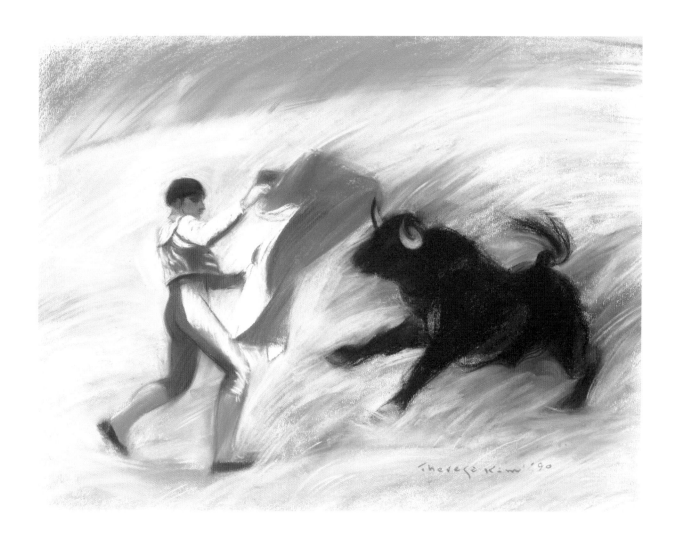

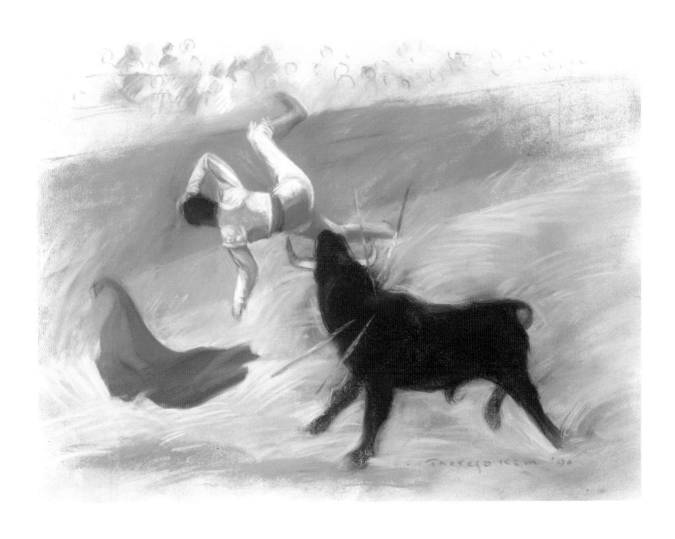

Theresa Kim '90

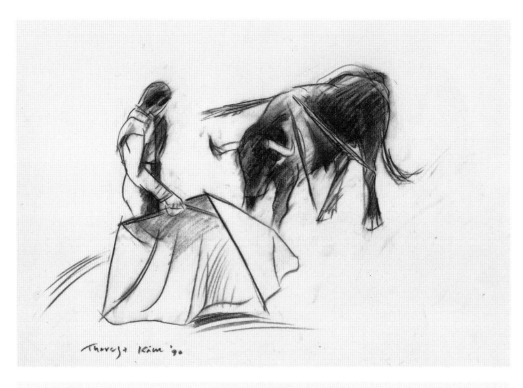

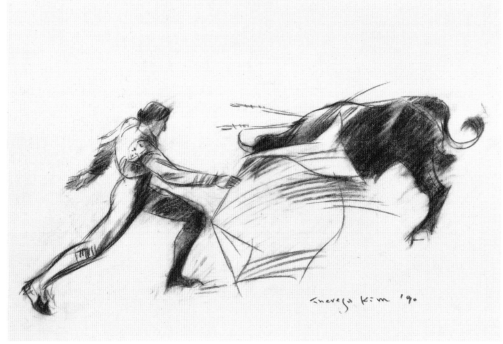

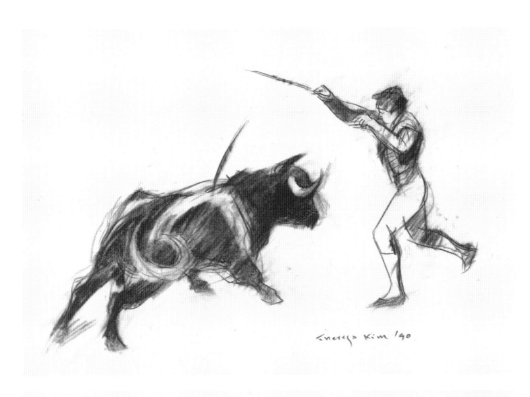

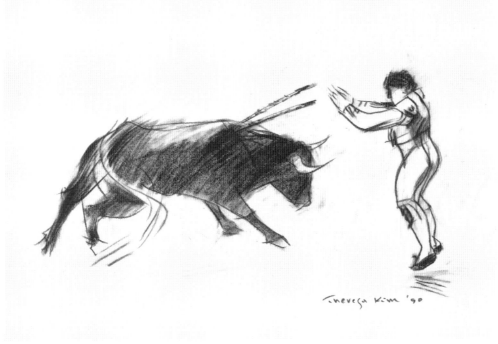

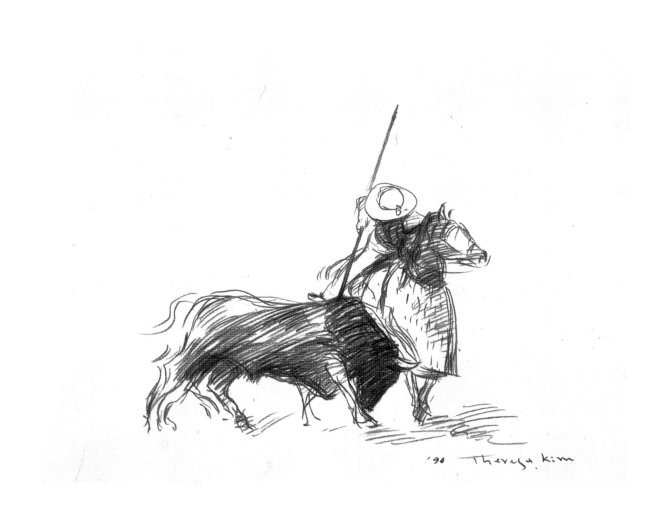

'90 Theresa. kim

4

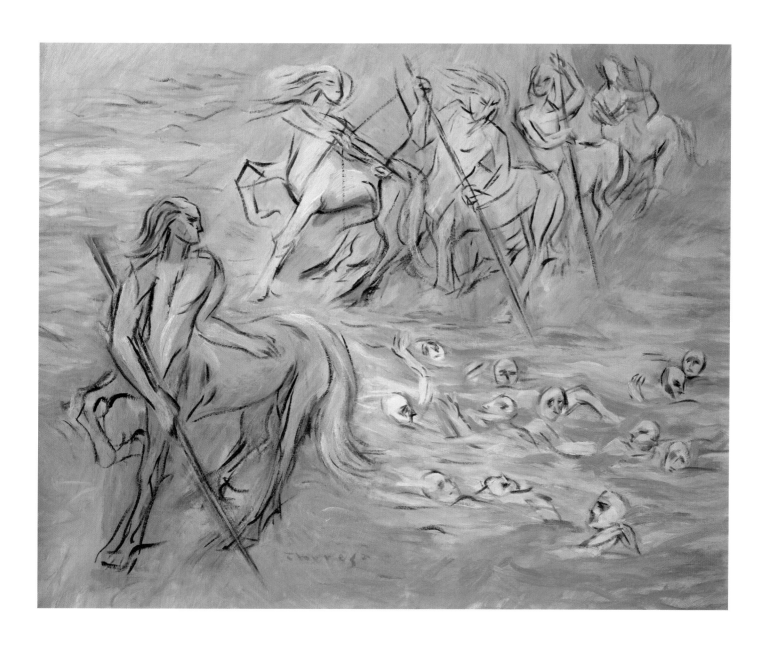

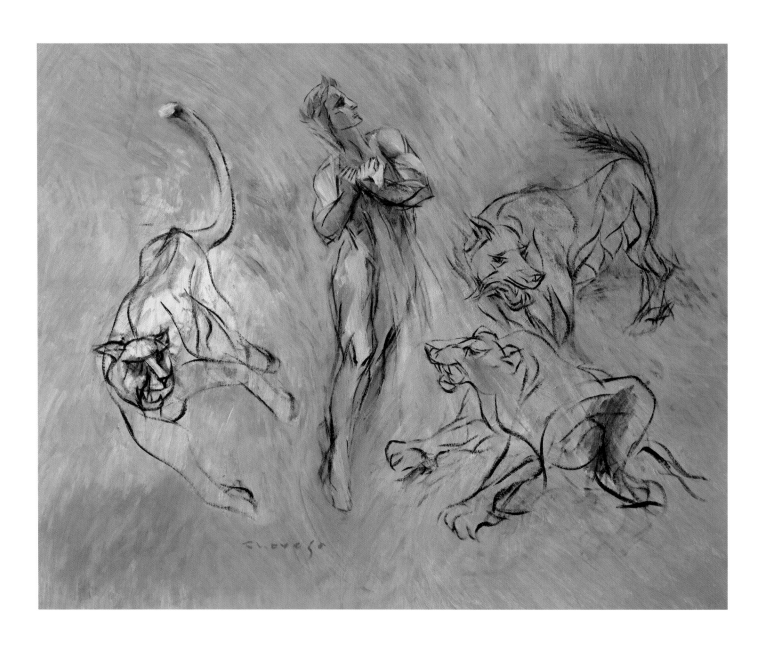

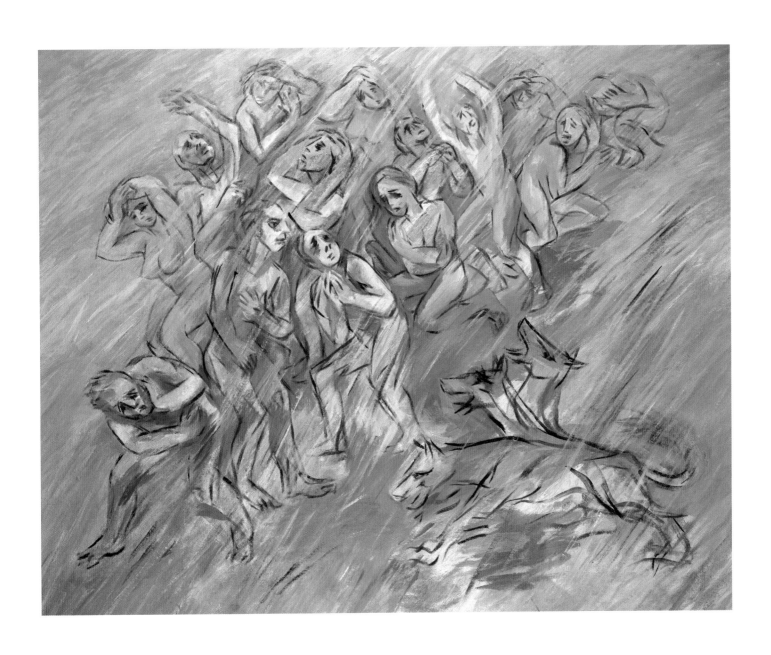

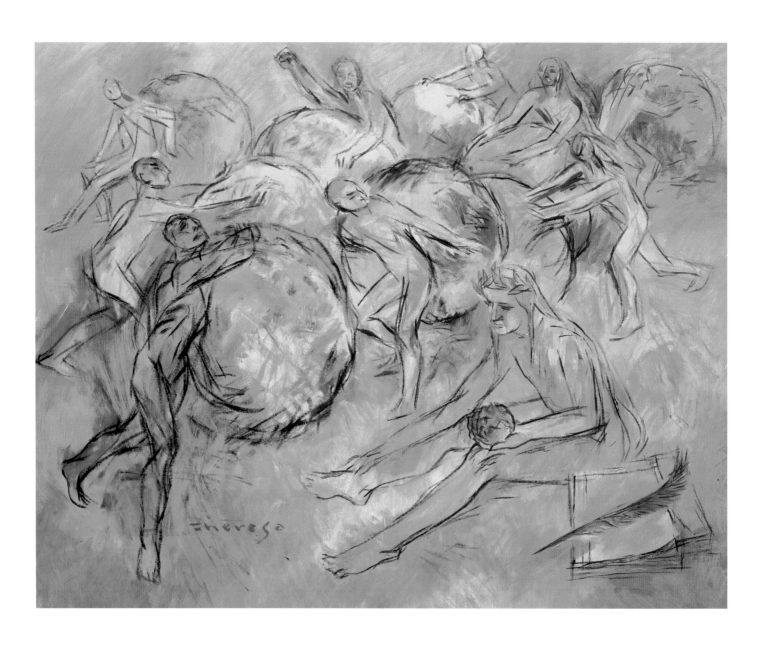

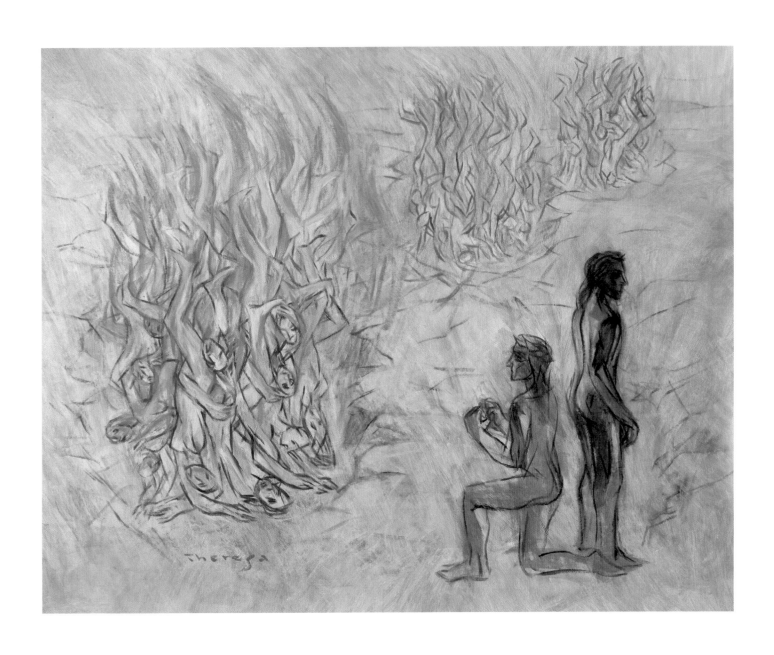

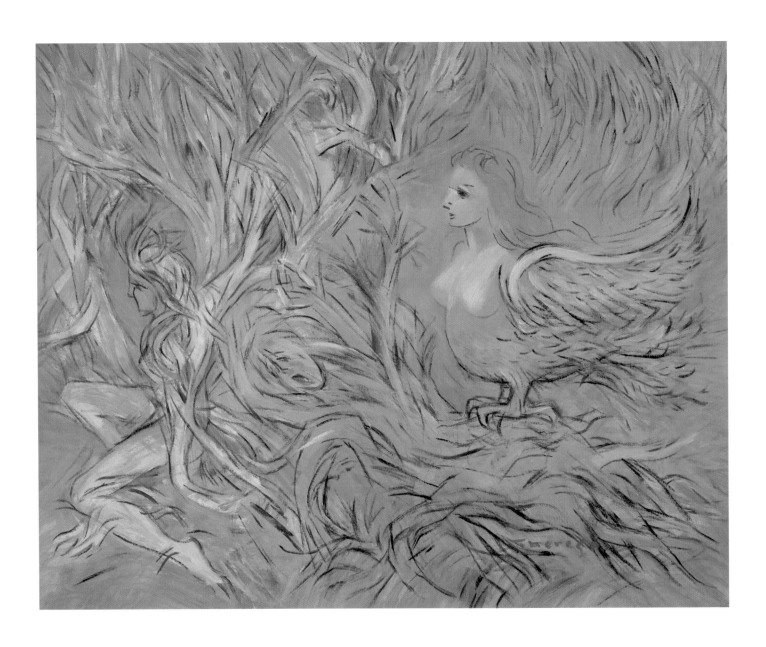

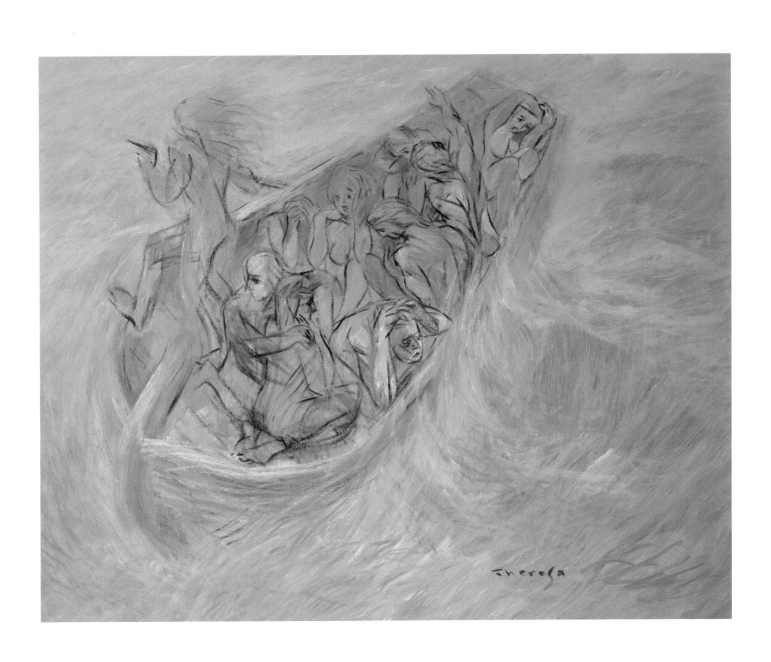

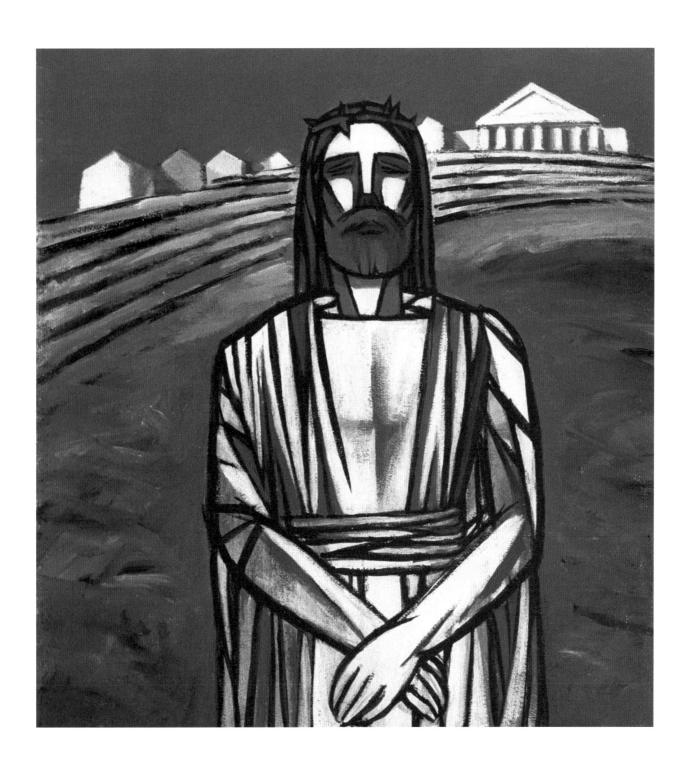

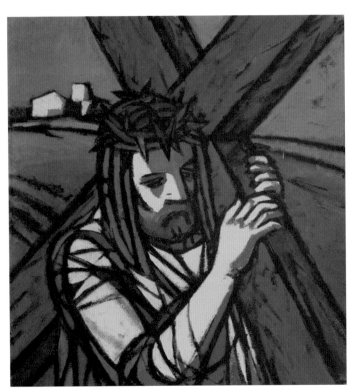 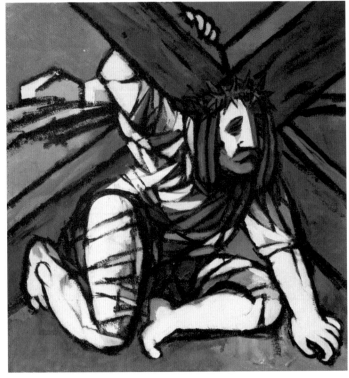

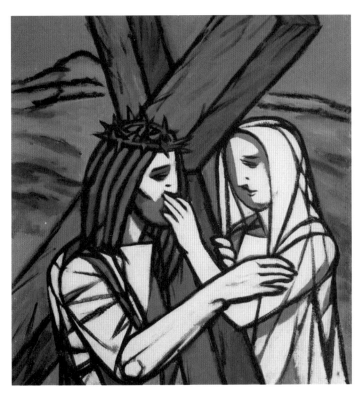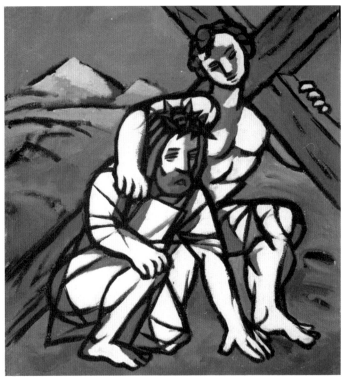

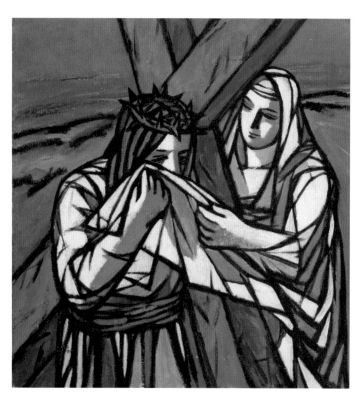
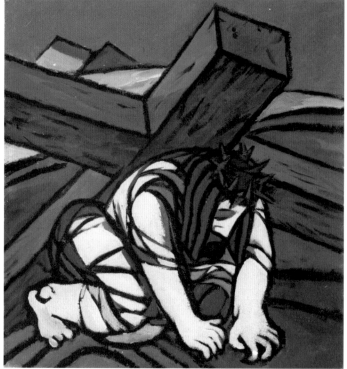

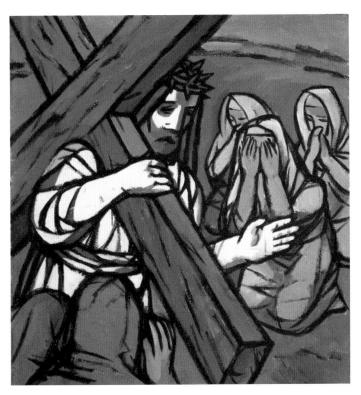
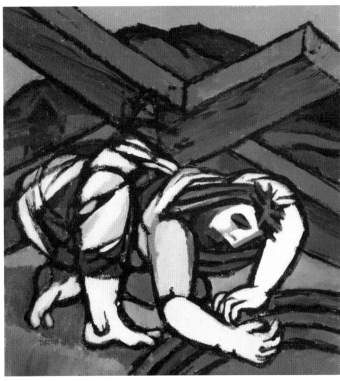

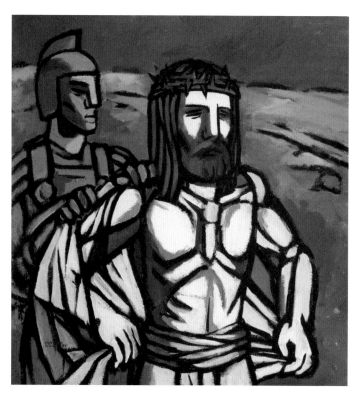 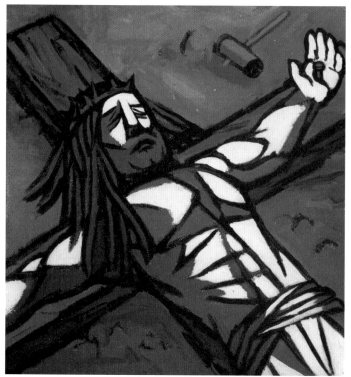

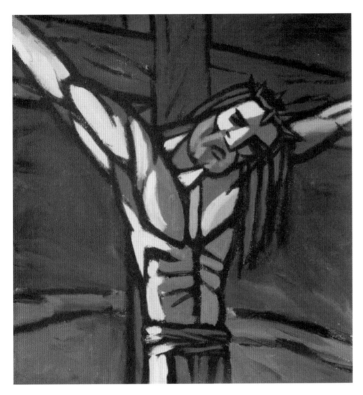 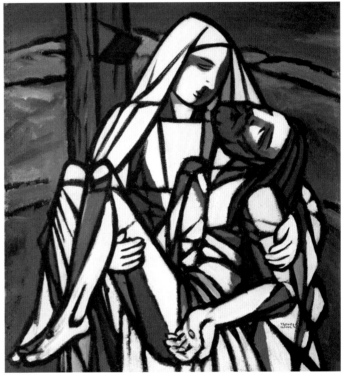

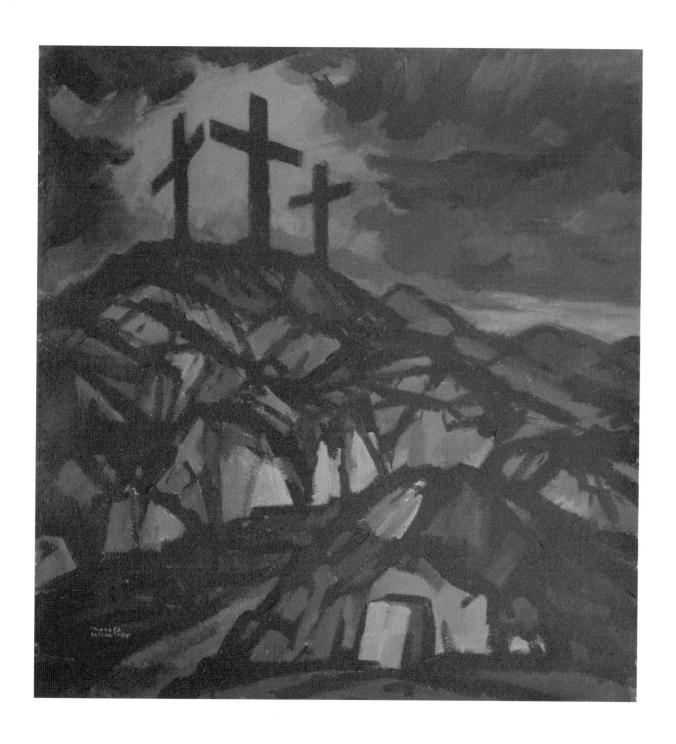

293

김테레사를 말하다
Essays on Art of Theresa Kim

자유로운 발상과 원색의 향연

이경성李慶成 미술평론가

1979년 12월 뉴욕에 갔을 때의 일이다. 마침 해외에 살고 있는 한국인 화가들의 동태를 살피고 화실을 탐방하는 일을 하고자 뉴욕 주변의 여러 화가들의 화업畫業을 조사하였다. 그러한 어느 날 뉴욕에 살고 있으면서 그림을 그리고 있는 김테레사의 화실을 탐방했다.

김테레사는 숙대에서 교육학을 전공하고 같은 대학원에서 교육학 석사를 받은 사람이지만, 재학시절부터 사진에 뛰어난 재질이 있어서 숙미전淑美展의 핵심 멤버로 여러 공모전에 입상하고 사진작가로서는 꽤 이름이 난 사람이었다. 그러한 그가 뉴욕으로 옮기고 나서부터는 그림으로 전신轉身하고 프랫 인스티튜트 대학원 과정에서 이 년간의 수업을 마쳤던 것이다. 재학시절에는 독특한 개성과 강한 표현으로 말미암아 두각을 나타내고 졸업전 때에는 장래가 촉망되는 화가로서 지도교수들의 기대를 모았던 것이다.

김테레사의 화실은 차이나타운을 거쳐서 다리를 건너는 섬에 위치하고 있었다. 한적한 주택가의 아담한 이층집인 그의 집을 들어서니 온통 집안이 작품으로 가득 차 있었다. 별로 화실을 꾸미지 않고 집 전체를 제작장으로 쓰고

Free-spirited Ideas, Feast of Colors

Lee Kyung Sung Art Critic

It was back in December, 1979 and I was on a trip to New York. I had been looking into the work of various Korean artists in New York as part of a project to examine the careers of Korean artists working overseas by visiting their studios, and one day, found myself at the studio of Theresa Kim, a painter living in New York.

Theresa Kim had majored in education as an undergraduate at Sookmyung Women's University, and earned a master's degree in the field at the same university, but she had also displayed an outstanding talent in photography as a student, winning many contests as a member of the university photography club and soon establishing herself as an artistic photographer in Korea. After moving to New York, however, Kim had taken up brushes and paints and completed two years of graduate coursework at the Pratt Institute. At Pratt, Kim had stood out thanks to her originality and intense artistic expression, and was praised at the graduation exhibition by her professors as a promising artist.

Theresa Kim's studio was then located on an island, reached by passing through Chinatown and crossing a bridge. When I entered the cozy two-story house situated in a quiet residential area, I saw that it was filled

있는 것 같았다. 집에 들어가는 순간 모든 작품들이 일제히 나에게 덤벼든다. 그것은 강렬한 색채와 대담한 구성, 그리고 자유로운 환상의 힘들이 전체가 되어서 눈 속으로 뛰어들었기 때문이다.

나는 우선 슬라이드를 통해서 그의 재학시절의 작품과정을 하나하나 더듬어 갔다. 프랫 인스티튜트의 입학 시부터 졸업까지의 모든 작품에는 하나의 강렬한 리듬이 흐르고 있었다. 그것은 여성이라고 생각하기 어려울 정도로 강력한 표현과 자유로운 발상이다. 순간 나는 도대체 이와 같은 조형의 힘이 어디에서 오는지 생각해 보았다. 그것은 다행하게도 한국에 있을 때 미술에 빠지지 않고, 미국에 건너가 비로소 미술에 몰두하였다는 데서 오는, 선입관의 부재에서 오는 대담한 행위인 것이다.

그와 같은 구체적인 예로는 철사와 같은 강한 힘을 지니고 있는 데생력도 문제이거니와 한국사람이 빠지기 쉬운 백색에의 함정과 중간색에서의 탈출을 지적할 수가 있다. 김테레사는 아무 부담 없이 원색의 세계에 뛰어들었던 것이다. 그같은 원색의 세계는, 굳이 그의 체질 속에 잠재해 있는 한국적인 원인을 든다면 민중의 생명 속에 살아 있는 원색의 세계, 예컨대 민화民畵의 색감이나 단청의 색깔 같은 것을 들 수가 있다.

이날 본 그의 작품은 데생과 수채화, 그리고 유화 등이다. 그의 데생은 도저히 가냘픈 여자가 그렸다고 믿기 어려울 정도의 강인한 발상과 수법으로 이루어지고 있다. 어찌 보면 마티스의 데생을 방불하는 것이지만, 그것보다는

with her work. It seemed that instead of setting up a single room as a separate studio, she was using the entire house as her workshop. As soon as I crossed the threshold of the house, every single artwork seemed to hurl itself toward me. The combined force of the vivid colors, the bold composition, and unfettered fantasies leaped into my eyes.

I first went over the slides from Pratt, fumbling to get a sense of each of the different phases of her work. A single powerful rhythm was running through every piece completed between the start and the finish of her program. Her work showed powerful expressions and free-spirited ideas not often found in female artists. I tried to understand where such visual force came from. Her bold approach probably resulted from the absence of any preconception since, fortunately, she had not fully devoted herself to painting in Korea and began concentrating on her art only after moving to the States.

Specifically in her drawings, her intense, wiry lines demonstrate her free-flowing techniques. Unlike many Korean painters who are apt to overuse white or neutral colors, she took up vivid colors without any inhibition. The world of primary colors might have been created by the Korean genius in her genes. Koreans, after all, have always embraced primary colors, as seen in folk paintings and the multi-colored decorations on traditional buildings.

The paintings I saw that day included drawings, watercolors, and oils. The drawings captured powerful ideas

분단된 선의 효과 위에서 선의 리듬을 지니고 있다. 데생이라기보다는 크로키에 가까운 즉화성卽畵性을 지니고 있기에 대상의 파악이 순간적이고 선에 생명력이 깃들어 있다.

수채화는 두 가지 현상으로 분류되는데, 하나는 달과 해, 나무와 새 같은 자연의 형상을 살린 구상적인 세계의 것이고, 또 하나는 기호나 부호 같은 기하학적인 문양을 그의 추상작업에 의해서 표현한 작품이다. 그 어떤 것이든 간에 그의 색채는 대비적이고 강렬했다. 마치 생명력을 지니고 있는 한국의 민화를 보듯이 말이다. 동시에 그들 수채화는 많은 설화성說話性을 머금고 있다. 무엇인지 모르지만 보는 사람에게 호소하고자 하는 많은 이야기들이 있었다.

유화는, 우연의 일치인지는 몰라도 초기 작품에는 남관南寬적인 형상과 이응로李應魯적인 형상이 엿보였다. 그것은 그들의 작품의 영향이라기보다는 한 화가가 내재적인 생명력을 외부에 방출할 때 조달할 수 있는 우연한 일치인지도 모른다. 그러나 우연한 일치는 뒤에서 온 사람에게 불리한 까닭에 그러한 경향에서의 탈출만이 그의 유화의 갈 길이었던 것이다.

이번에 개최되는 서울전展은 소묘와 수채화만을 다루었다. 그것은 미국에서 현대미술의 세례를 받고 뉴욕 화단의 새로운 감각을 몸에 지닌 화가 김테레사의 모국에 대한 가벼운 인사라고 생각할 수가 있다. 왜냐하면 다음번에 개

and techniques, which I could hardly believe were created by such a frail young woman. One might say they were evocative of Matisse's, but Kim's were unique in that a certain rhythm was generated by the effect of the broken lines. They could be called croquis drawings since they displayed an improvisatory quality, capturing the subject instantaneously with lines full of vitality.

Her watercolors were classified into two groups: the representational painting that illustrates the forms from nature such as the sun, moon, trees and birds, and the non-representational painting that uses abstract geometric forms such as signs or symbols. In both cases, her colors were vivid and powerful, showing strong contrast, as in Korean folk paintings that overflow with vitality. At the same time, these watercolors were narrative in content, containing many stories, mysterious yet appealing.

It may be a coincidence, but in Theresa Kim's early oil paintings one can see forms resembling those of Nam Kwan and Lee Ungno. This is probably the kind of coincidence that can be produced when an artist expresses her inner vitality to the outside world, rather than reflecting the actual influence of those artists'works. But as such coincidences disadvantage the person who comes later, the path for her oil paintings to take was to escape from that tendency.

The current exhibition in Seoul consists of drawings and watercolors. This can be considered a gentle greeting to her motherland from an artist who has been baptised into the contemporary art world in America

최될 그의 유화전이야말로 한 화가로서 한국 현대 화단에 정식으로 등장하는 계기가 되기 때문이다.

최근에 외국에서 공부를 하고 돌아오는 젊은 화가들이 꽤 많다. 그러한 화가 중에서 김테레사는 강렬한 인상의 데 생과 원색의 향연을 보여 준 수채화로써 그의 개성을 엿보였던 것이다. 그중에서도 수채화로써 추상회화를 기도 한 것은 전에도 없었던 새로운 현상이다. 그러나 돌아온 모든 젊은 화가에게 적용되듯이, 화가 김테레사의 경우도 이제 막 한국 화단에 첫발을 디뎌 놓았다는 것이다. 그가 앞으로 어떻게 성장하고 전개하느냐는 것은 전혀 앞으로 의 그의 노력과 능력에 달려 있는 것이다.

* 1980년 5월 선화랑에서 열린 개인전에 맞춰 씌어진 글임.

and absorbed the new sensibility of New York's art scene. The oil painting exhibition that will be held next time will provide the occasion for Kim's full entry as an artist in the contemporary Korean art scene.

In recent days, a large number of young artists who studied abroad have come back to Korea to settle down or to hold exhibitions. Among them, Theresa Kim clearly displays her individuality in the form of sketches that give a powerful impression and watercolors busting with the feast of primary colors.

Among Kim's works, her venture in abstract watercolor painting was a new phenomenon that had not existed before. But like all the young artists who come back to Korea, Theresa Kim has now taken her first step into the Korean art world. How she may grow and develop in future depends entirely on her own efforts and abilities.

* This essay was originally written in May of 1980 for the solo exhibition held in Sun Gallery, Seoul.

화사한 색채와 경쾌한 구성

오광수吳光洙 미술평론가

김테레사의 화면엔 구상具象과 추상抽象이 공존해 있다. 구상과 추상이 동일한 화면 속에 있다는 것은 그만큼 역설적으로 들릴지 모르나, 가령 구상적 추상이라든가 추상적 구상이라고 했을 때 충분히 가능한 내용이다. 동시에 두 개의 이질異質한 표현방법이 혼재한다는 것은 어디에고 구애되지 않는 표현의 진폭을 말해 주는 것이기도 하다. 굳이 구상이니 추상이니 하는 개념 속에 속박되지 않기 때문이다.

그의 화면을 보고 있으면, 거기 분명 느낄 수 있는 자연적 소재들이 명멸하면서도 그것을 굳이 설명하려고 하지 않는다. 한편, 순수한 색채와 구성의 즐거움이 화면을 누비지만, 거기엔 언제나 자연으로부터 오는 감동이 부단히 점철된다. 순수한 색채들로 구성되는 조형적 질서이면서도 그 속엔 자연적 요소들이 부담 없이 끼어들고 있다. 아니 끼어든다기보다 색채와 구성의 질서 속에 자연스럽게 태어난다고 말해야 좋을 것이다.

김테레사는 화가로서보다 먼저 사진작가로 활동했으며, 이 방면에서 명성을 얻었다. 회화는 사진을 하는 한편에서 새롭게 시작된 작업이라고 할 수 있다. 이미지를 추구한다는 그 본래적인 출발에 있어 회화와 사진은 대단히 유

Brilliant Colors and Sprightly Composition

Oh Kwang Soo Art Critic

In Theresa Kim's paintings co-exist figuration and abstraction. That figuration and abstraction are seen at the same time in the same picture plane may sound paradoxical at first, though, in fact, such terms as figurative abstraction or abstract figuration are readily available in referring to any kind of painting works. It also means the wide range of expression the artist employs, and Kim, too, in her search for liberation, declines the definitive concept regarding either figuration or abstraction.

Without the attempt for explanation, certain objects in nature are frequently found and clearly felt in her paintings. Pure colors and delightful compositions fill the plane, accompanying the moving impressions from nature. In other words, elements in nature interfere with the formative order created by pure colors with such naturalness. Nay, it'd be better to say that they are born most naturally from the orders established between colors and composition.

Before she began painting, Theresa Kim was a photographer with reputation. For her, painting is a relatively new sphere of work after her long career as professional photographer and she recognizes well enough that, for all their shared origins to pursue the images, painting and photography show a sharp difference in

사한 관계에 있으나, 그것의 표현방법에 있어선 현격한 차이를 드러낸다. 그러니까 사진에서 출발해서 다시 회화를 시도한 그의 경우에는 쉽게 사진의 연장선상에서 회화를 보게 하는 선입견이 작용될 수 있다. 그러나, 그의 회화작업을 보는 이는 사진과 별개의 길과 별개의 방법의 진전임을 확인할 수 있다. 즉 사진작가로서의 김테레사와 화가로서의 김테레사는 별개의 것이란 것이다.

사실 그럼에도 그의 화면에 포착되는 재빠른 인상의 종합은 아마도 오랜 사진작업의 체험과 관계되는 것이 아닐까 생각된다. 재빠른 인상의 종합이란, 일종의 순간의 포착, 강렬한 인상의 해석을 말하는데, 그러한 요소가 회화에 등장했다고 했을 때 이는 다분히 사진 작업의 체험에서 오는 극히 자연스러운 변형이라고 볼 수 있기 때문이다. 설명적인 것이 제거되고 순수한 인상의 극대화로 나타나는 표현방법상에서 특히 그러한 체험관계를 떠올리게 한다. 설명이 제거된다는 것은 일종의 요약의 작업이요, 개념화의 인식이요, 추상화의 과정이다. 구상적 추상이란 말이 가능한 근거가 여기에 있다.

그러면서도 대상성이 완전히 지워지지 않을 때 거기에 나타나는 것은 일종의 기호화의 작용이다. 기호는 설명이 극도로 억제되면서 나타나는 상형화의 단계이다. 그의 작품에서 이 기호들은 몇 가닥의 화사한 색채의 선묘로 겹치는 구조체로 나타난다. 토막지면서도 리드미컬한 구비의 겹침으로 나타나는 이 독특한 색채구조는 화면 전체에

their expressive methods. As such, she is always conscious of the potential risk to make her painting as the mere extension of photography. In her endeavor to avoid this, one is eventually to confirm that Kim as artist is wholly different from Kim as photographer.

And yet, the overall impressions of her speedy planes seem to have something to do with her experiences in photography. The capture of the instantaneous moment and the rendering of intense, powerful images naturally remind one of her former career. In particular, her expression to maximize the pure impressions to the exclusion of anything explanatory is closely associated with the photographic methodology. Putting aside explanation, what she is intent on is the process of recapitulation, conceptualization and abstraction. Hence such terms as figurative abstraction are aptly applicable to her works.

When the material character of object still lingers there, not wholly effaced, what appears is the interaction of signs. These signs, as a hieroglyphic stage with the utmost restraint of explanation, reveal the overlapped structure of linear descriptions with brilliant colors. Here the unique colors in fragmentary but rhythmical curves endow her whole plane with certain light-heartedness. Effused in the rich sensibility of the artist herself, they almost remind one of a certain delicate moment at which several couples in bright dance costumes make exquisite ensemble among themselves.

As such, no vestiges of seriousness or anguish are seen in her plane. To those who tend to interpret all

경쾌함을 자아내고 있다. 마치 화려한 무도복舞蹈服을 입은 몇 쌍의 무리들이 어우러져 있는 다감한 한순간을 연상시키기도 한다. 아마도 생에 대한 작가의 솔직한 감정이 아무런 제약도 받지 않고 그대로 쏟아져 나오고 있기 때문일 것이다.

그럼으로 해서 화면엔 심각함이나 고뇌의 흔적이 보이지 않는다. 화가의 작업을 너무 무거운 자의식으로 해석하려는 사람들에겐 그의 작품이 너무 단조로울지 모른다. 그러나 자연을, 세계를 보다 솔직하게 보고 감동하는 이들에게 그의 작품은 많은 공감을 줄 것이다. 다감하면서도 명징한 꿈의 세계로 이끌어 가는 그의 작품이 주는 매력은 쉽게 지나칠 수 없을 것이다. 더더욱 날로 심각해져 가고 우울해져 가는 병리적인 사회 심리의 지평에서 보았을 때, 그의 화면은 우리에게 자연을 보는 명랑한 또 하나의 방법을 시사하기에 충분하다고 할 수 있다.

* 1996년 9월 박영덕화랑에서 열린 개인전에 맞춰 씌어진 글임.

artistic works as something of the grave self consciousness, her works strike as too simple or even monotonous. On the other hand, those who see or feel the world of nature as candidly as it is will elicit much sympathy from her works. The attraction of her works that lead the viewers to this rare world of dreams and fantasies in such delicate, lucid terms is not something to be overlooked easily. Indeed, amidst the social pathology nowadays that incites more of the graveness and gloominess which are already rampant, her paintings suggest a fresh way of appreciating nature in all its inherent brightness.

* This essay was originally written in September of 1996 for the solo exhibition held in Galerie Bhak, Seoul.

곡마단 인생—공중그네 밑에 분칠한 얼굴

김영태金榮泰 시인

그들은 누구란 말인가? 이 유랑의 예인藝人들은.

아무나 분장할 수 없는 것이 피에로의 얼굴이다. 또 아무나 맡을 수 없는 것이 피에로의 역할이다. 피에로, 그는 누구란 말인가. 그는 이 세상에 태어날 때부터 슬픔의 몫을 안고 탄생한 자이다. 그는 이름이 없다. 아니, 이름 같은 게 무슨 소용이 있으랴. 그는 유랑인이고, 자유인이고, 소외당한 자, 그들 중에 맨 마지막 구성에 남은 향기이고, 슬픔 덩어리이고, 울면서 겉으로는 남을 웃겨야 하는 비정한 생존자이다.

하지만 아무나 피에로가 될 수 없듯이, 그들의 성역聖域을 침범할 수도, 침입해서도 안 된다. 그에게는 이름이 없지만, 그러나 그에겐 배역이 주어지고 성격이 부여된다. 우연히 거기에 있는 단역이 아니라(주역이면 어떠냐) 숙명적으로 맡은 배역을 완수해야 한다. 고깔모자를 쓰고, 눈썹을 그리고, 주먹코를 붙이고, 자주색 입의 과장된 그 회떡 같은 우스꽝스러운 얼굴은, 그래서 이미 자기의 신분을 감춘 지 오래다.

곡마단에 모인 아이들에겐 친절하고, 노인들에겐 공손하며, 여자들에겐 일부러 밉상인 그, 그러나 피에로는 왜

Circus Life: A Made-up Face Below the Trapeze

Kim Young-Tae Poet

Who are they, these wandering artists?

Not just anyone can be made up with the face of pierrot. And not just anyone can take the role of pierrot. Who is pierrot? He is a man born to embrace the portion of sadness from the moment he enters the world. He has no name. What use would a name be? He is a wanderer, a free agent, an alienated subject, the scent that remains when the last of them is formed, a bundle of sorrow, a heartless survivor who has to make others laugh even while weeping within.

But just as not just anyone can become a pierrot, we must not invade or intrude on their sanctuary. Although he has no name, he is given a role and a character. It may not be even a minor role, let alone a major one, yet he must perform the role that fate has given him. With his peaked hat, his drawn-on eyebrows, his round clown's nose, his purple mouth, and his exaggeratedly comical pasty face, he has been hiding his identity for a long time.

He is kind to the children who come to the circus, polite to the elderly, deliberately obnoxious to the women, yet he knows why he remains as an unknown figure and not as the flower of the circus.

자기가 곡마단의 꽃으로 남지 않고 무명으로 남아 있는지를 안다.

화려한 공중 묘기 뒤에 그는 사이사이 막간에 나와 경직되고 긴장된 관객들을 편안히 어루만진다. 일부러 자빠지기도 하고, 촌극에서 핏대를 내며…. 그러다가 어린 양羊처럼 금세 풀이 죽기도 한다. 피에로의 얼굴은 그래서 '천의 얼굴'이다. 쇤베르크A. Schönberg의 「달빛 아래 어릿광대」를 들을 때 나는 그 천의 얼굴 중에 한 슬픔 덩어리의 분신과 만난다.

'우연히 거기에 있는 자'가 내게 부여된 시인의 몫이라면, 피에로의 배역은 이미 태어날 때 정해졌을지도 모른다. 다만 나는 공방工房에 은둔해 있거나 구석에 있다. 그러나 그는 대중 앞에 모습을 나타내고 달빛 아래 홀연히 사라진다. 누군가 지금 울고 있다. 세계의 어느 곳에서. 라이너 마리아 릴케Rainer Maria Rilke는 그렇게 탄식했다. 그러나 어떤 역경에 처해도 그는 눈물을 보이는 법이 없다. 슬픔은 언제나 새로운 것이다. 이런 역설이 가능하다면, 슬픔은 누구의 말대로 다른 슬픔과의 약속인지도 모른다.

내가 미대 다닐 때 그린 첫 작품이 '피에로'였다. 두 나부裸婦 사이에 서 있던 피에로, 그때부터 내 머릿속에는 언제나 가설무대가 펼쳐지곤 했다. 1957년도부터 지금까지 나는 얼마나 많은 피에로를 소묘했던가. 내가 낸 책 본문 안에, 혹은 시집 표지에, 전람회, 그리고 써 보낸 편지 여백에, 하찮은 종잇조각 위에….

After a dazzling flying trapeze act, he comes out in the interval to make the tense and nervous audience more comfortable. He falls down on purpose, gets angry in a comic sketch.... Then like a little lamb he soon gets disheartened. That's why pierrot's face is "the face of a thousand." When I hear A. Schönberg's *Pierrot Lunaire*, I meet, among those thousand faces, the alter ego of a bundle of sorrow.

If my role as a poet was given to me by "someone who happened to be there," the role of pierrot was perhaps already cast from birth. I just hide away in my studio or in some corner. But he shows himself before the public and then suddenly disappears in the moonlight. Someone is crying right now, somewhere in the world. That was the lament of Rainer Maria Rilke. But no matter what hardships he faces, pierrot never shows his tears. Sadness is always new. If that paradox is possible, then perhaps sadness, as someone once said, is a contract with a different sadness.

When I was at art school, the first picture I drew was called *Pierrot*. Ever since then, the image of pierrot standing between two naked women has constantly been replayed on the makeshift stage in my head. From 1957 to the present day, how many pierrots have I drawn? In a book of mine, on the cover of a poetry collection, at an exhibition, in the margin of a letter, on an unimportant piece of paper....

One day in August, when I met Theresa Kim, who flew in from New York several times a year, petite and pretty like a silent movie actress with her long raised eyebrows, she showed me 38 circus scenes. I seemed

8월 어느 날, 일 년에도 두서너 번 뉴욕에서 날아오는, 쪼그맣고 예쁜, 눈썹이 길게 치솟아 무성영화 시대의 배우 같은 김테레사를 만났을 때, 그는 서른여덟 점의 '곡마단 풍경'을 내게 보여 주었다. 그들이 왜 엽서 두 배 크기 속에 모습을 나타내야 하는지, 나는 알 것도 같았다. 테레사가 이국 땅에서 열 일을 제치고 곡마단을 매일 찾아간 것도 어렴풋이 짐작이 갔다. 공중그네에서 꽃이 지다 멎듯, 꽃의 발목을 꽉 잡고 회전하는 억센 손목도 보였다. 난장이가 튀어나오고, 말이 달리고, 코끼리가 뒤뚱뒤뚱 걷고, 빈 그네가 바람을 가르며 천장으로 올라가고, 어름사니가 줄을 타고 입으로 불을 삼키며, 꼬챙이로 접시를 돌리는 마술사, 채찍을 든 사육사 앞에서 으르렁거리는 사자 울음이 들린다. 그러나 테레사가 곡마단에 개근한 것은 그런 주역이나 조역이 아닌 집단 속의 소외자 피에로를 만나러 갔을 것이다.

나는 테레사에게 '울므'가 어딘지 아느냐고 물어보았다. 그는 고개를 흔들었다. 나도 지도상에 울므가 어디에 있는지 알 수 없다. 울므는 피에로가 그나마 주어진 단역도 힘에 겨울 때 향하는 떠돌이의 마지막 귀착지이다. 페터 오토 코체비치Peter Otto Kochevich의 「여행」이란 시에는 울므가 나온다. "나는/ 그 기차를 타고 울므를 향해 여행하였다." 울므행行은 이렇게 시작된다. 그리고 같은 말이 계속해서 행을 바꿔 반복되다가 다음 두 행으로 끝난다. "이제 나는 울므에 있다./ 나는 여기서 무엇을 해야 하나?" 나의 수첩에는 몇몇 피에로들의 이름이 적혀 있다. 머

to understand why they had to show themselves within the size of a couple of postcards. I also dimly intuited why Theresa had made time amid her busy schedule in a foreign land to go to the circus every day. She showed me her strong wrists holding the ankle of a woman as if to stop her falling from the swinging trapeze. The midgets jump out, the horses gallop, the elephant walks heavily, the empty trapeze slices through the air as it soars up to the roof, the tightrope walker swallows fire, the magician spins plates on rods, and the lion roars at the tamer with his whip. But it was not to see these starring and supporting roles that Theresa kept going back to the circus. It was to see the outsider within the troupe, pierrot.

I asked Theresa if she knew where Ulm was. She shook her head. I have no idea where Ulm is myself. Ulm is the final destination of the wanderers, where pierrot tries to go when he is struggling to fulfill even he trivial role that is given him. "Ulm" is mentioned in Peter Otto Kochevich's poem *The Journey*. "I took that train and set off for Ulm." That is how the Ulm part begins. Then after repeating the same words with some changes, it ends with the following two lines. "Now I am in Ulm. What should I do here?" The names of several pierrots are written in my notebook. Soon they too will arrive in Ulm. Don't ask where Ulm is. That is a foolish question. Perhaps the unknown place where death awaits us, the hiding place where I too must go in the end, may be Ulm.

Along with Marcel Marceau, Rolf Scharre, Helfried Foron, Jean-Louis Barrault, and Madeleine Renaud, are

지않아 그들도 울므에 도착할 것이다. 울므가 어디냐고 묻지 마라. 그것은 어리석은 일이다. 죽음이 예비된 낯선 장소, 나도 결국 가야 할 은신처가 울므일지 모른다.

마르셀 마르소Marcel Marceau, 롤프 샤레Rolf Scharre, 헬프리트 포론Helfried Foron, 장-루이 바로Jean-Louis Barrault, 마들렌 르노Madeleine Renaud 옆에 젊은 김성구金成九, 유진규柳鎭奎, 김동수金東洙, 기국서奇國敍, 죽은 함현진咸賢鎭의 이름도 적혀 있다. 다시 한번 나는 그들이 맡았던 배역을 상기하고 싶다. 마르셀 마르소의「나비」, 롤프 샤레의「어느 가정의 저녁 한때의 독신자」, 헬프리트 포론의「새」, 장-루이 바로의「인생유전」(원명「꼭대기 좌석의 사람들」), 마들렌 르노의「오, 행복한 날들이여」를, 그리고 김성구의「수중시계」, 유진규의「아름다운 사람들」, 김동수의「숙련공」, 기국서의「햄릿」, 함현진과 김성옥金聲玉이 출연했던「고도를 기다리며」무대를….

외람되지만, 나도 그들 뒤꽁무니에 여분으로 끼워 준다면, 나는 이런 모습으로 막간 사이에 등장하고 싶다. 주저 앉은 나무 뒤에 떠돌이들이 망연하게 하늘을 올려다보는 중이다. 멜빵 끝에 깔개를 매달고 먼저 바람이 어디서 불어 와 바람이 어디로 불어 가는지 콧김을 벌름거리며 손가락에 침을 발라 허공에 휘저으면서, 빠따띠 빠따띠 시미미 시미모 끄시로 끄라라… 노래를 새기며…. 나는 성구와 진규를 위해, 그들의 헐렁한 마음만큼, 고락을 같이하기도 했다.「비」라는 단시가 곧 성구의 모습이다. 수염은 한 자나 바지통은 홈통 같았다. 목구두는 겉돌고 바람 부

written the names of young Kim Seonggu, Yu Jingyu, Kim Dongsu, Ki Gukseo, and the late Ham Hyeonjin. I want to recall once more the roles they played. Marcel Marceau in *The Butterfly*, Rolf Scharre in *A Single Person in a Family One Evening*, Helfried Foron in *The Bird*, Jean-Louis Barrault in *Propagation of Life* (original title *People of the Summit Seats*), Madeleine Renaud in *Oh, Happy Days*, and Kim Seonggu in *Clock in the Water*, Yu Jingyu in *Beautiful People*, Kim Dongsu in *Skilled Labor*, Ki Gukseo in *Hamlet*, and *Waiting for Godot* with Ham Hyeonjin and Kim Seongok.

Although it would be an undeserved honor, if I could be added to the end of that list, I would like to come out in the interval like this. The wanderers crouch behind a tree, gazing up vacantly at the sky. With a cushion hanging from the end of my suspenders, breathing heavily through my nose, I spit on my finger and hold it up to see which way the wind is blowing, then I hum a song, "ppatatti ppatatti simimi simimo kkeusiro kkeurara…." With Seonggu and Jingyu, I shared all the sadness and joy as I shared their baggy hearts. *Rain* was the image of Seonggu. His beard was long and his trousers as wide as drainpipes. His boots were too big, and with his expression of supreme indifference he looked like a toad. He threw away all artificiality of mind, just anywhere on the ground. Even if they were reborn, they….

Occupying an end seat, I was bound to become a pierrot too. The scarecrows that guard the fields come to me in the form of weeping. The birds fly, the wild flowers bloom, the rice ears rub against each other.

는 대로 휩쓸려 가는 대로 표정을 만들다 옴두꺼비 같았다. 만든 마음을 버렸다 땅바닥에 아무 데나. 다시 태어난다 해도 그들은… 말석을 차지한 나까지 피에로가 될 수밖에 없다. 들판을 지키는 허수아비들이 내겐 울음으로 다가온다. 새가 날고, 풀꽃이 엉켜 피고, 벼이삭들은 서로를 부빈다. 허수아비들은 분장만 지웠을 뿐이다.

지난 봄에 「사람」이란 무용을 관람했을 때 무대 앞으로 한 무리들이 지나간다. 표정이 다르고, 의상이 판이하고, 걸음걸이가 각양각색이다. 웃고 있고, 혹은 울고 있다. 정신 나간 채 떠밀려 가는, 대열에서 자꾸 처지는, 입술이 퍼런 멍새도 있다. 다시 한번 나는 후렴처럼 읊고 싶다. 대체, 그들은 누구란 말인가.

* 1988년 5월 조선화랑에서 열린 개인전에 맞춰 씌어진 글임.

The scarecrows have taken off their makeup, that's all.

Last spring, when I watched a dance called People, a group moved towards the front of the stage. Their expressions were different, their costumes were varied, their ways of walking were diverse. Some laughed and some cried. There was also a little runt with blue lips, pushed aside unawares and frequently falling behind the group. I want to recite it again like a refrain. Who on earth are they?

* This essay was originally written in May of 1988 for the solo exhibition held in Chosun Art Gallery, Seoul .

'투우' 연작의 신선한 표현시각

이구열李龜烈 미술평론가

김테레사는 이십 년 전에 뉴욕으로 가서 정착한 뒤에 화가가 되어 그간 서울에서도 여러 차례 개인전을 가진 바 있는 내밀한 감성과 선명한 독자성 추구의 여성 작가이다. 미국의 온갖 국제적 미술 기류와 시대적 사조를 접하고 자극을 받은 가운데에서도 자신 그림의 창작적 실현에 충실하려고 하였음이 분명한 내면을 그간의 서울 작품전 때마다 명료하게 엿볼 수 있었다.

이번 개인전은 올 가을의 바르셀로나 올림픽의 주최국 스페인의 상징적 국기國技인 '투우'를 연작한 유화, 파스텔화, 스케치 들을 단일 주제로 보여 주는데, 화면마다에는 작가 자신의 현장 체험이 생동감 넘치게 표상되어 있다.

이 전시의 초대자인 조선화랑은 사 년 전에도 세계주의자적인 위치와 그에 상응한 자유로운 예술정신의 작가인 테레사의 '피에로' 주제 연작을 초대 전시한 적이 있었다. 그 '피에로'에 이은 이번 '투우'의 연작은 두 주제성 자체의 극적 연관성 및 낭만성과 더불어 이 작가의 남다른 체질적 선택의 그림 소재와 화면창작의 여성적인 상념의 집착 및 자기충족을 잘 드러내고 있다.

Fresh Expressive Perspectives in Theresa Kim's Bullfight Series
Lee Ku-Yeol Art Critic

Korean artist Theresa Kim began her career as an artist after moving to New York 20 years ago and has since held many solo exhibitions back in Seoul, displaying works that express her innermost emotions and vivid individuality. Kim, while influenced and inspired by diverse international art currents and contemporary styles, has apparently exerted strenuous efforts to be faithful to her own creative style, which I could recognize in many of her Seoul exhibitions.

Her recent exhibition includes a series of oils, pastels, and drawings on the single theme of bullfight, the national sport of Spain, which happens to be the host country of this summer's Olympic Games in Barcelona. Each canvas delivers a sense of immediacy achieved through Kim's own observations of the sport.

Four years ago, Chosun Art Gallery, the host of her current show, invited Kim, known for her free-spirited cosmopolitanism to exhibit a series of her paintings on the theme of the pierrot. The new Bullfight series shares with the previous work a dramatic link as well as romanticism. They show the obsession and self-fulfillment in her unique choice of subject matter and her feminine visual representation of the subject.

In her previous exhibit, Kim sought to capture the playful jests, appearances, and expressions of clowns

서구문화의 연극이나 서커스에 등장하는 어릿광대 역할자인 '피에로'의 익살스런 놀음과 모습 또는 표정, 그리고 세상사와 인간사의 웃기는 풍자놀이 등을 예민한 미美의 감성으로 반응한 표현충동을 화면에 생생하게 담으려고 한 것이 연작 주제의 '피에로'였다. 그에 대해 작가 자신, "뉴욕의 메디슨 스퀘어 가든에서 본 세계적인 서커스의 피에로 모습에서 감동한 소재"라고 카탈로그에 써서 밝히고 있다.

작가는 또 어린 소녀 때부터 장고춤, 탈춤 등의 춤판과 곡마단 구경을 무척 좋아했었고, 무용을 직접 배우기도 한 그는 춤사위와 곡예사의 율동적이고 변화에 넘치는 몸짓의 감동을 그림으로 표현하고 싶었던 충동의 체험을 말하기도 한다. 근래의 '투우' 연작도 결국 그에 연결되는 소재인 셈이다.

연극적이고 곡예적인 미남 청소년 투우사가 찬란한 복장과 정열의 몸놀림으로 까만 털빛의 험상하고 야성적인 소와 긴장감을 고조시키는 싸움의 통렬한 상황을 현장에서 체험한 김테레사는, 그를 이색적인 미소년과 소의 장쾌하고 극적인 춤판으로 즐겁게 소재 삼고 있다.

'투우' 연작을 위해 테레사는 1990년과 1991년에 스페인의 유명한 베네수엘라 투우장과 멕시코의 칸쿤 투우장에 찾아가서 그 현장의 감동과 흥분을 마음껏 많이 스케치할 수 있었고, 그를 토대로 뉴욕의 화실에서 유채와 파스텔로 작품화시켰다고 한다. 그 화면들은 투우사들의 찬란한 입장, 투우사와 소와의 사전에 잘 훈련되고 각본된 쇼

lampooning mundane life and human nature with a keen sense of beauty. The artist herself says in the exhibition brochure that she took on the subject after being enchanted by one of the clowns in a world-class circus staged at the Madison Square Garden.

Kim also reminisces that she was always fascinated by Korean traditional mask dances, drum dances and travelling circuses, and took dance lessons as a child, which evoked in her the urge to depict dance moves and the dynamic motions of acrobats. Her new bullfight paintings are also connected to these themes.

After watching a bullfight in person, the handsome, youthful matador, as dramatic as an acrobat, moving in his dazzling costume, engaged in his intense, suspenseful battle with the formidable black bull, Theresa Kim has captured her experience in a cheerful manner, viewing bullfighting as a thrilling, dramatic dance between an exotic young lad and a bull.

For her new series, Kim visited famous bullrings in Spain, Venezuela and Mexico between 1990 and 1991 to fully utilize the opportunity to make firsthand sketches of the emotion and excitement of the sport. The drawings provided the foundations for the oils and pastels that she completed in her New York studio. Each canvas captures the spectacles and sensations of bullfighting, illustrating various moments—the entrance of toreros, the choreographed and rehearsed showdown between the matador and the bull, the thrilling climax in which the handsome matador is being forced into the corner, his assistants running at the

와 관중의 열광, 미소년 투우사가 위급하게 몰린 긴박한 순간, 달려든 예비사에 의한 소의 급소 공격 등으로 연출되는 극적인 광경과 감동을 속도감 있게 그려내고 있다.

그 긴장 속의 투우 장면과 스페인 민족 특유의 정열적 쇼의 분위기와 진행의 열기를 순간순간의 드라마로 화면화시키기 위해 작가는 동적이고 즉흥적인 필치의 수법을 취한다. 세밀하고 정확한 묘사로서의 투우 장면 표현과는 달리, 투우의 시간적 연출과 그 상황 및 분위기의 시각적 내지 감동적 체험이 명쾌하게 단순화시킨 형태로 그려지고 있는 것이다.

따라서, 그 화면들의 주체적 표현 형태는 소박하고 단조롭게 이루어지고 있다. 그 대신, 그 표현성과는 자유롭고 비기교적인 형상으로서의 생동성과 순수성을 구현시키고 있다. 다시 말해서, 그 화면들은 투우의 현장감과 시간적인 긴박한 움직임, 그리고 그것이 조성하는 통렬감과 관객의 흥분 도출의 요인에 테레사의 표현충동과 눈이 집중된 이외의 시점視點을 완전히 배제시키면서 투우 장면 자체만으로 화면을 성립시키고 있는 것이다.

테레사는 미국에 건너가기 전에 사진예술 활동으로 1968년부터 1970년까지 동아사진콘테스트와 동아국제사진살롱에서 연속 특선과 은상을 차지하는 등 특출한 평가를 받은 적이 있다. 뉴욕에 정착해서도 한동안은 사진의 연구작업을 지속했었다. 그러다가 그림으로 방향을 바꾸어 1979년에 뉴욕의 프랫 인스티튜트 대학원에서 회화를

bull and attacking its vital points.

Kim uses dynamic improvised brush strokes in an attempt to capture the moment-to-moment drama arising from the suspenseful bullfight sequences, the passionate atmosphere unique to Spanish culture, and the riveting emotions of the sport. Instead of closely and precisely describing each scene, Kim transforms the stirring visual experience into simplified forms according to time sequence.

As a result, the thematic expressions are rendered on the canvas a simple, tactless style. On the other hand, the result helps bring out a free-spirited and artless representation of the liveliness and authenticity of the images. In other words, the pictures focus only on the bullfighting scenes in order to accentuate the vitality and speed that create ferocity and excitement for the audience, leaving out all other points of view except of those on which Kim's artistic impulse and eyes are focused.

Before moving to the States, Theresa Kim had pursued a career in photography, winning Gold and Silver prizes at the Dong-A Photo Contest between 1968 and 1970. Kim did not, switch to painting straight away but continued to practice photography for some time in New York until she took up painting at the Pratt Institute in 1979. Her work in photography seems to serve her well in her composition, her grasp of the subjects in movement, and the instantaneous forms in capturing the shift and progress in time and space, as shown in the Pierrot and Bullfight series.

전공하면서 화가생활에 열중하게 되었던 것인데, 앞에서 말한 '피에로'나 '투우'의 연작 주제에서 보는 화면구성과 움직임, 그리고 그 시간적 공간적 변화와 진행의 순간 포착 형태는 이 작가의 지난날의 사진작업 바탕과 관련시켜 볼 만하다.

김테레사의 그림의 또 다른 기법적 특성으로는, 앞에서 좀 말했듯이 밝고 명쾌하며 단순화시킨 생동감의 색채 구사와 필치의 즉흥성 등이 이루는 미국생활 배경의 자유롭고 신선한 표현취향이다. 그의 미적 감수성이나 '피에로' '투우'의 주제 및 소재 착상도 그러한 취향의 일환인 것이다. 그러한 방향에서 다음에는 그가 또 어떤 주제에 매달리게 되려는지 궁금하다.

* 1992년 6월 조선화랑에서 열린 개인전에 맞춰 씌어진 글임.

Kim's paintings are characterized by her fresh, free-spirited expressions, visualized through her command of bright, simple, vivid colors and spontaneous brush strokes, apparently resulting from her liberal and fresh American experience. Such characteristics are also reflected in Kim's artistic sensitivity and choice of theme and subject matter, such as the pierrot and bullfighting. Given this, I am already beginning to wonder what theme Theresa Kim would explore next.

* This essay was originally written in June of 1992 for the solo exhibition held in Chosun Art Gallery, Seoul.

김테레사의 말
Theresa Kim's Note and Others

작가의 말
Artist's Note

작품 목록
List of Works

작가 약력
Artist's Biography

작가의 말

프랫 인스티튜트 대학원 첫 학기 시작 때였다. "내 학생 하나를 잃어버렸어"라고 떠들썩하게 말하며 보베Bové 교수가 내 작업 공간으로 들어왔다. 나는 그때 보베 교수의 드로잉 강좌를 학기초부터 빼먹고 있는 처지였다. 사실 나는 내심 무척이나 드로잉 수업을 겁내고 있었다.

벌거벗은 남자가 방 한가운데 높은 곳에 서 있고 학부생까지 합쳐서 꽤 여러 명이 모델을 둘러싸고 앉아서 노련하게 스케치하는 풍경, 프랫에 오기 전까지 나한테는 이런 나체 사생의 경험이 전혀 없었다. 다른 나의 동기생 대부분은 미술대 출신들인데, 나는 대학과 대학원에서 교육학을 전공했기 때문이다. 결국 프랫 인스티튜트가 나의 첫 정식 미술교육 경험이었다.

하여튼 보베 교수는 나를 내 자리에서 끌어내 드로잉 수업의 제일 앞줄의 이젤 앞에다 앉혔다. 나도 결국 피할 방도가 달리 없음을 금세 알아차렸고, 교실의 다른 사람들에게 뒤떨어지지 않고 스피드 드로잉을 해야겠다는 결심을 했다.

삼십 초마다 자세가 바뀌는 스피드 드로잉 시간에, 내 드로잉 속도로는 세 시간 동안 계속되는 강좌에서 그림 한

Artist's Note

"I lost one of my students" said Professor Bové loudly as he entered my cubicle. I had been avoiding his drawing sessions since the beginning of the semester. My first semester as a graduate student in Fine Art at Pratt Institute had just begun.

The drawing class had been a dreadful experience. A naked man had stood on a high platform in the middle of the classroom while several students, including undergraduates, had expertly and swiftly sketched him. I had never experienced a live drawing class before that. Unlike most graduate students at Pratt, I was not an art school graduate. My prior studies had been in the field of education and educational planning. Pratt Institute was my first formal art education.

Anyway, Professor Bové got me out of my cubicle and dragged me to an easel in the front row of the drawing area. I soon realized I would have no choice but to keep up with the pace of the class. I made up my mind that would not be left behind, especially in speed drawing exercises.

My normal drawing pace wouldn't even give me the time to finish a single drawing during an entire class session which lasts about three hours. Speed drawing could last less than half a minute before the model would change pause. I figured I would have to somehow compensate for my lack of training; I tried to see

장도 변변히 완성할 수 없었다. 어떻게든 나의 경험 부족을 만회할 특별한 방도를 생각해내는 수밖에 없었다. 우선 내 앞에 있는 형태나 모습을 지극히 단순화한 후 형태를 재구성하는 노력을 시작했다. 그러고 나서 내가 새로 구성한 마음속의 형상에 따라 재빨리 선을 긋는 식으로 드로잉을 완성하기 시작했다. 이런 방법에 몰입하자니, 어느덧 내가 어디 있는지, 시간이 어떻게 흐르는지도 잊어버리고 계속 드로잉을 하고 있었다.

갑자기 온 교실이 이상하게 조용하고 텅 빈 방 속에 혼자만 있는 것 같은 느낌에 정신이 번쩍 들어 주위를 돌아보니, 보베 교수가 바로 내 등 뒤에 서 있었다. 같은 교실에 있던 학생들이 전부 뒤에서 내 드로잉을 보고 있었다. 그러고는 누군가가 내게 이전에는 나체 사생을 해 본 적이 정말 없느냐고 물었다.

보베 교수가 질 좋은 종이로 만든 새 드로잉 패드를 건네면서 내가 쓰고 있던 신문지 드로잉 패드를 버리라고 했다. 지금부터는 드로잉을 나쁜 용지에 낭비하지 말라고 했다. 그리고 그날부터 보베 교수는 내 드로잉을 하나의 완성된 작품으로 취급했다.

나는 어릴 때 전쟁통에 여기저기 피란을 다닌던 기억 외에 이렇다 할 즐겁던 추억이 별로 없다. 옛날 우리 집은 과수 나무와 꽃, 그리고 여러 가지 돌과 암석이 잔뜩 있는 큰 정원이 딸린 집이었다. 아버지는 그림 그리기와 글씨 쓰

the simplified lines of the figures and shapes in front of me. Then, in a determined manner, I quickly traced what I saw. I kept on tracing the lines while in deep concentration, eventually I lost track of time and of where I was.

All of a sudden, I realized the classroom had become silent, it sounded as if I was all alone. I looked around and saw Professor Bové standing immediately behind me. The majority of the student body had gathered around to admire my drawings. Eventually, someone asked if it was really true I had never practiced live drawing before.

Professor Bové handed me a new pad of fine quality drawing paper and told me to get rid of the customary newsprint drawing pad used by most students for class purposes. He told me that none of the drawings I produce should be lost on poor quality paper. From that day onward, Professor Bové treated each drawing of mine as a complete work of art, independent from the practice drawing class it was produced in.

I do not remember much from my early childhood. I suspect my memories were wiped out because of what I suffered while hiding in the shelters during wartime. Our family house was a very big one with large gardens full of fruit trees and pretty stones. My father enjoyed taking photographs and drawing pictures of the flowers and rocks. I enjoyed the arts with my father. I learned calligraphy from him. He would hold my hand; actually,

기, 사진 찍기를 즐기셨다. 나도 아버지와 함께 그림을 그렸고, 붓글씨 쓰는 법도 배웠다. 아버지 무릎에 앉아서 아버지 손을 잡고 따라 그려 완성된 그림이나 글씨를, 나 혼자 한 것처럼 손뼉치며 크게 웃으면서 즐거워하던 기억이 있다. 또 발레 연습을 정기적으로 했고, 여기저기 공연을 다니던 기억이 있다.

한국전쟁 발발로 이 모든 일상들이 사라지고 전쟁터가 된 집에서 피란을 나오면서 우리는 전부를 잃었다. 이런 중에도 나는 발레 토 슈즈를 소중히 어디나 가지고 다녔고, 그것이 내가 가진 것의 전부였다.

전쟁 중의 힘든 환경은, 집안 살림 이외는 아무것도 모르던 나의 어머니를 굉장히 현실적인 사업가로 만들어 버렸다. 어머니는 현실적이지 못한 예술이나 예술가들을 경멸하기 시작했다. 이런 상황에서 나는 발레를 계속하고 싶다거나 그림을 그리고 싶다는 소망을 입에서 꺼내지도 못했고, 형편이 좋아진 꽤 나중까지도 그렇게 자랐다.

결혼하고 미국으로 옮겨 온 후, 그 먼 지리적 거리가 어머니의 예술에 대한 질시를 잊게 했는지는 몰라도, 갑자기 걷잡을 수 없는 그림에 대한 열망이 되살아났다. 뉴욕대에서 영어를, 커뮤니티 칼리지에 미술을 등록하고 열심히 다녔다. 젊은 사람들과 다시 어울리는 것도 즐거웠고, 미술을 해 보겠다는 자신감도 생겼다.

같은 미술과에 다니던 학생들의 정보에 따라 프랫 인스티튜트 대학원 미술 전공에 지원서를 냈다. 나는 이미 교육학으로 학사와 석사과정을 끝냈으므로, 학부 과정을 다시 갈 수는 없었다. 커뮤니티 칼리지에서 준비한 작품들 중

I would hold his hand while sitting on his lap until the writing would be completed. When done, I would be delighted, clapping hands and laughing loudly, feeling I had accomplished it all by myself. I also enjoyed learning classical ballet which I did regularly. I was one of the selected child prodigies in the region.

It all stopped abruptly with the break of the Korean War. Our family lost all of its possessions during the migration. After all that, I still carried with me a pair of ballet toe shoes wherever we went, I had no other possessions.

The hardships of the war turned my mother into a practical business woman. She became contemptuous of all the arts. She felt artists were unskilled for war time challenges. I did not dare express to her how I yearned to dance and draw during that unstable period of time. It continued that way long after the war was over.

After I married, I moved to the United States. There, far away from my mother's contempt for the arts, my yearning for the arts returned almost immediately. I enrolled in English classes at New York University and in art classes at a community college. I felt happy to be with young classmates and to feel the spirit of the arts ignite again within me.

Eventually, I applied for Graduate School of Fine Art at Pratt Institute. It might have been foolish to return to school since I already had undergraduate and graduate degrees. Anyway, I prepared myself to the best

심으로 최선을 다해서 포트폴리오를 만들어 제출했다. 합격 통지가 날아왔다. 한동안 믿겨지지 않았다.

합격을 기대하지 않았기 때문에, 내가 살고 있는 스테튼 아일랜드에서 학교가 위치한 브루클린까지의 통학을 제대로 준비하지 못했다. 결국 남편이 직장에 한 달 휴가를 내고 내가 브루클린 길에 익숙해질 때까지 통학을 도왔다. 어느 날, 회화 담당 교수이자 대학원장인 위카이저Wiekeiser 박사에게 강의실 내 옆 자리에 앉아 있는 남편을 들켰고, 이제부터 수업시간에 남편과 동행하지 말라고 주의를 들었다. 여하튼 그때쯤엔 다행히 나도 학교 근처와 브루클린 환경과 운전에 익숙해 있었다.

내가 유화를 시작하게 된 것은 굉장히 많은 양의 세넬리에Sennelier 유화물감을 프랑스 여행 중이던 아버지로부터 선물받았기 때문이었다. 그 전부가 코발트나 카드뮴, 티타늄 같은 고급 피그먼트로 된 전문가용으로, 색깔 자체가 질감을 가진 보석 같은 물감이었다. 나중에 그림 그리는 양이 많아지면서 빨리 건조되는 아크릴 물감으로 바꿔 쓰게 됐지만, 여전히 그 고급 피그먼트들을 합성 피그먼트로 대체할 수는 없었다.

나는 색 자체가 형상을 보조하는 것이 아니라, 독립적인 추상의 의미를 포함하고 있다고 생각한다. 피그먼트 는 그림의 설명적 형상과는 달리 그 자체의 독특한 질감으로 오브제적인 역할을 해낸다. 마치 금관에 있는 커다란 보

of my ability, gathering a portfolio of artworks I had created while at the community college. When I was accepted, I couldn't believe it.

I had not counted on getting in and so was unprepared for the commute to school which implied I would have to drive from Staten Island to Brooklyn. My husband took a vacation from work and drove with me for an entire month. One day, Dr. Wiekeiser, my painting advisor and Dean of the Graduate School, noticed that other person sitting besides me in class. He asked who the man was and told me to stop bringing my husband to class. Luckily by then, I had become comfortable with the school environment and the drive.

There were great oil paint tubes in our house which my father had brought home following a trip to France. The supply was of a professional grade quality by Sennelier, it included a wonderful array of cadmium, cobalt and titanium based hues. This is how it came to be that I began painting using oil paint. I liked working with oil paint because it allowed me to imbue colors with multiple tones. When I became more mature as an artist, I switched to acrylic paint on linen canvas as it allowed me to be more spontaneous.

When I paint an artwork, I consider colors for their abstractive powers. Each color pigment, by itself, enhances the work with its own beauty independently of the object it represents. For me, colors are not unlike jewels in a decorative ornament.

석들처럼 자신들의 역할을 다투는 것이다.

반 고흐V. Van Gogh의 많은 작품들에서 볼 수 있듯이, 각각의 색깔들이 찬란하게 빛나며 그 형태보다 우선하여 작품의 내용을 강화하는 것은 반 고흐도 색깔의 오브제적인 역할을 의식했기 때문일 것이다. 훗날 어떤 사람들은 그가 특별히 노란색에 편향되었던 것을 치료약 때문에 생긴 색감의 변화로 해석하기도 했다. 하지만 그의 그림에서 보이는 굉장히 까다로운 색깔의 선택을 고려하면, 그를 잘못 평가한 것이 아닌가 한다. 반 고흐가 동생에게 보낸 편지에서, 카드뮴 대신 크롬, 코발트 대신 합성 피그먼트로 만든 색깔을 받고서 그림을 그릴 수가 없다고 심각하게 불평한 것을 보면 더욱 그렇다.

나는 색깔을 섞지 않는다. 각 색깔을 원색 그대로, 무작위적이지만 필연성으로 연결된 구성으로 진행해 나간다. 작은 상념이나 간단한 설명적 힌트로써 특별한 구성적 계획을 하지 않고, 한구석에서부터 책장을 정리하듯이 빠르게 해 나간다. 각 요소들이 개개의 독립된 역할을 하기 때문에, 나중에 화면이 찼을 때는 예상할 수 없는 결과를 만들어낸다. 어떤 것들은 설명할 수 있는 형태가 되기도 하고, 어떤 것은 완전히 추상적인 것이 되기도 한다. 내 색깔들은 하나하나가 오브제이기 때문에, 나와 너를 바꿀 수 없듯이, 같은 파란색이라도 다른 색과 치환할 수 없다. 그림이 완성됐을 때 이 색깔들은 거의 현실과의 연결성이 없다. 다만 본능적으로 느껴지는 대로 놓이는 것이다.

I think the masterworks of Van Gogh are a great example of the radiance that emerges when prioritizing individual color pigments over form. Van Gogh used bright, pure colors to heighten the expressiveness of his work. Yellows are brilliantly contrasted with just the right amount of blue tones and vice versa.

Van Gogh used yellow a lot. Some say his vision was affected by a medication he took to treat an ailment, that his yellow paintings are in part the result of his distorted vision due to the medication. I have never bought into those stories. It would be impossible for me to believe that such a masterful orchestration of colors would be in any way unintentional. Van Gogh was very precise about his color pigments. In a letter to his brother, he complained with frustration about receiving ultramarine blues when he had actually requested cobalt blues, and cadmium yellows instead of the chrome yellows he had asked for. I can relate to that.

When I begin an artwork, I lay the colors on their surface rather independently from one another, by necessity as an inevitable consequence of the situation progressing in the painting. I begin spontaneously, with little planning, perhaps a hint of an idea or a sketchy concept inspired from a literary source. It is hardly a representational arrangement. Other times, I begin with a purely abstract motif. The image builds from its abstract state and evolves toward a more pictorial expression. My color choices are specific: a cerulean blue is not interchangeable with a Prussian or cobalt or ultramarine blue. When the artwork is finished, the

아마 여기에 현실의 세계와 미술가들이 만든 세계가 관객과 소통하는 방법의 차이가 있지 않나 하는 생각이 든다. 피카소P. Picasso가 〈아비뇽의 여인들〉에서 검은색을 얼굴에 쓴 것이나 마티스H. Matisse가 창가의 붉은 석류를 황금색으로 그린 것이, 결국은 현실의 색깔은 아니었지만, 그림을 보는 사람들에게는 별다른 불평이나 저항 없이 받아들여지는 것을 보면 알 수 있다.

우리 부모 세대에 속하는 한국 중진화가들과 내가 교류할 수 있었던 것은 참으로 큰 행운이었다. 이들은 한국에서 서양화를 수용한 첫 세대여서 전통적 한국화와 다양한 뿌리를 가진 서양화에 대한 나의 색깔을 정립하는 데 많은 도움이 되었다.

친분이 있던 중진화가들 중 남관南寬 선생에게는 개인적으로 갚아야 할 빚이 있다. 프랫에 입학했을 때 내게 제일 먼저 축하 편지를 보내 주셨고, 뉴욕에 와서 맞는 첫 새해에는 우리 가족에게 손수 그린 연하장을 보내 주셨다. 한국을 떠나기 전 내 개인 사진전에 오셨을 때, 사진 중 하나를 마음에 들어 하시면서 자신의 작품과 바꾸자고 하셨다. 나는 말할 것도 없이 즉시 그 제의를 수락하고, 남 선생의 작품 중에서 마음에 드는 소품 하나를 골랐다. 내가 고른 작품을 보신 남 선생은 깜짝 놀라면서 좀 망설이는 눈치였다. 결국 "약속은 약속이지" 하시면서 그 작품을 내

colors have no connection with reality yet instinctively, they feel right.

Perhaps it is this difference between the real world and the altered reality that emerges out of art that binds the art to its public. Like Picasso's decision to use black instead of skin tones to depict the features of the women in his *Les demoiselles d'Avignon* or Matisse's choice to use gold instead of red to depict the fruit in his *Still Life with Pomegranate*. These colors are not the real colors of what they represent, yet, they are extraordinary and just right in the creative worlds of their artworks, without any resistance on the eye of the viewer.

I feel lucky to have been acquainted with the Korean Old Masters who belonged to my parent's generation. These artists; sometimes referred to as the "bridge generation" have shaped my attitude toward the arts and provided a platform in which traditional Korean art concepts interacted with western art ideas.

I have developed a personal friendship with some of these Korean Masters. One of them is named Professor Nam Kwan. I feel deeply indebted to him. He was the first person to send me a letter upon my acceptance at Pratt Institute. For the New Year, he sent me a drawing made by his own hand. Professor Nam liked one of my photographs and offered that I choose one of his new works as an exchange. I promptly accepted and chose a painting. He was very surprised by my choice and for a moment he looked slightly perturbed. "A

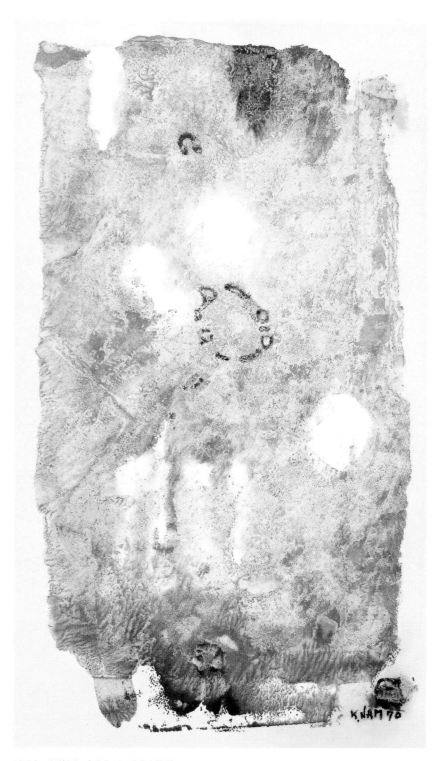

남관 〈고대 석(古代石)에서 오는 히니의 형대〉 1970.
Nam Kwan. *Image of an Ancient Temple*. 1970.

게 주셨다. 그러고는 "이 작품은 아직 아무에게도 보여 준 적이 없는 실험적 시도이니, 적절한 시기까지는 보관하다가 나중에 기회가 되면 발표해 주게" 하고 당부하셨다. 남 선생께서 돌아가신 후, 내게는 계속해서 이 약속이 큰 빚으로 남았고, 바로 지금이 그 적절한 때임을 믿는다.

2010년 11월
김테레사

promise is a promise" he said. "You can have the piece, but this painting actually is a new experiment of mine and no one else has seen it. Promise me you will not present it to others until you think the proper time has come." Now he has passed away and so I believe the time has come for me to present it to others.

November, 2010
Theresa Kim

작품목록 List of Works

앞의 숫자는 페이지 번호임.
The front figures are page numbers.

131 1999–2010. 한지에 잉크와 파스텔. Ink and Pastel on Rice Paper. 72.7×60.6cm.

132 1999–2010. 한지에 잉크와 파스텔. Ink and Pastel on Rice Paper. 72.7×60.6cm.

133 1999–2010. 한지에 잉크와 파스텔. Ink and Pastel on Rice Paper. 72.7×60.6cm.

135 1999–2010. 한지에 잉크와 파스텔. Ink and Pastel on Rice Paper. 72.7×60.6cm.

137 1983. 캔버스에 유채. Oil on Canvas. 33.4×24.2cm.

138 1983. 캔버스에 유채. Oil on Canvas. 33.4×24.2cm.

139 1983. 캔버스에 유채. Oil on Canvas. 33.4×24.2cm.

140 1983. 캔버스에 유채. Oil on Canvas. 12.1×11.2cm.
1983. 캔버스에 유채. Oil on Canvas. 12.1×11.2cm.

141 1983. 캔버스에 유채. Oil on Canvas. 12.1×11.2cm.
1983. 캔버스에 유채. Oil on Canvas. 12.1×11.2cm.

143 1999–2010. 은판화. Silver Plate Print. 34.8×27.3cm.

144 1999–2010. 은판화. Silver Plate Print. 33.4×24.2cm.

145 1999–2010. 은판화. Silver Plate Print. 32.4×24.2cm.

147 1999–2010. 은판화. Silver Plate Print. 34.8×27.3cm.

148 1999–2010. 은판화. Silver Plate Print. 34.8×27.3cm.

149 1999–2010. 은판화. Silver Plate Print. 34.8×27.3cm.

150 1999–2010. 은판화. Silver Plate Print. 34.8×27.3cm.

151 1999–2010. 은판화. Silver Plate Print. 34.8×27.3cm.

153 1999–2010. 은판화. Silver Plate Print. 34.8×27.3cm.

155 1999–2010. 은판화. Silver Plate Print. 34.8×27.3cm.

157 1999–2010. 은판화. Silver Plate Print. 34.8×27.3cm.

159 1978. 종이에 펜. Pencil on Paper. 50.7×40.5cm.

160 1978. 종이에 펜. Pencil on Paper. 40.5×50.7cm.

161 1978. 종이에 펜. Pencil on Paper. 50.7×40.5cm.

163 1979. 종이에 펜. Pencil on Paper. 50.7×40.5cm.

165 1978. 종이에 펜. Pencil on Paper. 50.7×40.5cm.

169 1999–2010. 캔버스에 유채. Oil on Canvas. 97×130.3cm.

171 1999–2010. 캔버스에 유채. Oil on Canvas. 130.3×97cm.

172 1999–2010. 캔버스에 유채. Oil on Canvas. 130.3×97cm.

173 1999–2010. 캔버스에 유채. Oil on Canvas. 130.3×97cm.

175 1999–2010. 캔버스에 유채. Oil on Canvas. 162×130.3cm.

176 1999–2010. 캔버스에 유채. Oil on Canvas. 130.3×97cm.

177 1999–2010. 캔버스에 유채. Oil on Canvas. 130.3×97cm.

179 1999–2010. 캔버스에 유채. Oil on Canvas. 145.5×112.1cm.

180 1991. 캔버스에 유채. Oil on Canvas. 60.6×72.7cm.

181 1991. 캔버스에 유채. Oil on Canvas. 60.6×72.7cm.

183 1991. 캔버스에 유채. Oil on Canvas. 72.7×60.6cm.

185 1991. 캔버스에 유채. Oil on Canvas. 80.3×65.1cm.

187 1999–2010. 캔버스에 아크릴. Acrylic on Canvas. 162×130.3cm.

189 1999–2010. 캔버스에 아크릴. Acrylic on Canvas. 130.3×97cm.

191 1999–2010. 캔버스에 아크릴. Acrylic on Canvas. 130.3×97cm.

193 1999–2010. 캔버스에 아크릴. Acrylic on Canvas. 145.5×112.1cm.

194 1999–2010. 캔버스에 아크릴. Acrylic on Canvas. 130.3×97cm.

195 1999–2010. 캔버스에 아크릴. Acrylic on Canvas. 130.3×97cm.

196 1999–2010. 캔버스에 아크릴. Acrylic on Canvas. 130.3×97cm.

197 1999–2010. 캔버스에 아크릴. Acrylic on Canvas. 130.3×97cm.

198 1999–2010. 캔버스에 아크릴. Acrylic on Canvas. 145.5×112.1cm.

199 1999–2010. 캔버스에 아크릴. Acrylic on Canvas. 145.5×112.1cm.

201 1999–2010. 캔버스에 아크릴. Acrylic on Canvas. 145.5×112.1cm.

203 1999–2010. 캔버스에 유채. Oil on Canvas. 80.3×65.1cm.

204 1988. 캔버스에 유채. Oil on Canvas. 80.3×65.1cm.

205 1989. 캔버스에 유채. Oil on Canvas. 80.3×65.1cm.

207 1999–2010. 캔버스에 유채. Oil on Canvas. 80.3×65.1cm.

209 1999–2010. 캔버스에 유채. Oil on Canvas. 80.3×65.1cm.

211 1988. 캔버스에 유채. Oil on Canvas. 145.5×112.1cm.

213 1984. 캔버스에 유채. Oil on Canvas. 116.8×91cm.

215 1984. 캔버스에 유채. Oil on Canvas. 80.3×65.1cm.

217 1983. 캔버스에 유채. Oil on Canvas. 27.3×18cm.

218 1983. 캔버스에 유채. Oil on Canvas. 22×27.3cm.

219 1983. 캔버스에 유채. Oil on Canvas. 22×27.3cm.

220 1983. 캔버스에 유채. Oil on Canvas. 22×27.3cm.
1983. 캔버스에 유채. Oil on Canvas. 22×27.3cm.

221 1983. 캔버스에 유채. Oil on Canvas. 27.3×22cm.
1983. 캔버스에 유채. Oil on Canvas. 27.3×22cm.

223 1983. 캔버스에 유채. Oil on Canvas. 27.3×16cm.

225 1983. 캔버스에 유채. Oil on Canvas. 27.3×22cm.

226 1989. 캔버스에 유채. Oil on Canvas. 80.3×65.1cm.

작가 약력

김테레사 / 김인숙 金仁淑

1943 서울 출생.

학력

1968 숙명여자대학교 교육학과 졸업.

1970 동 대학원 교육학과 졸업.

1970–72 숙명여자대학교 문리대 강사.

1972 미국으로 이주.

1979 뉴욕 프랫 인스티튜트 석사 졸업.

회화전

2010 한국국제아트페어(KIAF), 서울.

2008 「동아시아의 비전」, 베이징 올림픽, 베이징.

2005 개인전, 서울아트페어, 예술의 전당, 서울.

1998 초대전, 「한국현대미술」, 서울프레스센터, 서울.

1996 개인전, 박영덕화랑, 서울. / 메이아트페스티벌,
 박영덕화랑 · 조선화랑, 서울.

1992 개인전, 조선화랑, 서울. / 단체전 「봄으로 가는 길목」,
 조선화랑, 서울.

1991 「서울아트페어 추천작가전」, 조선화랑, 서울.

1990 「현대한국미술전」, 교토시국제교류회관, 교토.

1989 「오늘의 한국회화 7인전」, 오이시갤러리, 후쿠오카 외.

1988 88서울아트페어, 호암갤러리, 서울. / 개인전, 조선화랑,
 서울.

1985 중앙일보 초대전, 한국문화원, 뉴욕.

1984 개인전, 공창화랑, 서울.

1982 「해외 한국작가 초대전」, 국립현대미술관, 서울. / 개인전,
 선갤러리, 서울.

1980 개인전, 선갤러리, 서울.

1979 개인전, 히긴스 갤러리, 뉴욕.

사진전

1994 「장미」(8×10 폴라로이드전), 파인힐갤러리, 서울.

1984 「뉴욕의 대중문화, 보통사람들의 벽화」, 파인힐갤러리,
 서울.

1975 「워싱턴 스퀘어」, 미도파화랑, 서울.

1972 「바람」, 국립공보관, 서울.

1970 「비원」, 국립공보관, 서울.

수상

1969 제7회 동아사진콘테스트, 특선, 서울.

1969 동아국제아트쇼, 금상, 부산.

1968 제6회 동아사진콘테스트, 특선, 서울.

1968 제3회 동아국제사진살롱, 은상, 서울.

작품소장

숙명여자대학교 박물관, 서울.

서울외국인학교, 서울.

금암성당, 전주.

공항터미널 컨벤션센터 벽화, 서울.

대호 헬스랜드 벽화, 서울.

한서 빌딩, 서울.

베어리버 골프리조트, 익산.

박영사, 서울.

앙또아네뜨패션 빌딩, 서울.

Artist's Biography

Theresa Kim / In Sook Kim

1943 Born in Seoul, Korea.

Education

1968 B. A. in Education, Sookmyung Women's University, Seoul.
1970 M. A. in Education, Sookmyung Women's University.
1970–72 Instructed at Sookmyung Women's University.
1972 Went to USA.
1979 M. F. A., Pratt Institute, New York.

Painting Exhibitions

2010 Korea International Art Fair, Seoul.
2008 *Vision of East Asia*, Beijing Olympic, Beijing.
2005 Solo exhibition, Seoul Art Fair, Seoul Art Center, Seoul.
1998 Invitational exhibition, *Korean Modern Art*, Seoul Press Center, Seoul.
1996 Solo exhibition, Galerie Bhak, Seoul. / May Art Festival, Galerie Bhak and Chosun Art Gallery, Seoul
1992 Solo exhibition, Chosun Art Gallery, Seoul. / Group exhibition, *Road to Spring*, Chosun Art Gallery, Seoul.
1991 *Seoul Art Fair's Choice*, Chosun Art Gallery, Seoul.
1990 *Korean Contemporary Art*, Kyoto City International Foundation Center, Kyoto.
1989 *Today's Korean Paintings by 7 Artists*, Gallery Oishi, Fukuoka etc.
1988 '88 Seoul Art Fair, Hoam Gallery, Seoul / Solo exhibition, Chosun Art Gallery, Seoul.
1985 Invitational exhibition by Joong Ang Daily, Korean Cultural Center, New York.
1984 Solo exhibition, Kong Chang Gallery, Seoul.

1982 *Korean Artists Abroad Invitational Exhibition,* National Museum of Contemporary Art, Seoul / Solo exhibition, Sun Gallery, Seoul.
1980 Solo exhibition, Sun Gallery, Seoul.
1979 Solo exhibition, Higgins Gallery, New York.

Photo Exhibitions

1994 *The Roses* (Polaroid image transfer), Pinehill Gallery, Seoul.
1984 *Graffiti in Manhattan*, Pinehill Gallery, Seoul.
1975 *Washington Square*, Midopa Gallery, Seoul.
1972 *Wind*, The National Information Center, Seoul.
1970 *Secret Garden*, The National Information Center, Seoul.

Awards

1969 Gold prize, The 7th Dong-A Photo Contest, Seoul.
1969 Gold prize, Dong-A International Art Show, Busan.
1968 Gold prize, The 6th Dong-A Photo Contest, Seoul.
1968 Silver prize, The 3th Dong-A International Photo Salon, Seoul.

Collections

Sookmyung Women's University Museum, Seoul.
Seoul Foreign School, Seoul.
Geumam Catholic Church, Jeonju.
Wall painting in Airport Terminal Convention Center, Seoul.
Wall painting in Daeho Health Land, Seoul.
Hansur Building, Seoul.
Bear River Golf Resort, Iksan.
Pakyoungsa, Seoul.
Antoinette Fashion Building, Seoul.

theresa kim

김테레사 작품집 1978-2010

초판1쇄 발행 2011년 2월 10일 **발행인** 李起雄 **발행처** 悅話堂
경기도 파주시 교하읍 문발리 520-10 파주출판도시
전화 031-955-7000 팩스 031-955-7010
www.youlhwadang.co.kr yhdp@youlhwadang.co.kr

등록번호 제10-74호 **등록일자** 1971년 7월 2일
편집 이수정 조윤형 박미 **북디자인** 공미경 황윤경
인쇄 · 제책 (주)상지사피앤비

＊값은 뒤표지에 있습니다.

theresa kim ⓒ 2011 by Theresa Kim
Published by Youlhwadang Publishers.
520-10, Paju Bookcity, Munbal-Ri, Gyoha-Eup, Paju-Si, Gyeonggi-Do, Korea.
Tel 82-31-955-7000 Fax 82-31-955-7010
Printed in Korea.

ISBN 978-89-301-0392-3

이 도서의 국립중앙도서관 출판시도서목록(CIP)은
e-CIP 홈페이지(http://www.nl.go.kr/ecip)에서
이용하실 수 있습니다.(CIP제어번호: CIP2011000083)